Impact-
Photography
for Advertising

William A. Reedy

Published by Eastman Kodak Company

© Eastman Kodak Company, 1973

First Edition—First Printing

Library of Congress Catalog Card Number: 73-87796

Standard Book Number 0-87985-081-7

The practice of picture-making with a camera has become so simplified so quickly that a child can record a scene with a clarity and color quality matched only by skilled technicians merely a few decades ago. This is marvelous. The child can also push a button to record a voice, use a pencil to form words, hit a nail with a hammer, stir vibrant paints onto a surface, and finger the national anthem on the piano. The fact that he can make something happen with all these creative media does not necessarily lead to the conclusion that he made something out of them. He may have had fun, but he hasn't said anything.

Saying something is what photographic illustration is all about. It is the presentation of an idea in a photographic language. Being visual makes it quicker in its transmission than a written appeal, but its purpose is similar. The photographer who creates such images does so on demand. This labels him professional. This book is about professional images that say something, usually for commercial purposes.

Acknowledgements

End papers from photography by JASON HAILEY
Title page from photography by HENRY RIES
Photography not otherwise credited, by the author
Design by Dan Marciano
Printed by Case-Hoyt Corporation

A significant portion of the material in this book has appeared in *Applied Photography,* a quarterly magazine edited by the author and published for communications people by East-man Kodak Company.

The author and the publisher wish to thank all of the gifted photographic illustrators whose work has made possible not only this volume, but *Applied Photography* itself. Hundreds of photographers have contributed the offspring of their talent to that publication, and every one has added to an already extensive vocabulary in the photographic language.

Impact-

Photography for Advertising

The professional communicator, be he in advertising, public relations, or publishing, has spent most of his life learning his spoken and written language. He studied and used it as long as he was in school, and practiced it as long as he breathed. He knows words are important, for his life and his work are wrapped in words. When he uses words with consideration for their exact meaning and arranges them in forceful patterns, he shows his respect for their importance.

In a visual world, the communicator is less than half a professional, however, if he makes no effort to understand and respect the pictured portion of his story. That photography is a language is well understood; that pictures often occupy the lion's share of space in a communication is obvious; yet, too frequently the photographic half of a communicating partnership is dismissed as an afterthought.

In the preparation of an advertising or editorial communication, the illustration should be part of the total concept. In fact, the illustra-

tion often can *be* the total concept, with words serving the minimum purpose of prosaic identifications. The photographer charged with creating the illustration obviously must be fully informed if he is to make his contribution. His function as a camera operator is, of course, a necessary one. But his value to the partnership goes beyond the mechanical. His is the true visual world where ideas are translated into pictures as naturally as the writer translates ideas into words.

All too often all concerned, even photographers, become overjoyed with techniques and equipment and new combinations of things, when in fact what is important is the idea and how to make the picture into a piece of universal communication. A way to make the product look larger than it is may be a technical and artistic achievement. But where the sales advantage is a product's smallness, such an achievement becomes ridiculous. But never to try something new would be even sadder. The trick is to leaven the enthusiasm with logic.

Photography is a very lively art, and the imaginations of photographers very active. Coupled with an almost continuous procession of new equipment and supplies, it is difficult to conceive of photography standing still. There is always a different or new way of doing something, each of them intriguing.

The forward-looking advertising manager and art director will keep himself posted on new developments and new ways. A fine investment in communications is an occasional series of photographic experiments. Ideas come from doing, and experimental experiences have a way of developing into effective advertising campaigns.

The individuals who collectively form the audience for communicators have never known a world not saturated with pictures. Magazines, newspapers, television—everything they contact is illustrated. If education is—in part—exposure, the public is, indeed, visually well educated. Advertisers who would be noticed had better wear their finest clothes.

To stop the eye... To set the mood... To start the sale...

To stop the eye is all important in an advertising illustration. And without visual impact, nobody stops and nothing happens.

To set the mood is all important in an advertising illustration. For visual pleasure invites the reader to stay a while and participate.

To start the sale is the whole point of an advertising illustration in the first place. Its ability to persuade is often predicated on its degree of promise and the way in which the product is presented.

Visual impact illustrated.
The exact millisecond of exposure
was triggered by the sound of
breaking glass through a microphone.
Photography by RUDY MULLER

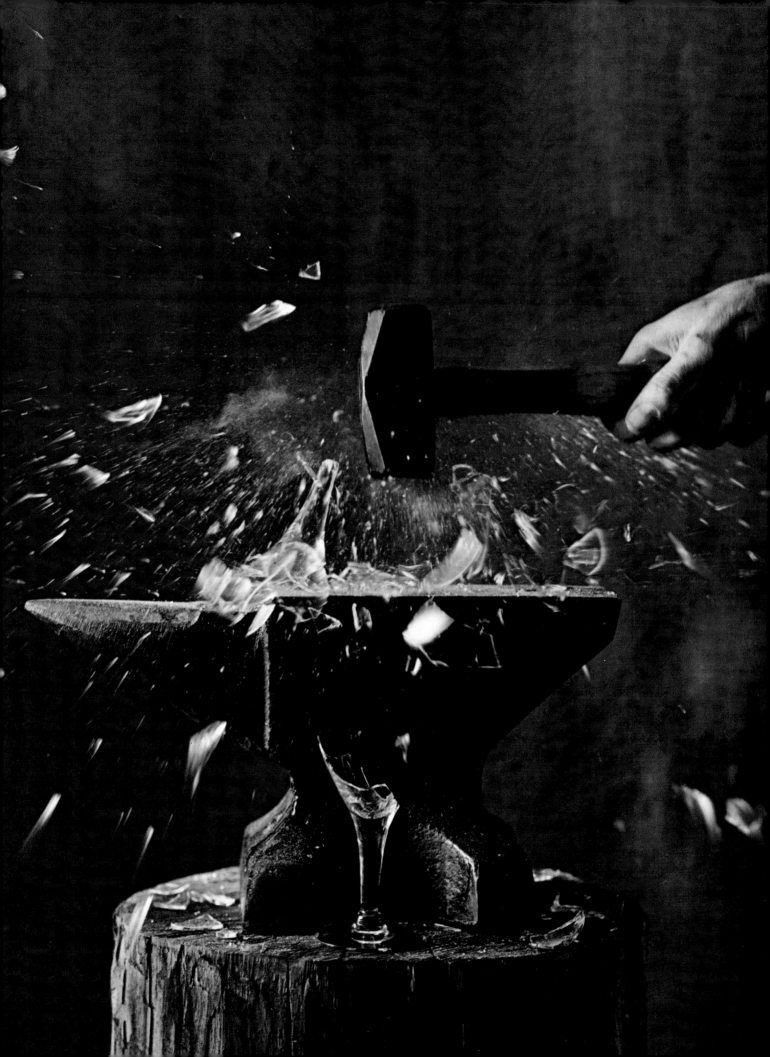

Advertising is supposed to function by having a cooperating judge called an advertising manager pass judgment on the efforts of a creative establishment called an agency. The writer writes and that's fine because the bossman knows writing and he can tell if it says what it's supposed to say, and if it's good or bad. The art director directs, a photographer photographs, and that's not so easy because the boss may not have the same standards for pictures as he has for words. If his standards are low, he may feel there is financially more photograph than he needs. The art director is therefore extravagant. If his standards are high, he may not like the photograph and cannot explain. The art director is in trouble again. And if the art director does not understand photography, he's been in trouble all along. So how does one determine quality?

It is highly significant that people choose to indicate their approval or disapproval of many things by saying that they like—or dislike—them. The amateur wine taster twirls his glass and says he *likes* it. The casual listener accepts a musical performance by *liking* it. A photograph is most often either *liked* or disliked. Seldom does anyone claim the critic's privilege of saying a thing is good. By keeping matters on the personal plane of likes and dislikes, the responsibility of expertise is avoided.

It is true that all such appraisals are subjective in that they are made within the context of personal experience. But a subjective judgment is an incomplete one and depends upon the limitations of that experience and the emotions of the moment. An objective evaluation, on the other hand, is based on knowledge of standards —set either on factual information or on a consensus honed fine by time.

Fortunately, there are factual standards by which the technical excellence of photography can be judged. And while technical excellence alone does not make a successful illustration, the lack of it can ruin one.

Sharpness and tone separation are the two

major indicators of photographic quality. In fact, the ability to render detail sharply and to separate tone gradations from the deep shadows through brilliant highlights are the two unique properties of the photographic process.

In judging sharpness, one concerns himself, of course, with the sharpness of the main subject. It is seldom desirable to have background and subject equally sharp, since a softness in the background emphasizes the sharpness of the subject. Closely allied with sharpness is texture, whose rendering is a function of the way in which the subject was lighted originally. If the subject was smooth, had a surface pattern, or was rough, a technically fine photograph should show that it was.

The dark, or shadow, areas of the scene should have sufficient tone separation to show detail; and the highlights should show tones ranging from just off-white for the brightest downward. Most important is the subject of the photograph, and its tones should have enough separation or contrast to demonstrate its shape.

The effect of correct placement of tones in a photograph is to achieve a proper contrast or ratio of lights to darks. A flat photograph lacking in contrast is one that is dull to look at, while a photograph having too great a contrast is ugly and harsh. As a matter of fact, quality in a photograph is most obvious when the photograph is poor. When there is good quality, each characteristic of photography is doing its part and the viewer sees only the subject.

A photograph for advertising use is usually only a steppingstone to the printed reproduction which actually carries the message to the public. Therefore, it is not enough to judge the photograph simply as an end in itself. A small original which is to be reproduced in a large size must be examined accordingly. Does it just look sharp or is it really sharp? Will it come apart when enlarged? Will the enlargement be too great for the original?

Remember that highlights which catch the eye and distract attention from the subject matter will catch the eye and distract even more when the picture is enlarged. Shadows which are annoyingly lacking in detail in the original will probably be more annoying in reproduction. And subject matter which seems to recede into the background will recede even farther on the printed page.

Because photography is such a versatile medium, and because so many effects can be achieved by judicious manipulation of the medium, any objective evaluation must take into consideration the purpose and story line of the picture. Obviously, the misty mood of a foggy evening can best be rendered by the soft unsharpness caused by the subject matter. And certainly there should be no detail in a shadow shape where the intention is to show it as a silhouette. The dictum of maximum sharpness and tone gradation is one applicable only to photographs which are purely descriptive.

If there can be a simple summing up in the matter of judging photographic quality it might be in the admonition to step back from that subjective enchantment gleaned from a quick look and really examine the picture objectively. Learn what good is and demand it. The pursuit of excellence is what professionalism is really all about.

Overleaf: An illustration
to stop the eye, to set the mood,
and start the sale.
Photography by MICKEY McGUIRE,
Boulevard Photographic, for Ford Motor Company

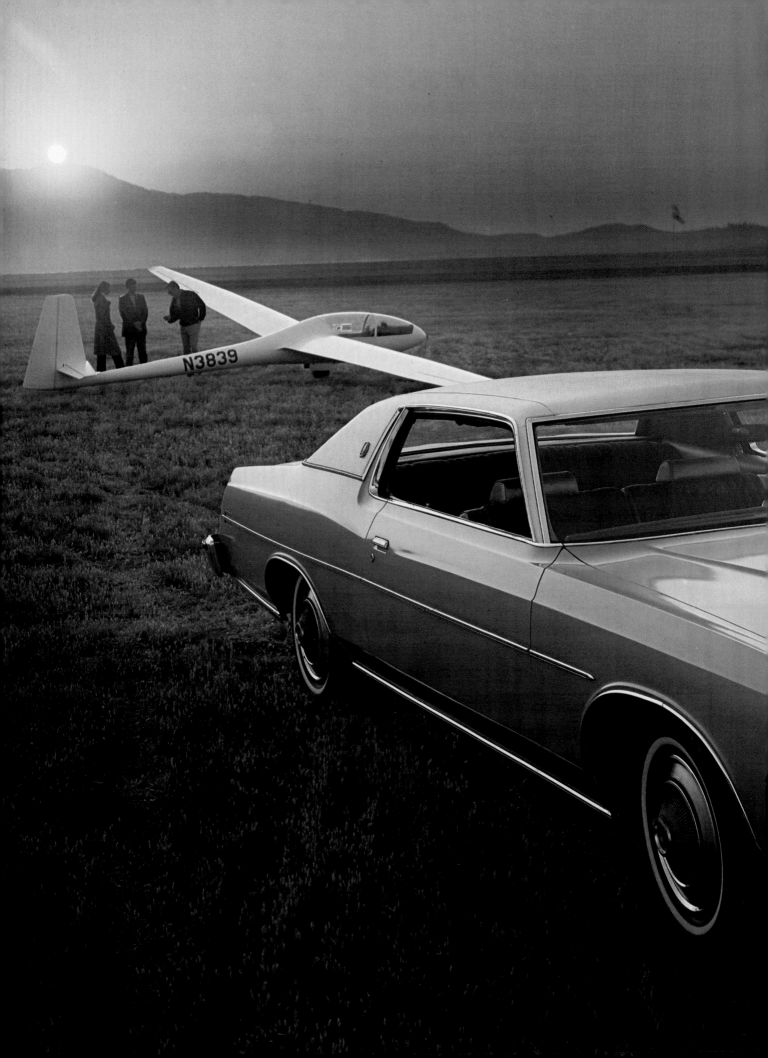

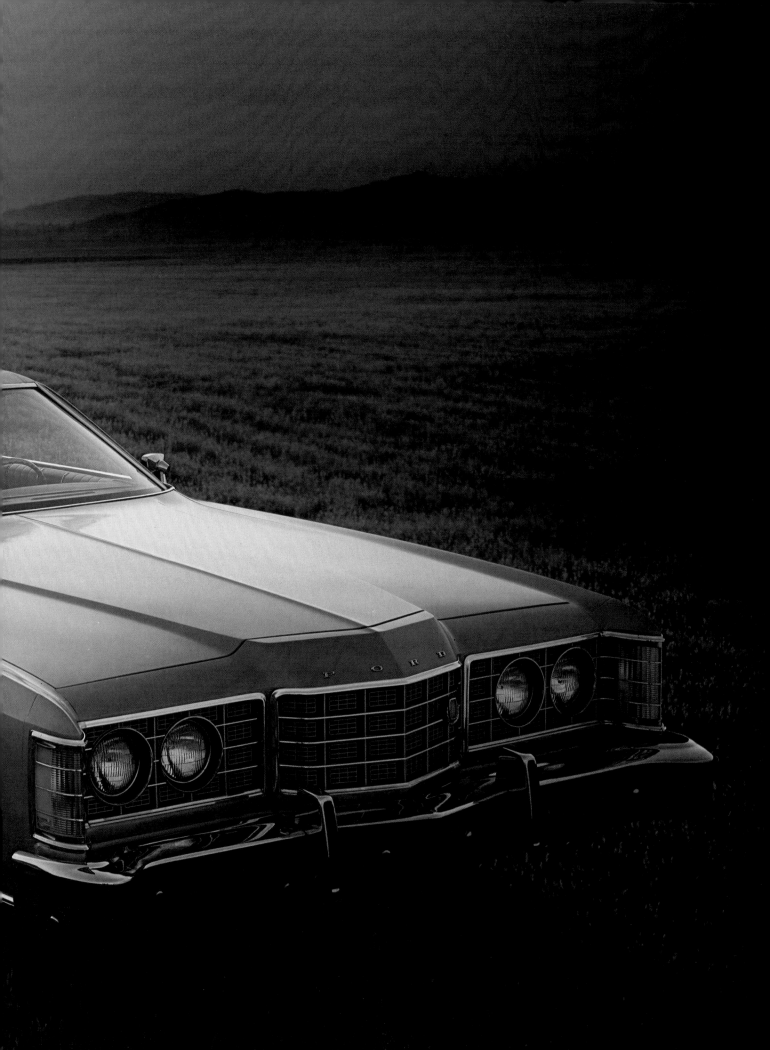

To stop the eye...

There are probably a few people so egotistically wrapped in their private worlds that their eye is not caught by anything. But the overwhelming majority of the human race, despite any question of its total wisdom, has a considerable capability to enjoy beauty. This enjoyment seems to be an intrinsic thing, regardless of age, sex, or state of educational or intellectual stimulation. It would seem, then, that a basic way in which to stop the eye is to present beauty as an environment for the rest of the message.

It is probably because photography is more familiar to the average viewer than other media. It is an area where he is at home. But he responds to a comparatively high level of aesthetics when presented photographically, whereas a fine piece of ''art'' may discourage him from even a cursory inspection.

There will be no definition of beauty here. But suffice to say it will not need defining. Like the ocean, it will be known when seen.

In addition to presenting things in a beautiful and charming way, rather than ugly and clumsy, there are other devices to stop the eye without resorting to outrageous innuendos. For example, the picture here stops the eye with its bright splash of red set in an otherwise neutral background.

Photography by WILLIAM RIVELLI

Overleaf: The eye is stopped by the *design* of the draping cloth.

Photography by PETER SAMERJAN

And on the facing page,
the evidence of swirling water
stops the eye with its *motion*.

Photography by RICHARD ATAMIAN

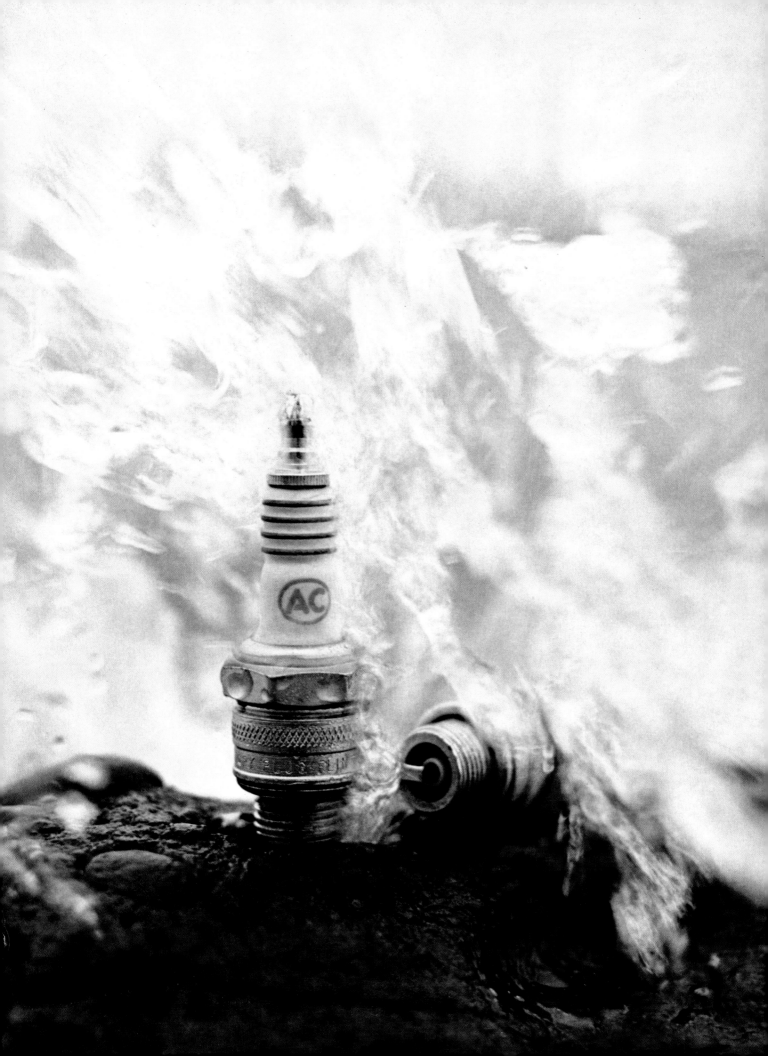

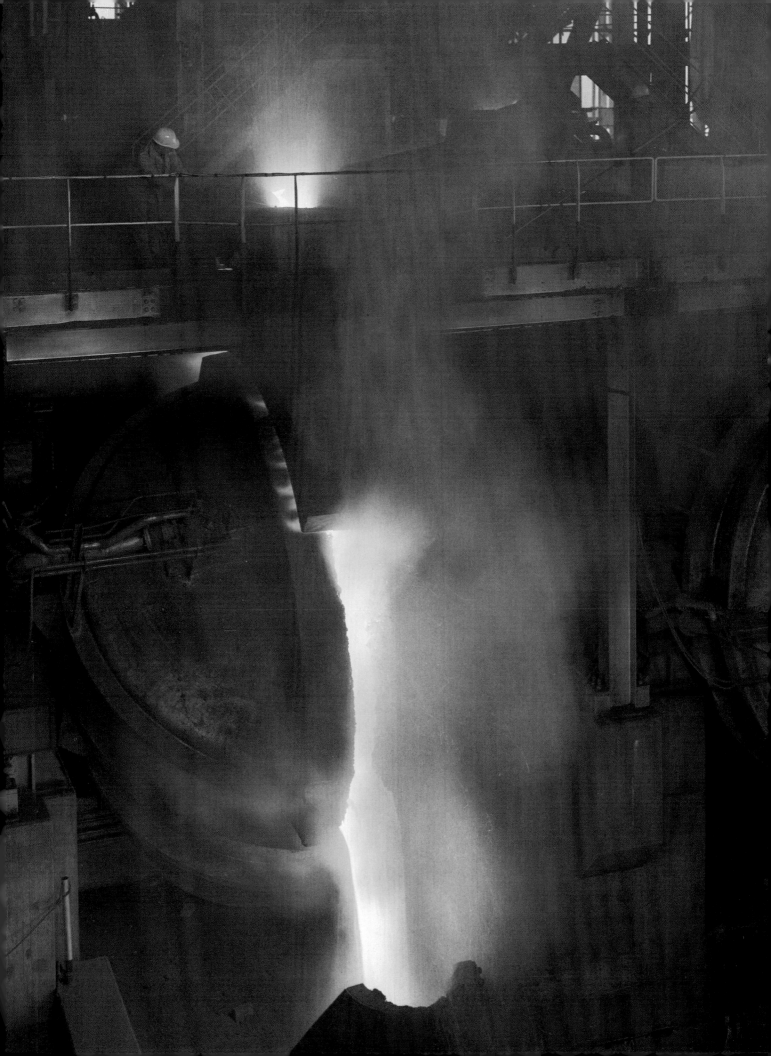

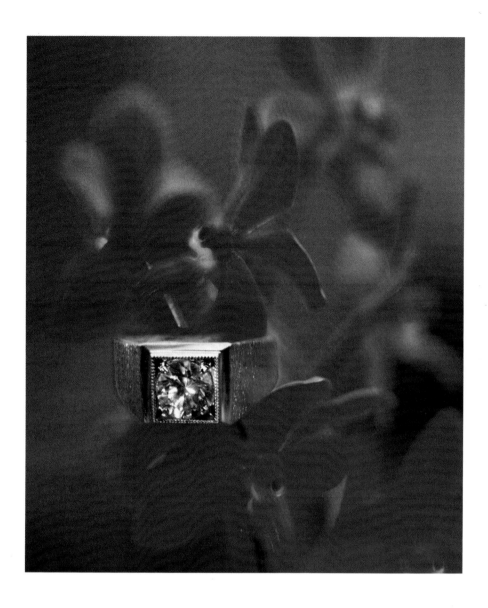

There are big subjects and small subjects. Small subjects may stop the eye when they are shown big or small, but big subjects must be shown big. The illustration of the mill for Allegheny Ludlum Steel by ARTHUR d'ARAZIEN could be easily overlooked if it were reproduced as small as the orchid and diamond photograph.

Overleaf: The whole character of this illustration would have been lost if reproduced too small. This is a big subject, and it requires bigness in space. Photography by HAROLD CORSINI

To set the mood...

Catching the eye is the fun-and-games part of advertising illustration. Color, design, size, or bizarre technique can make a picture attractive. But it is content which keeps the viewer's attention and makes the illustration start to do its work. It is content which sets the mood.

Now, obviously, every picture has content or it wouldn't exist. Any thing, or group of things, in front of the camera creates content in one sense. But in the sense meant here, content is the fundamental idea of the picture and the story line used to carry out that idea.

To set a mood, an illustration must have a certain degree of logic. It should be simple enough to be understandable. And, above all, it should be visually pleasing to encourage the eye to linger. One cannot tell his story if the guest refuses to stay around long enough to listen.

The logic of a picture need not be an everyday obvious one. A bar of soap may almost always be used in a bathroom. This does not mean that the logic of illustration demands a bathroom setting. Perhaps the advertising appeal of the product is in the refreshing reward which comes with its use. Would not a setting of sparkling mountain stream surrounded by the cool greens of moss and ferns say refreshment? Such a setting forms its own suggestive-ness and contributes to success because it sets a mood of refreshment.

On the other hand, the message about soap may be mainly its magnificent ability to create suds, in which event an interestingly composed mountain of bubbles with the soap as its boulder may more directly make the point. The bubbles set the mood of soapiness.

Most good advertising illustration is comparatively simple. All elements in a picture should be there to make a contribution to the whole. The temptation to include extraneous material because of its appeal to the maker is ever present. Excluding it is the mark of an admirable, but necessary, discipline.

There are charming ways to say something—and ugly ways. Those who are most cherished in society are those whose charm eases the daily clash of the war to stay alive. It will be found that beautiful visual presentations will better help to set the sought-after mood than dull ones. Photography can make anything beautiful if given half a chance. It is a plus which helps make the difference between an illustration and a report. The illustration on the facing page by TONY FICALORA is of great taste and beauty because the idea of the picture was a simple one executed beautifully with the tools of light, color, and arrangement.

Continued on page 22

Color and light are dominant factors in the establishment of mood. Sometimes natural conditions are such as to suggest the mood of a photograph to be made at that time, and the photographer need only take advantage of the opportunity. However, professionalism implies execution on demand, and there is considerable improbability that cooperation of this sort can exist with any degree of frequency.

Fortunately, the photographer can influence light and color, both while making the picture, and after the fact in the darkroom. The negative-positive way to color, in particular, offers extensive control of the image. The overall balance of the color print can be made considerably different than the original scene when that seems desirable, and the densities of parts or the whole of the image can be changed to lighter or darker from what might be considered normal.

Similar liberties with the truth of the matter can be taken with color transparencies by control during a duplicating step. Thus, to an appreciable extent, the photographer can overcome what might otherwise seem to be limitations of existing conditions in the establishment of mood. In the studio, obviously the photographer has complete control of both light and color, and the problems are reduced to skill and taste in handling the physical tools. Reproduction from an Ektacolor print whose density and color balance were altered from normal during print-making.

Photography by RALPH COWAN

To set the mood...

The mood of an advertising illustration must provide an atmosphere of pleasure if there is to be a climate for persuasion. This pleasure evolves from the visual delight the viewer derives, in part, from the photographic values of light and shade, sharpness and texture, or perhaps softness and tone gradation. The rest of his pleasure must come from content, its arrangement, and the story it tells. There isn't anything else.

It is not necessary for the viewer to know anything at all about photography to appreciate and find pleasure in photographic values—any more than the listener must have a composer's knowledge to delight in Beethoven. However, it is very necessary for the photographer to know practically everything about the techniques of photography if he is to be able to use these values successfully, on demand. The camera does not record what the eye sees. The camera records what the camera sees, and these are not the same things. The camera must not only be led to water, it must be forced to drink. And the ways in which this is done are the technical tools of the photographer.

Indeed, it is easy to let the camera have its way in forming a snapshot of what it sees. The rendering of tone values or color may be false and ugly, the shapes of objects not as remembered, the very concept of the picture undiscoverable. Yet the picture will fill a space if that is the level of the user's standards. The picture will be a very expensive one, however, because it will serve no function but to fill space.

The arrangement of shapes and objects in a picture has been labeled as being a "composition"; therefore, the art of composition is the

Continued on page 27

The ability of a composition or arrangement of shapes to set a mood is exemplified by this illustration by ANTHONY CUTRONEO, where lighting emphasizes the shapes, but does not, alone, define them.

Overleaf: The styling or décor of an illustration also can set the mood, as in the studio picture by LIONEL FREEDMAN for Fieldcrest Mills on the next spread. In part, the viewer absorbs the feeling the advertiser seeks from the lavish setting.

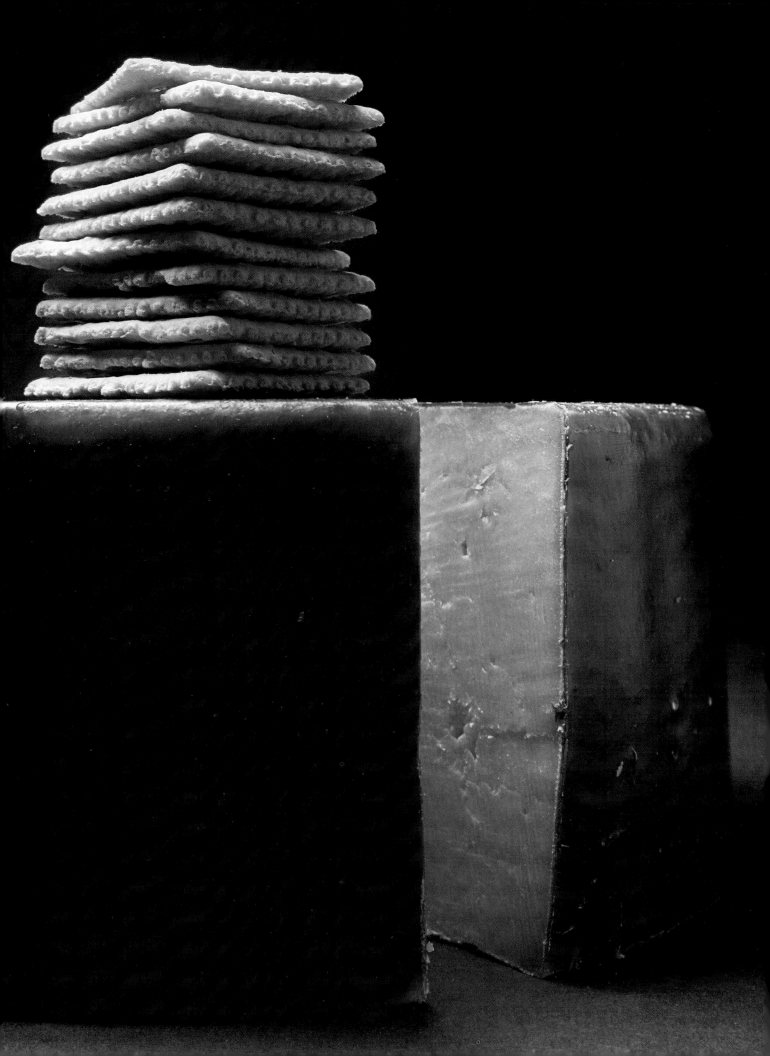

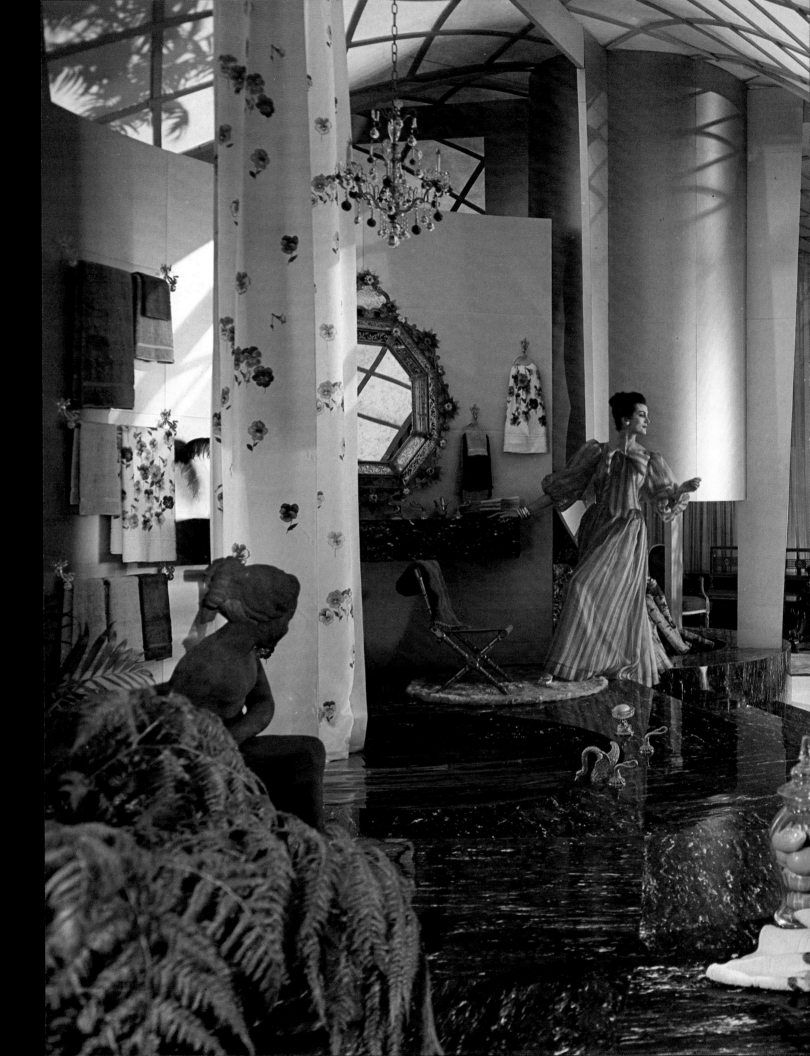

To set the mood...

arrangement of picture elements with regard to the way in which the particular camera being used sees them. Photographs are either "taken" or "composed." The former is best exemplified by a landscape which is snapped as seen, while the latter is one in which the subject matter is arranged as wanted.

The ability to compose a picture is not one which is fully learnable from books, because every picture presents new problems which are only solved when the photographer senses that he has arrived at the solution. This ability to feel the rightness of things comes from a standard of excellence, built on a base of native talent, embellished with experience.

The photographer's standards are influenced by his personal involvement with his medium and the importance it has attained within his life. The user of photography may benefit from the restless searching for excellence if he attaches sufficient importance to photography to seek it out.

Light is a major influence in the mood of an illustration. Its color, direction, quantity, quality, and balance can all affect the appeal of a picture, and the degree in which the viewer becomes involved. Light even can be used as a design element, directing attention to a desired area by its greater or lesser presence. Much of the dramatic effect achieved in a photograph is due to the way in which light is controlled.

It is unfortunately equally true that the improper use of light can be intrusive and detract from the story. It is not a compliment to the photographer to exclaim with delight over the lighting if it becomes the first comment rather than the last. While light is a co-partner to film in being the most necessary of tools for the photographer, it is a tool nonetheless. An illustration should be lighted to achieve the mood and story, not to draw attention away from the subject.

High Key–Low Key

One cannot be around photography long before he hears about high-key and low-key pictures. It might be wise to define these terms to further understanding.

First of all, every picture lighter than usual is not a high-key picture. For example, a scene which is overexposed is not high key. It's overexposed. And similarly, dark pictures which are the result of underexposure are not low key. They're underexposed.

Low-key and high-key pictures are correctly exposed pictures resulting from different ways of lighting a scene. The components of an average scene will reflect varying degrees of brightness when lighted in a normal, overall way. There will be darks in the resultant picture, and lights, and middle tones. However, if the scene is lighted so that almost all of the components are equally bright, the result will be a preponderance of bright areas, perhaps with dark accents, thus a high-key picture. Conversely, if most of the picture is made up of dark areas with but a few bright accents, then it is said to be low key.

Obviously, white or very light subject matter suggests a high-key treatment; and dark ones, low-key. But it is the lighting of the scene which determines the key of a picture rather than subject matter alone. It is no big thing to make a low-key picture with a white egg as the subject matter if that seems like a good idea.

In any case, the key of the scene lighting and hence the key of the picture is another way of setting the mood and thereby directing the viewer's feelings.

Both the direction chosen for the light and the overall color are major contributors in setting the mood of this illustration. The choice of time and place was the instrument for direction, and a red filter over the lens for color.
Photography by ROBERT HUNTZINGER

On the next spread are two fine demonstrations, one of low-key lighting, one of high-key. It will be noticed that both are full-scale pictures, but that one is composed of predominantly dark tones, the other of light ones. The moods of the two are diametrically opposed.
Both illustrations by RUDY MULLER for House Beautiful

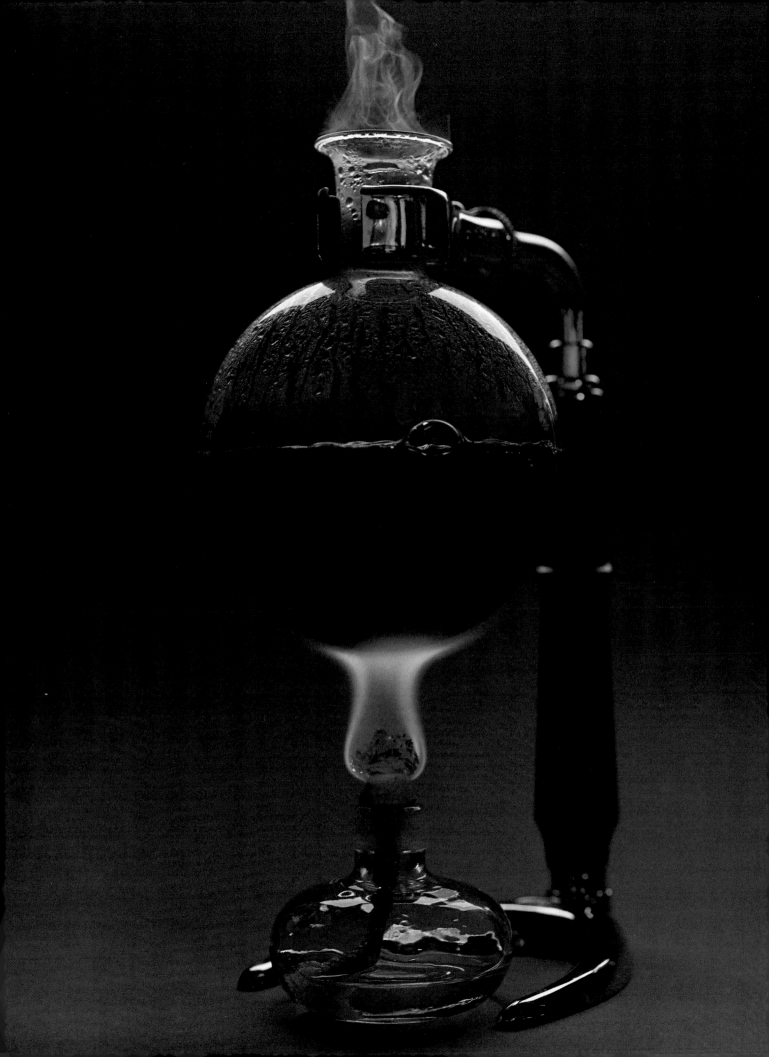

Symbols...
Telling the Story

An advertising illustration may or may not have a product as a portion of its content, but it must always have an idea as its starting point and some sort of story as its end. The story may be as simple as a message of beauty, goodness, taste, or size. Or it may be so complex that its effect is to conjure up a totally imaginary experience in the viewer's mind—an experience suggested, but not shown, in the illustration.

In either case, the use of symbols rather than literal objects as properties in building the picture very frequently will be amusing and intriguing to the viewer, and invite more lingering and thorough attention. The symbolic properties must be objects familiar to the audience. Those too esoteric may give satisfaction to the maker but leave the viewer in a foreign land without a guidebook, certainly not an objective of something supposedly definitive of a universal communication.

Let us take up the matter of an orange. A simple picture of an orange will define the product, but without a story. Cut the orange and allow the juice to accumulate underneath it and there is the beginning of a story. The puddle of juice is a symbol for the story of orange juiciness. Add a place setting and we have orange juice at mealtime. Add an egg and we define time of day: breakfast. Skip the egg and have sun rising through window and we still have breakfast. The place setting, the egg, and the sun are symbols. Together they say juicy oranges for breakfast without a word of copy.

The more subtle the symbolism, the more apparent that intellectualism is needed to understand the picture. There is a nicely balanced point—where the viewer feels pleased with himself in getting the point, but where there is little danger that he won't. The real intelligence here is in the original conception.

The clock springs in this illustration become a symbolic way of saying watch, which in turn more positively identifies the product as a watchband. Some advertising people might wonder why a watch wasn't used in the first place. A watch *was* used in many first places with this sort of product, hence the desire to be a bit different, to have the viewer linger just a bit longer.

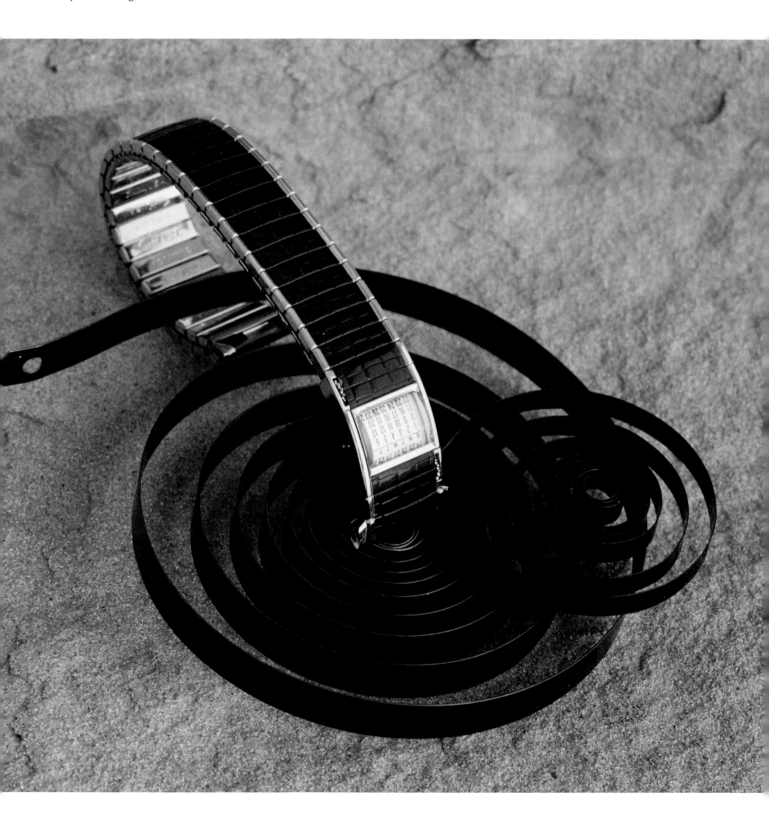

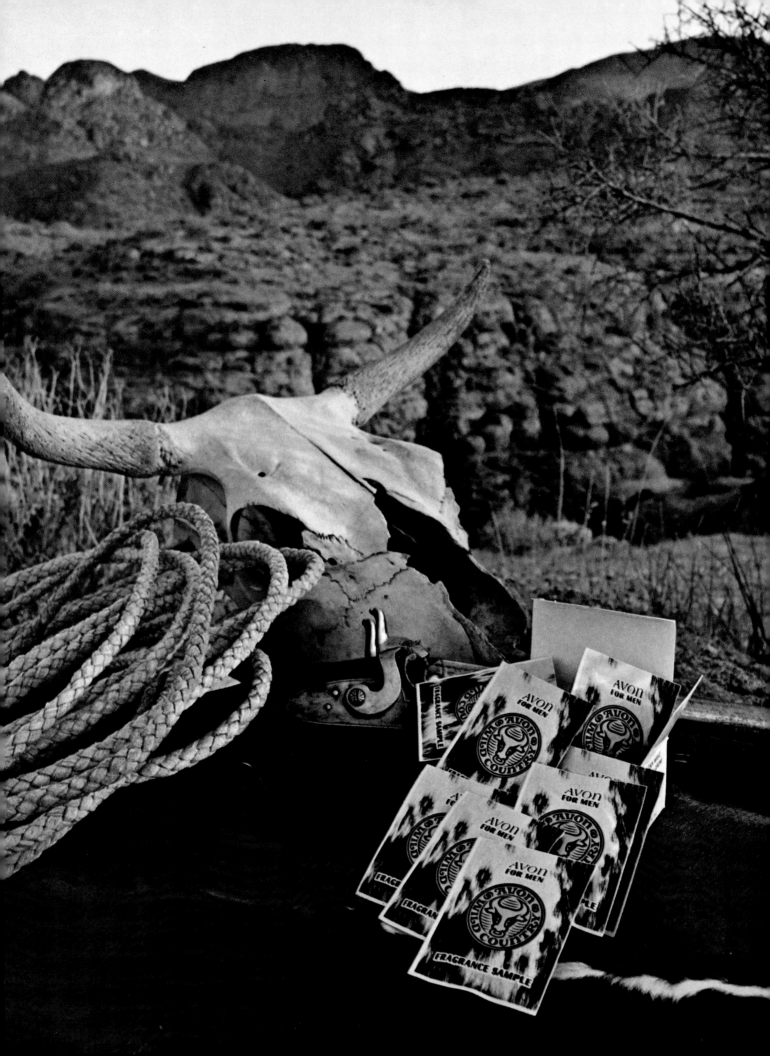

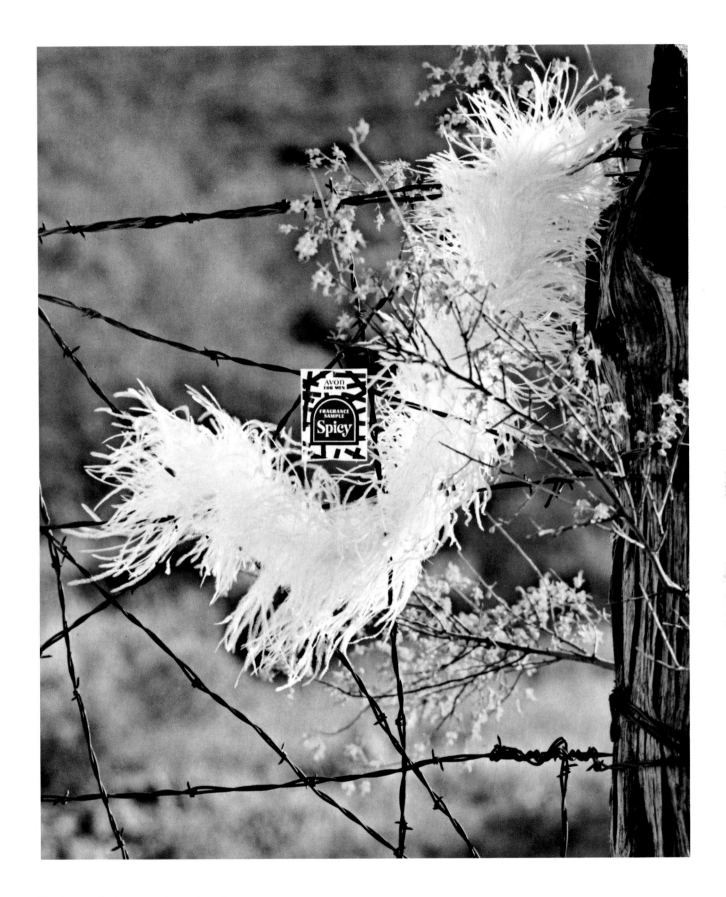

The two products are samples of Avon fragrances, Wild Country and Spicy. The names themselves suggest stories. Let the imagination roll, and one sees the cattle drives of the Old West, the rocky buttes, the desert country. One sees dance hall girls in their attempts at the can-can, and the barbed wire, and the smell of flowers. The illustrations use symbols to tell the story.

Photography by HERB McLAUGHLIN

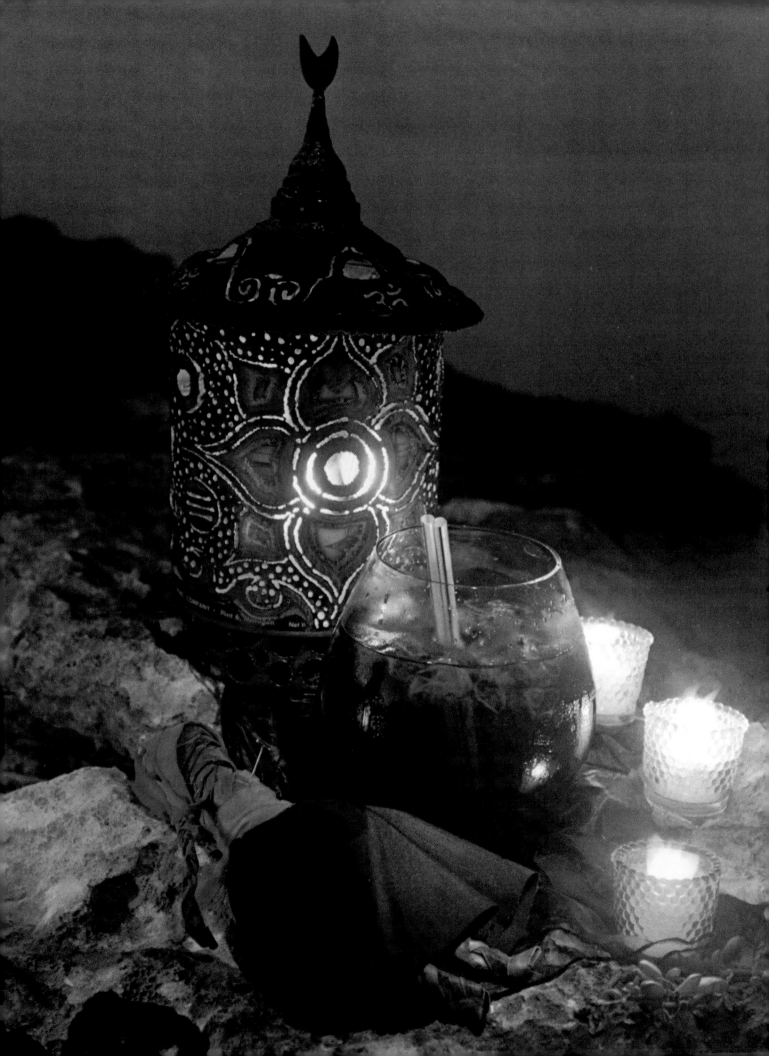

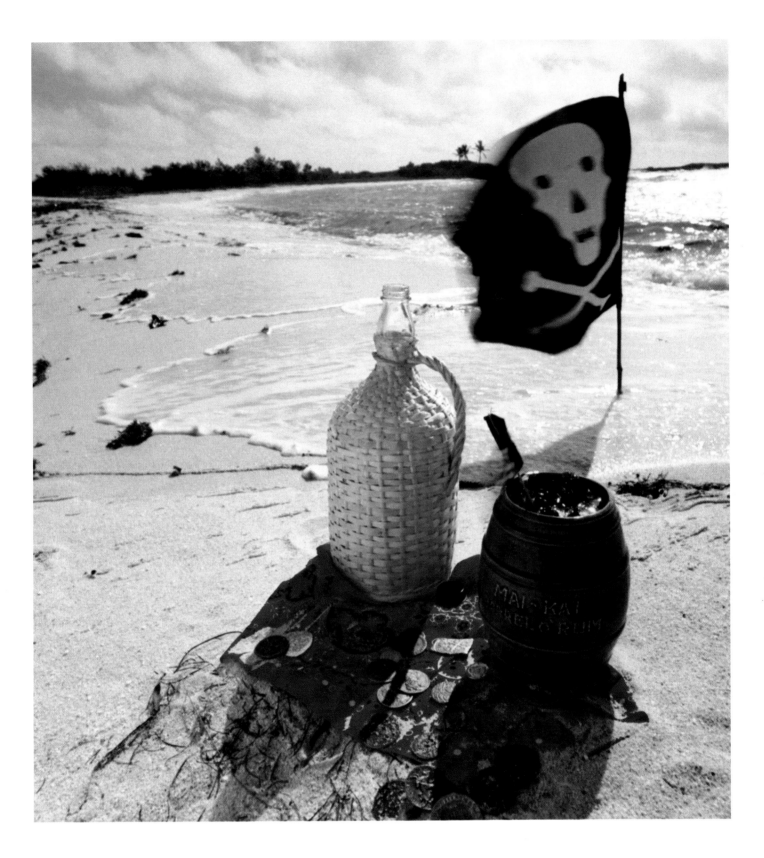

These two illustrations were made as a demon-
stration of how a mixed drink name could serve as
pictorial inspiration. Black Magic was the drink on
the facing page. Just pronouncing the words brought
visions of voodoo dolls and flames in the night. And
on this page, a drink called "Barrel of Rum." The
mind says yo-ho-ho and pieces of eight, and pirate
coves with flags flying. Symbols all.
Photography by ARDEAN MILLER

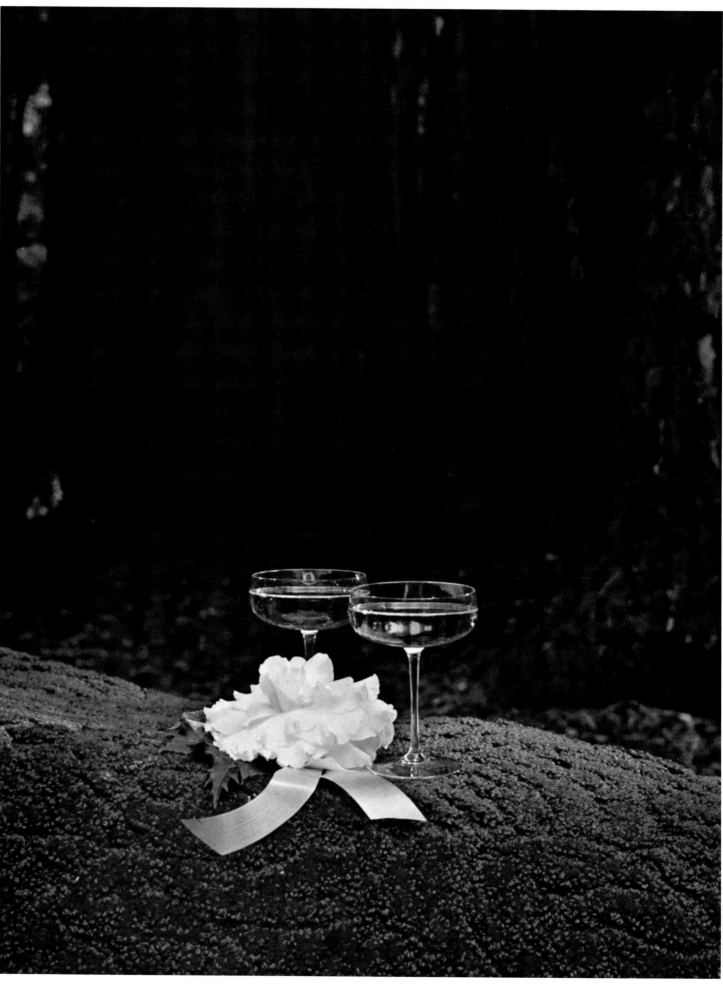

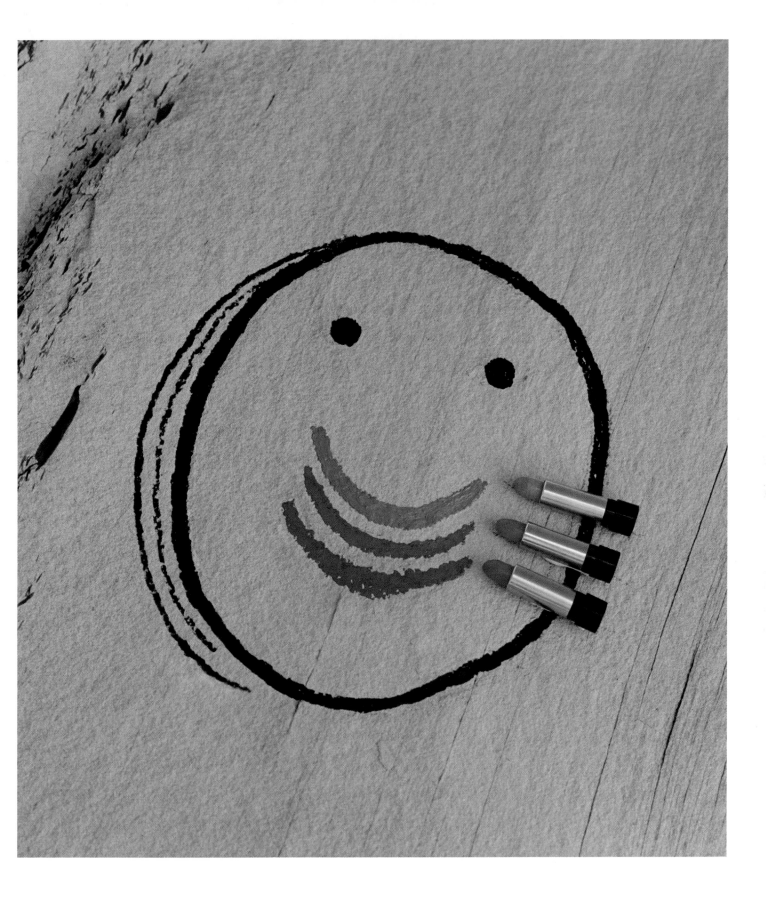

The green rug was part of an experimental series based on the premise that wedding anniversaries were appealing occasions for rug purchases. Since the series had to start someplace, it was started with a wedding. Here the champagne, the white begonia, became symbols in telling the story.
Photography by HERMAN WALL

The circle with marks for eyes, nose, and mouth is one of the earliest symbols of a person. Here is a visual idea based on such a symbol with the product becoming part of it.

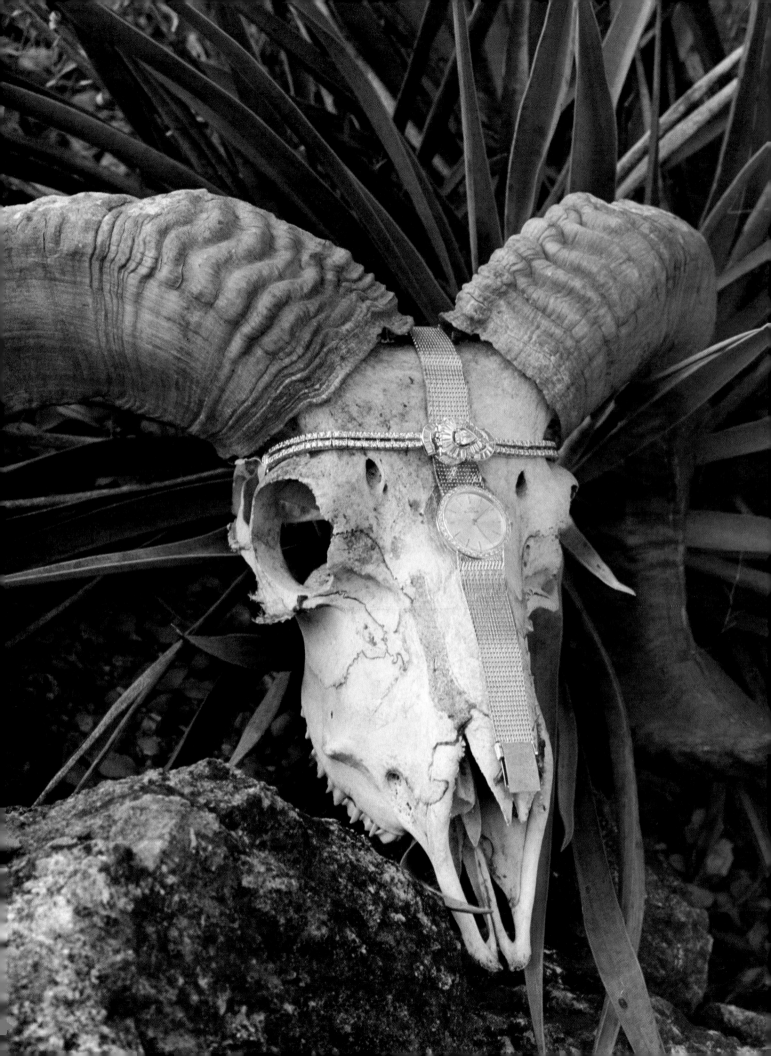

Getting Ideas...

It has been seen that the purpose of advertising illustration is to attract attention, tell a story, and help sell an idea, a product, or a service. It is the highly visible persuader, unabashedly designed to intrigue, describe and, if not exaggerate, at least further the purpose without undue modesty.

If the illustration is technically inept, it fails to communicate and nobody gets the point. If it serves as a vehicle for a highly obtuse graphic exercise, it becomes an inside ego trip about which nobody gets the point except its originators. And if it is aesthetically sterile, it bores everybody, and nobody *wants* to get the point.

A successful, hard-working illustration starts with a good idea about the presentation of an advertising premise, and presents it in a clear, logical, eye-catching, and attractive way. There is a large spot for beauty in advertising illustration, and its importance is based on simple human preference for love over hate, the beautiful over the ugly, the sweet over the sour. It doesn't matter either whether the picture is four-color or one, big or small, square or round. Beauty beats the beast every time.

Photography, in its intimate partnership with light, can cosmetize anything. And it can do it without being dishonest, although in some cases it must be admitted that difficulties exist. It has been said that photography is painting with light. All one needs to add beauty to the plain is the right paint.

In the creation of an illustration, there are
Continued on page 41

Aries, the sign of the ram, was part of an illustrative series in which objects were used for symbolically astrological settings for jewelry.
Photography by CHARLES COLLUM

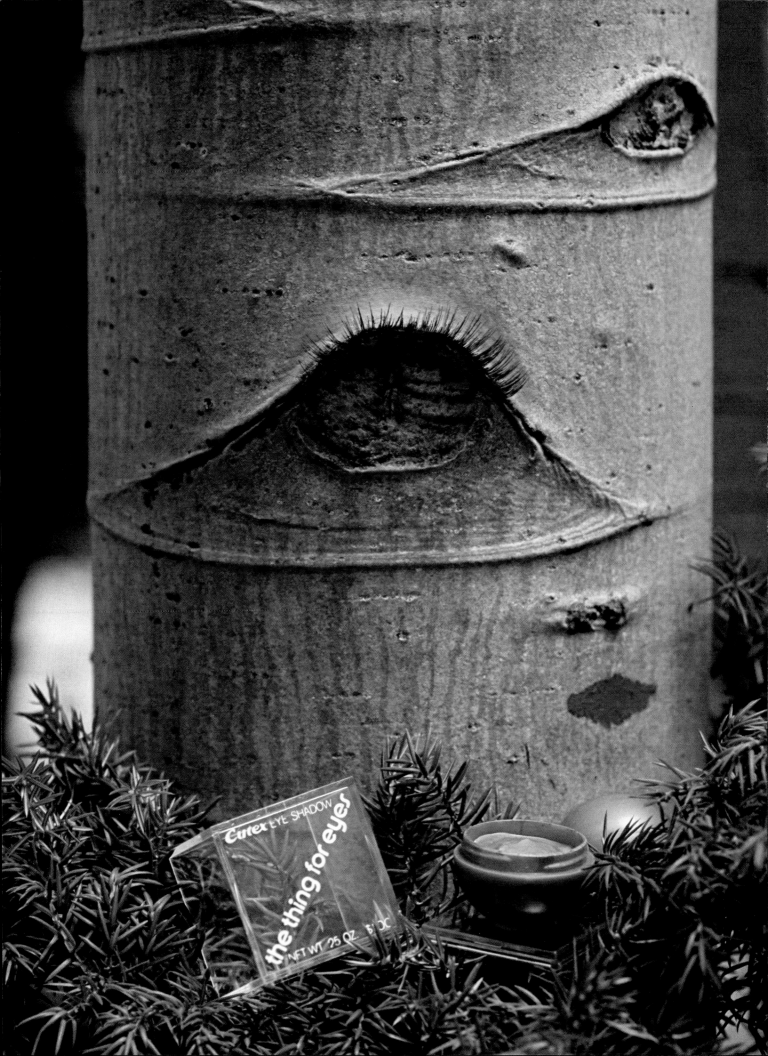

Getting Ideas...

certain obviously desirable components such as a product, a setting or location, a technique capable of handling the medium, and an idea. Quite frankly, it is possible to get along with less than optimum quality of almost all of these things. One can describe photographically without a setting, and it is even possible to attract favorable attention with a technically poor picture, although that seems like a last resort rather than a point at which to aim. It is highly probable that the product can be suggested rather than shown, thus even dispensing with the product. But without an advertising idea to serve as a starting point, and an aesthetic one on which to proceed, success will not come this way this day.

Ideas, of course, are what creative people are all about. There is something mysterious in the generation of ideas, and the creative person, himself, will admit it in the lonely hours of early morning. It is possible to explain what motivated or inspired the train of thought which finally arrived at a given idea, but to describe just why the what was the inspiration becomes impossible. And why some people have lots of exciting ideas, and others don't, must be dismissed with the undemocratic explanation that, in such matters, all men are not created equal.

The successful creative person who can operate in a wide variety of fields is one whose curiosity and catholicity of tastes and interests greatly exceed his immediate needs. He is in-

terested in many things, not because his tasks demand it of him but because he simply is, and always has been. Having been, he has developed a library of receptors which make him vulnerable to inspiration. Things remind him of things, and as his mind glides through the memory bank, it gathers substance. During this trip, he must discard much that is irrelevant, and evaluate each stopping point in a determination as to its excellence and suitability. The quality of this judgment is the quality of the idea, and it most often is highly colored either green or red by experience. To know whether the idea is worthy of development, or to discard the approach and pursue a different course is one of many marks of a mature talent.

Experience, too, becomes a source of an operating idea, for even a failure in the past may suggest a lesson learned which can serve as a success in the present. Perhaps a technique used in the past may spark an approach to an idea for the problem at hand. There is even the possibility that an idea successfully used last year is equally valid today. There is really nothing wrong with using something good more than once.

Ideas tend to generate ideas, they seem to breed within the creative person. To those who never seem to come up with anything useful, it seems almost unfair, and certainly undemocratic for the other fellow to have so many. Imagination, which is both father and mother of creative ideas, seems to be something capa-

Everywhere one looked in the aspen grove, eyes seem to be peering at the photographer. Since the idea for an eye shadow illustration was having its birth pangs coincidentally, it was natural to use the illusion of eyes among the aspens in the manner shown. It may be that the trunk scars looked like eyes because of the search for an idea at the moment. In any case, there is an eye there now. Ideas for pictures come from being receptive to the environment.

Getting Ideas...

ble of growth through practice and a favorable climate. So the rich get richer, and the poor depend on them.

The generation of ideas is generally the red blood of an advertising organization. And interesting efforts have been made to enhance the breeding grounds. Group think, wherein many trains of thought are encouraged to clash on a common battlefield, has been highly regarded by some. While it is true that one man's idea may be another's inspiration, and from many experiences comes one grand experience, it is still necessary to have a grand umpire for the grand idea. Someone must state "this is it." And woe to him who does not adhere to the dictum.

This can be quite a blow to creative photography. For the final word may all too often be followed by the closed mind, symbolized by a layout drawing ultimately delivered to the photographer as a blueprint.

The fact is that the train of creative thought does not necessarily end within the mystique of the committee room. While the idea so arrived at may be an excellent one, possibly better than an individual's, its execution should not be finalized before it even arrives at the photographer's studio.

It has been stated that the idea for the illustration is all-important, and that is true. But there are two parts to this idea: what it says, and how it says it. What it says is an advertising matter predicated on product, merchandising

aims, matters of the business world. How it says it is a graphic matter, the province of the art director and photographer. The frozen line of a layout provides scant room for development of the graphic idea. While the layout can communicate the advertising idea to the client, and it can orient the photographer on direction and purpose, it should be remembered that the pencil is a shackle to the camera. Each is a tool of a different media and they cannot harmonize lovingly.

This is not to say that a photographer cannot follow a layout. He can if the layout does not describe impossibilities of drawing and perspectives. Restricting him in this fashion, however, is to shortchange the art director, the client, and perhaps the effectiveness of the advertisement. When the photographer is not allowed to contribute his own ideas to a project, he has no opportunity to fulfill his potential as a partner in the project.

The execution of an illustration does not always follow a direct, preplanned route. Subject matter tends to have a will of its own, and often it almost literally demands to be handled in ways which were not anticipated. Furthermore, ideas in the execution of an illustrative idea tend to develop from a train of thought in the same way as the original advertising idea. One thing leads to another, as it so often does elsewhere, and the final result may well be quite different from that originally envisioned—and considerably better.

Continued on page 45

There are two types of ideas necessary for a successful illustration: one, the story idea; and two, the execution idea. The former is usually an advertising decision, while the latter is photographic. Here the product which says steel, combined with the stock market quotations saying business, adds up to a timely comment on the industry.
Photography by HENRY RIES

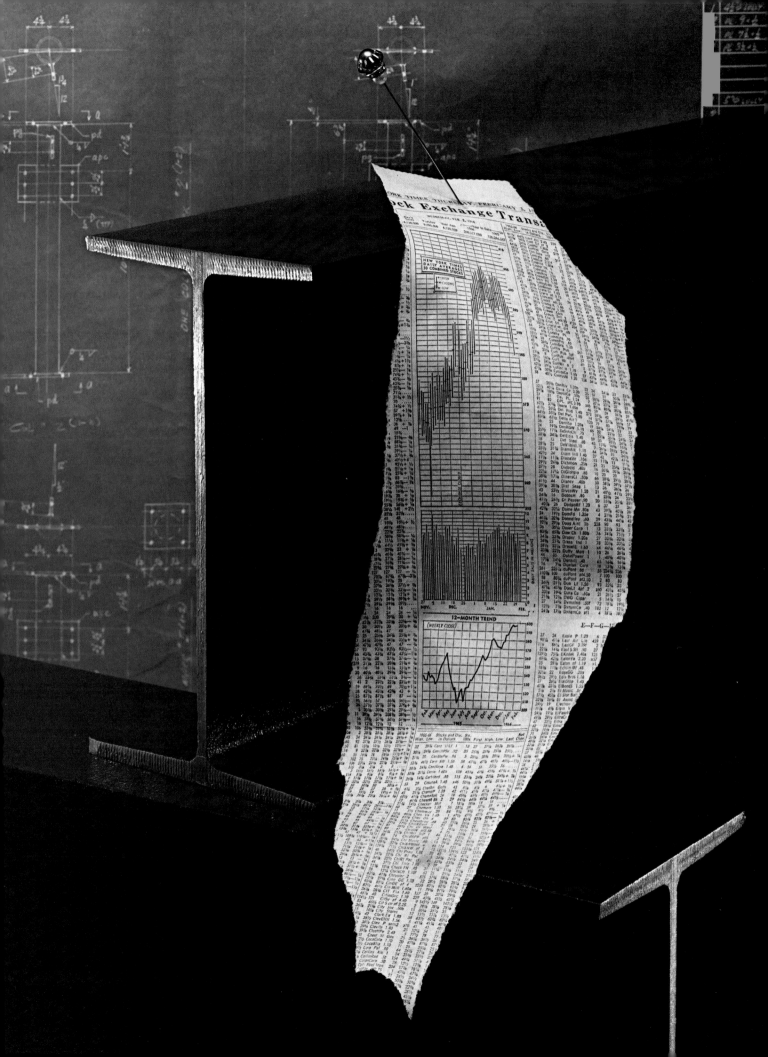

This is an unlikely, perhaps even weird, photograph; yet the progression of ideas from which it evolved was highly logical. The problem was to display Speidel watchbands in an interesting and different way. The product is worn on the wrist, so step one is the decision to use an arm as a main ingredient of the picture. A human arm would be an expected one, hence the idea of using a part of a display dummy for its shock value.

Positioning the arm evolved from the thought that tree limbs are tree arms; so, conversely, the arm should be part of a tree. It was painted green to further integrate the arm to the tree, and green fingernails added because every hand should terminate in fingernails.

Parts of an alarm clock were placed in the palm of the hand as a symbol that the products shown related to watches. A number of watchbands were used because the set would have overwhelmed only one, and gold rather than silver ones chosen because gold is more harmonious with green. The final result is somewhat unreal, for one does not expect to find an arm in a tree wearing watchbands— a green and artificial arm at that! Yet each step in the visualization of the picture was a logical one.

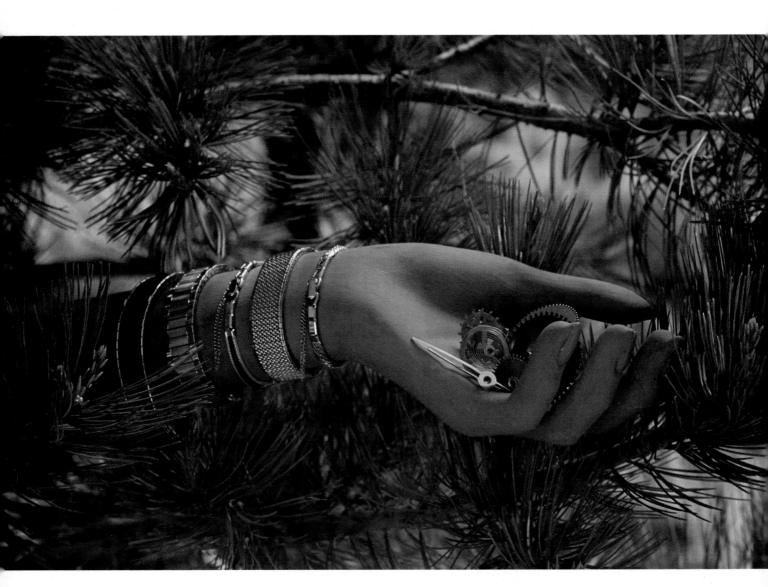

Getting Ideas...

This should not be interpreted as a general plea for a complete lack of direction. The direction must contain the advertising idea and the space limitations. To hand a photographer a product with the instruction, "Here, photograph this," is to ask for a photographic report. Even if he would like to make a graphic contribution, he cannot because he has no knowledge of where to start or where to go.

There are advertisements which are catalog pages. Here's the product; here's what it looks like; read what it does. There are advertisements which suggest a result. Use our product, get your man—or girl. Or, use our product, don't lose your man—or girl. Still others suggest benefits, some tangible, some not. The marketing ideas are different among them; illustration ideas, therefore, are based on different premises. But all have a need for illustration which is sound in design, quick to the point, and attractive, if possible. There is nothing wrong with pretty, and it's better than ugly.

In the search for an illustration idea, the beginning is the beginning of the advertisement itself: what's for sale; what are the benefits; where does it appear; who is the audience; why should they buy; and are we selling (showing) the beneficial result or the product itself. The answers to these questions set the stage, but there are still more. Is this to be a continuing campaign? Is it highly desirable to have a family resemblance among all of the insertions? Is the product a single, or part of a line? Are there any problems? Is there a sales resistance which must be attended to? All of these are advertising questions, but they are illustrative ones, too, because the illustration is a large portion of the advertisement.

Let there be a stove as an example. This is a very modern stove with a nifty new way of cooking very quickly. No mess; requires little space; economical of fuel; automatic; pretty in the kitchen; lasts a long time; food looks great; tastes fine; and finally, the price is right. Eleven features, counting "modern"; ten without. What is to be illustrated? What's to be front and center?

Well, what's the problem? If the product has all those lovely ten features, not counting modern, maybe there isn't any problem. In which event, the emphasis can be logically placed on the competition's weakest point, which might be lack of speed or whatever. Or solution one, based on faith in words, could eliminate any need for thought: show the stove, list the features, reasons why, and top it off with a pretty girl smiling in an evening gown!

But maybe there is a problem. Maybe people won't buy because they think that because it cooks quickly, it doesn't cook pretty. The solution is obvious—photographic proof of cooking pretty. And what is being sold is the promise shown: a beautiful roast, or a mouth-watering steak, or eggs-as-you-like-them, or homemade-bread-better-than-grandma's.

Now let's not succumb to the temptation of

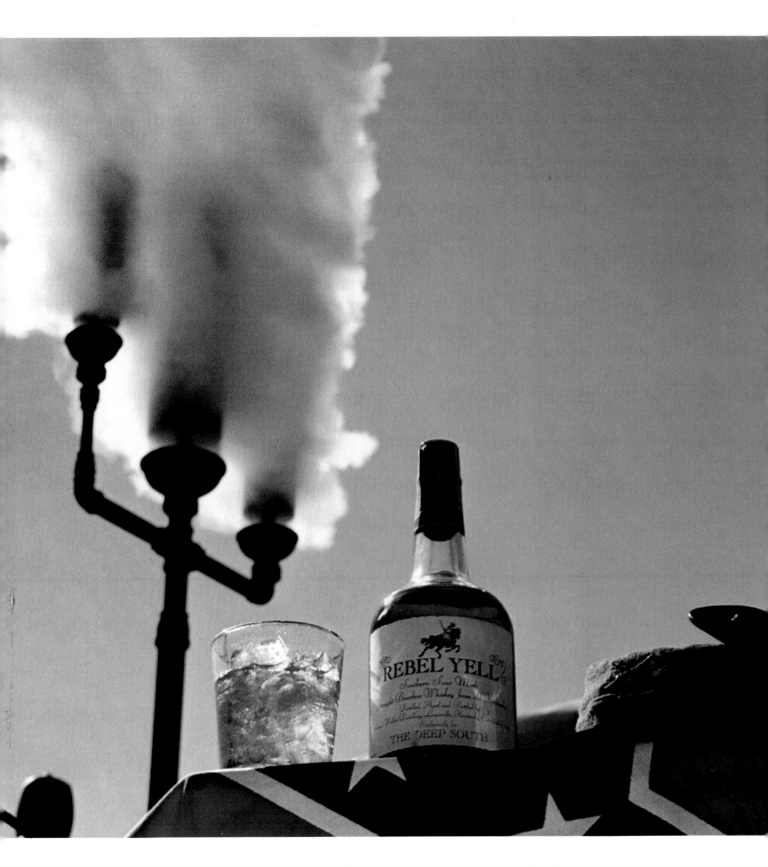

This illustration was part of a series in which the product was a bourbon whiskey brand. The product name was suggestive of the well-known battle cries of soldiers in the Confederate armies during the Civil War. The photographic location on board a Mississippi steamboat suggested the use of the whistle to symbolize the word Yell, and the flag and epaulets to carry out the idea of Rebel. These visual symbols spelled out the whiskey name, with the bottle and drink to help along those needing assistance in getting the point.

Photography by LIN CAUFIELD

Getting Ideas...

showing the stove, the room, the pretty girl, and the kitchen sink, too. Use the stove as the set; show the food right up there where it almost can be tasted. Make them hungry.

There is a whole campaign here: it bakes in one ad, it broils in another, fries in a third, and so forth. Naturally, there are other reasons to buy, and copy says so. But the *problem* concerns food appearance. It is logical to use a food picture. If the problem changes, the premise changes and illustrative thought starts correspondingly.

Whatever the point, it is important that the photographic proof be executed in a thoroughly professional way. For if the photograph is inadequate, the proof ceases to exist. Better by far not to advertise at all than to be proven wrong—with one's own investment!

In the procurement of photographic illustration, the open mind is the maximum opportunist, the recipient of bargains. The use of the photographer's studio, his equipment, and his technical knowledge can be only part of what the client buys. There is a creative talent needed in the development of graphic ideas, and it is available right along with the more physical and visible. Not to use it seems wasteful.

Good teamwork between an art director and photographer can become a fine synergistic relationship, each helping the other in achieving an excellence unexpected by either. If this is to be achieved, the art director must learn to see as the lens does, and to appreciate that the very contribution of photography is in its difference from drawing, painting, or other graphic forms. He must also gather enough courage to defend his own ideas against expediency, and accept the other's ideas in spite of pride. Neither photographer nor art director can be always right. And if in doubt, both can cooperate in proving the one or the other.

Quite often a fine result evolves from a kind of ping-pong exchange of ideas during which each inspires the other to an ultimate success. This is not possible where one is client and the other tradesman. There can be only one boss on an illustration, and that is the advertising idea. The personnel involved will find a partnership the best way of serving it. Obviously, both must also respect the medium and regard its practice with great seriousness. Advertising illustration is not a professional form of snapshooting. It is an intellectual, and often highly aesthetic, stimulation which creates fine photographs for a purpose of considerable economic importance.

The development of an illustrative idea can be an interesting, if sometimes time-consuming, exercise. A pleasing composition of objects may well bring a prize ribbon to the amateur in his pursuit of camera club recognition, but an advertising illustration must do more than not offend the eye. It must *illustrate,* which is to say, tell a story.

The composition of such a picture is governed by what is to be said. The background,

Getting Ideas...

or environment in which the photograph apparently is set, can help with the important task of stopping the reader, as well as assisting in setting the mood and telling the story. The color to which the picture is keyed plays its part, as well as the apparent time of day and level and contrast of overall lighting. As a matter of fact, emphasis, or punctuation by light, is one of photography's stronger attractions.

Attention can be directed by the arrangement of models and objects, by their color, their lighting, their contrast, and by their sharpness as compared with their fellow models or objects. The aim of an advertising illustration is to direct the viewer's eye to a predetermined portion of the picture and to communicate an idea after it gets to the proper spot.

Sometimes all components of an illustration seem to cry out for their logical places, and the scene created exactly meets the advertising need. Sometimes this doesn't happen. And recognizing when it doesn't is where the men and boys are separated. The recognition of an unsatisfactory solution, and eagerness—rather, insistence—of starting over can be considered a measure of professionalism. Only the amateur and the inexperienced can be always right!

Professional standards are rather difficult commodities to market unless demonstrated in practice. They involve the worship of perfection but they also recognize compromise. There are times when the surf at Jones Beach, while not as perfect as Hawaii's, is good enough.

Where the $5 property will do, even though absolute perfection requires a $50 one. Professional compromise, however, does not encompass technical or photographic sloppiness.

It is true that there are fortuitous circumstances. Something beyond the photographer's control happens, something beyond expectation. A quick exposure with the wrong lens, perhaps, is the best that can be done. If the event is momentous enough, any technical imperfection is secondary. It is professional to recognize the event's uniqueness and live with the result.

Knowing what is new is also professional, for this implies knowing what is not new. New is not necessarily good. And old necessarily not good. New does have the advantage of a greater attention possibility than old, if the viewing public realizes the new is new. It is not good to substitute newness for its own sake when the ultimate reader won't know and will care less—particularly when the new doesn't communicate.

This fetish for the new manifests itself quite frequently in a fierce enthusiasm for a unique or new piece of equipment. This new camera, lens, or whatever, may well do a magnificent job on something for which it was designed. Passions then flame to use it on things for which it was not designed—and doesn't do as well as the equipment grown gray in service. Knowing what to use for what is professional, too.

There are interesting ways of altering photo-

graphs, both old and recent ones, which tend to deny the photograph its birthright. Such techniques convert continuous-tone images to line, detail into areas of even tone, change color relationships, and otherwise convert reality to abstraction. Such techniques are particularly effective where the purpose is use as a poster. As a matter of fact, one technique is called "Posterization."

There are all sorts of possibilities to create nonliteral special effects, and many of them will be shown in this volume. The picture may be blurred to suggest motion; the subject matter can be distorted to enhance the appeal by changing the drawing from a literal report; there can be double and triple images to extend time and place; and many of these and other camera and darkroom techniques can be combined for almost endless variations.

All this is fine where the technique fits the purpose. When the technique fits an uncomfortable desire to be different, the purpose can be badly served. Knowing when is also professional.

Professionalism is important in the matter of ideas, because creating ideas which will solve problems and motivate people is a professional matter. That is why there are advertising managers, advertising writers, advertising art directors.

Sometimes photography is expected to tell all of the message, or a large part of it. Almost always it occupies most of the space. Always it is expected to stop the passerby and interest him. Certainly such a large portion of advertising practice must be regarded with great seriousness and respect. It would seem imperative to be as professional about pictures as about words. And such a professionalism must include standards of excellence as well as knowledge of the medium.

Professionalism in visual matters must also encompass enthusiasm. Some businessmen seem to regard external manifestations of enthusiasm as a sign of suspicious immaturity. Nonsense. An art director or photographer who does not get excited over an idea may well be one who shouldn't be trusted with it. That air of bored sophistication may hide a desert of tired sterility.

It is true that advertising people must consider media, motivations, markets, and mundane matters of personnel and budgets. But no reader was ever stopped by a plan, motivated by research, or sold by a budget. His eye was caught by an illustration which was born from an idea and reared by the love and enthusiasm which all truly creative people have for every one of their children.

To start the sale...
Presenting the Product

When the advertising and illustrative idea is settled upon, part of the battle is completed. There remains the execution of the illustration; and here, ideas are the photographic ones of what symbols or properties are to be used, the set in which they are to be arranged, the arrangement or composition itself, the lighting, the photographic equipment to be utilized, and other such matters. All of these are to present the product and/or idea with its best foot forward. And to do so in a way that the viewer will find attractive and understandable.

The purposes of compositional and such photographic matters as lens selection, camera viewpoint, color selection of components, and lighting are to lend emphasis to the original idea as well as to create a pleasing image. Color and arrangement, in particular, should be such as to lead the viewer directly to the point of the picture, and where appropriate, add an exclamation point.

It can be readily realized that the photographic ideas necessary to the execution of an illustration are almost always unique to, and dependent upon, the substance of the original advertising idea. For that reason each picture requires customized thinking.

Most successful advertising illustrations appear to be very simple even though the execution of the original idea may involve many photographic problems and be very complex. The ultimate viewer cares little for the photographer's problems. Indeed, if the picture is ultimately successful, the viewer may overlook its being a picture and see only the components which form its storytelling idea.

The photograph below is just such a simple-appearing illustration in which there are no extraneous elements. "Oreo cookies are so good they simply vanish from the plate" is the obvious message. The crumbs are the symbol of the cookies that were, and the cookie that is the product, front and center.

Photography by BILL KRELCHMAR

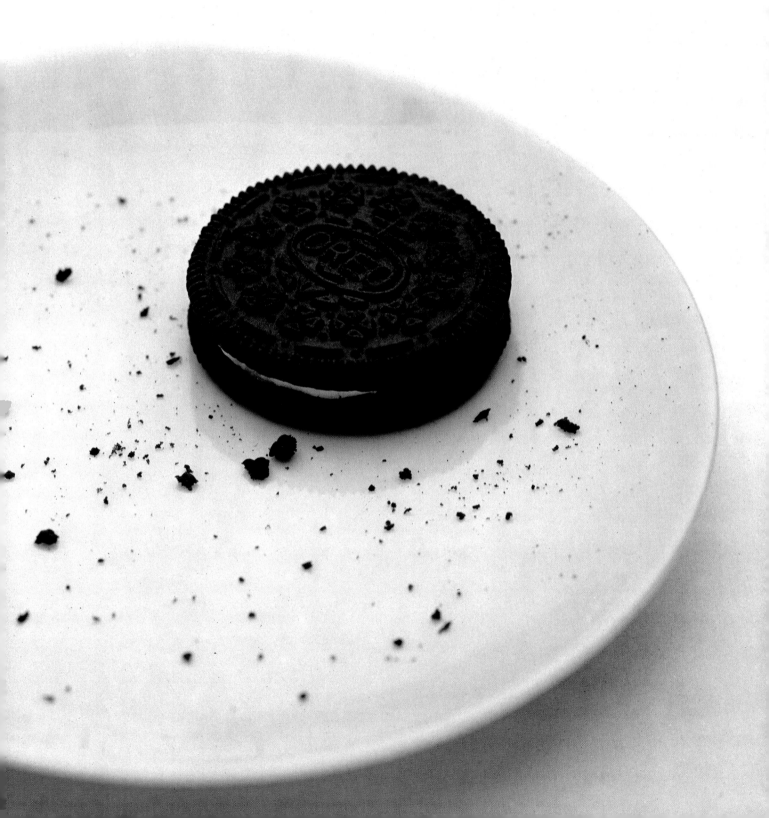

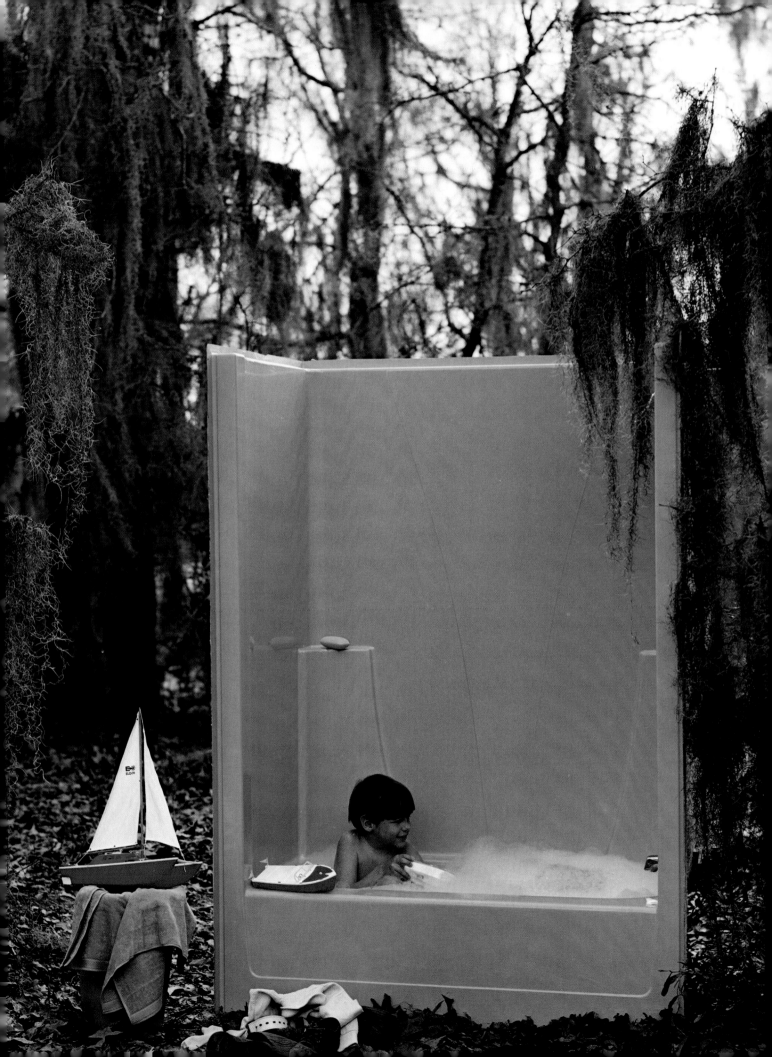

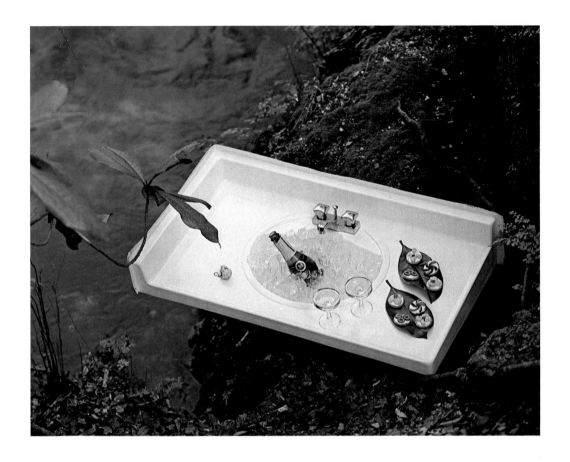

An effective way of presenting a product front and center is to place it in a setting strange to it. The visual shock of seeing the product apparently misplaced can add an emphasis to a sales feature and at the same time make the picture interesting and demanding of attention. The all-in-one completeness of these fiberglass units is emphasized by their being apparently in use in unexpected places.

Photography by JERRY SIMONS

Tubs and sinks by National Fiberglass Company

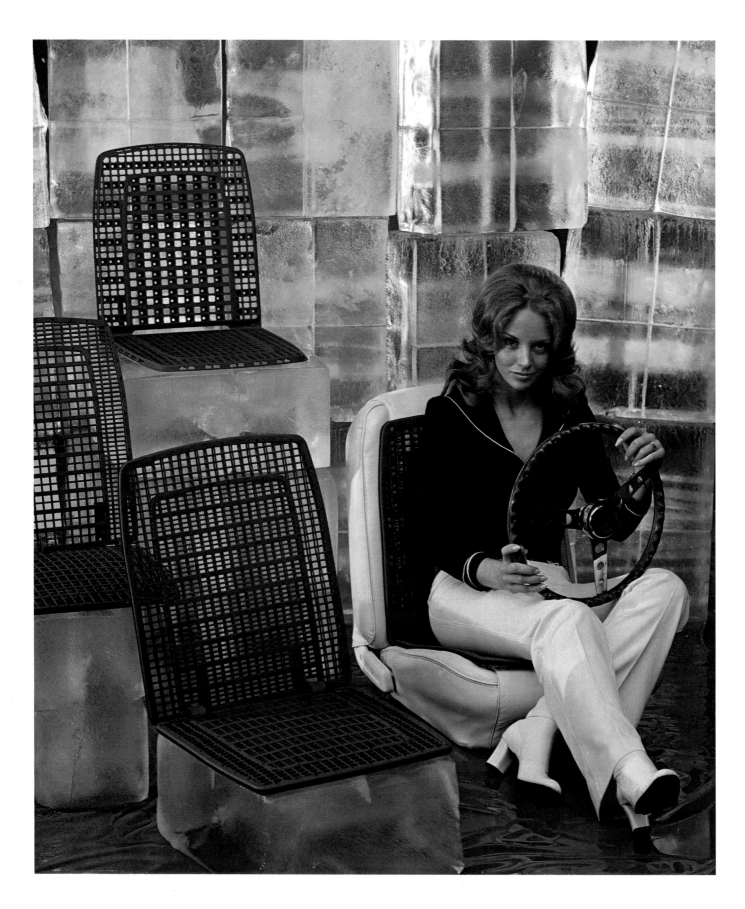

Here are illustrations created by two different photographers, neither one aware of the other. A similar advertising idea has been used, both to symbolize coolness. However, the photographic ideas used in the execution were obviously different.

The photograph above was by ED NANO for Kitchenmaid Corporation to underline the comfort to be expected from car seat pads, while the one on the right was by RUDY MULLER for Westinghouse air conditioners.

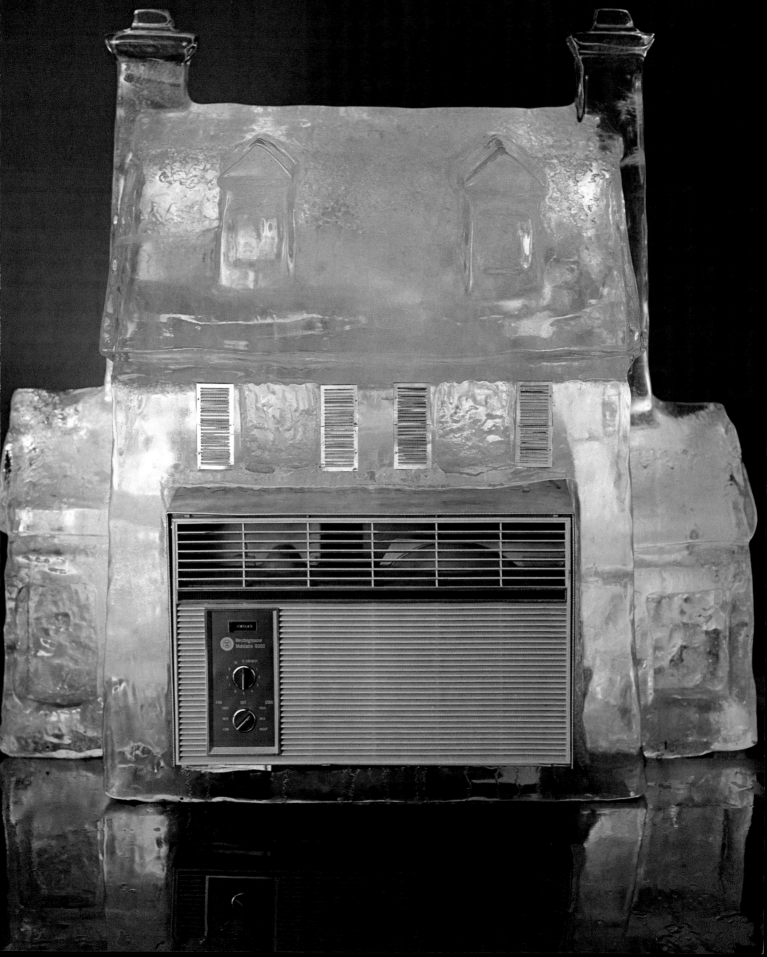

Emphasis

There is almost always a certain amount of window dressing in a photograph to provide interest and atmosphere. But there also must be the main show which is where the photographer must put his emphasis. He has many tools with which to do this: He can use color to lead the eye to the principal idea; he can emphasize his point through control of object sizes; he can lend weight to the idea by distorting subject matter; and he can emphasize simply through the choice of camera viewpoint. The object of any of these, or of other techniques available to him, is to tell the story quickly and with authority. Emphasis in a picture is a visual inflection which prevents the recitation from becoming a boring sing-song.

Emphasis in this illustration by ALBERT GOMMI for Abbott Laboratories is through the small area of the color red, and by the arrangement of lines leading the eye to it.

The illustration on the left makes its point simply
by the design of the whole.
Photography by JERRY SARAPOCHIELLO

And on this page, emphasis on the idea is contrib-
uted by the vivid contrasts of black and white.
Photography by MICKEY McGUIRE,
Boulevard Photographic

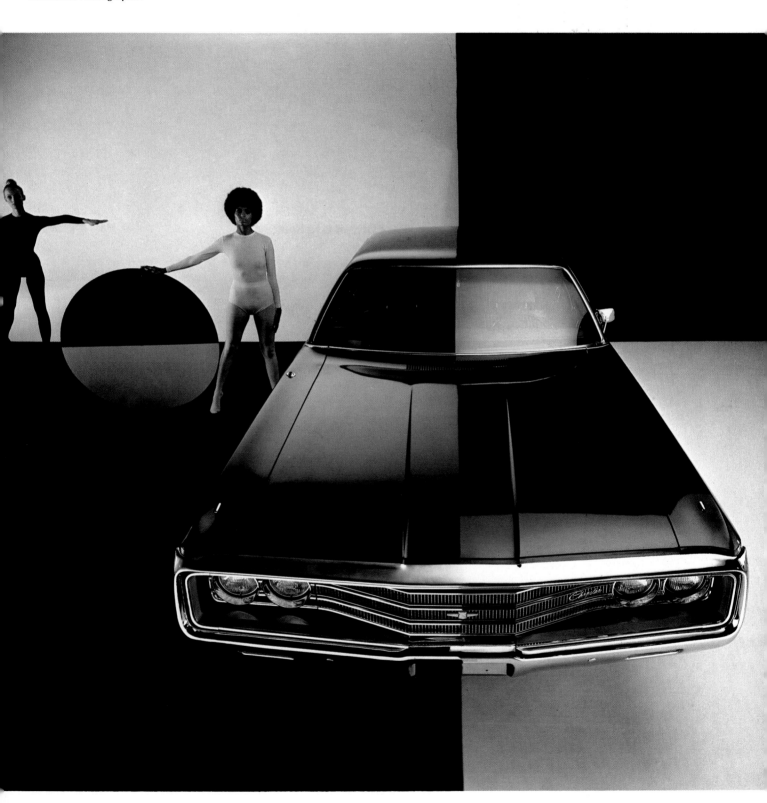

Things change with the viewpoint, and considerable emphasis can be achieved simply by choosing an unusually high or low camera viewpoint, or angle. In this illustration, a very low viewpoint was chosen, so low in fact that a special camera was necessary which enabled the photographer to have a viewpoint half underwater, half above water, simultaneously.

Photography by
BURTON McNEELY

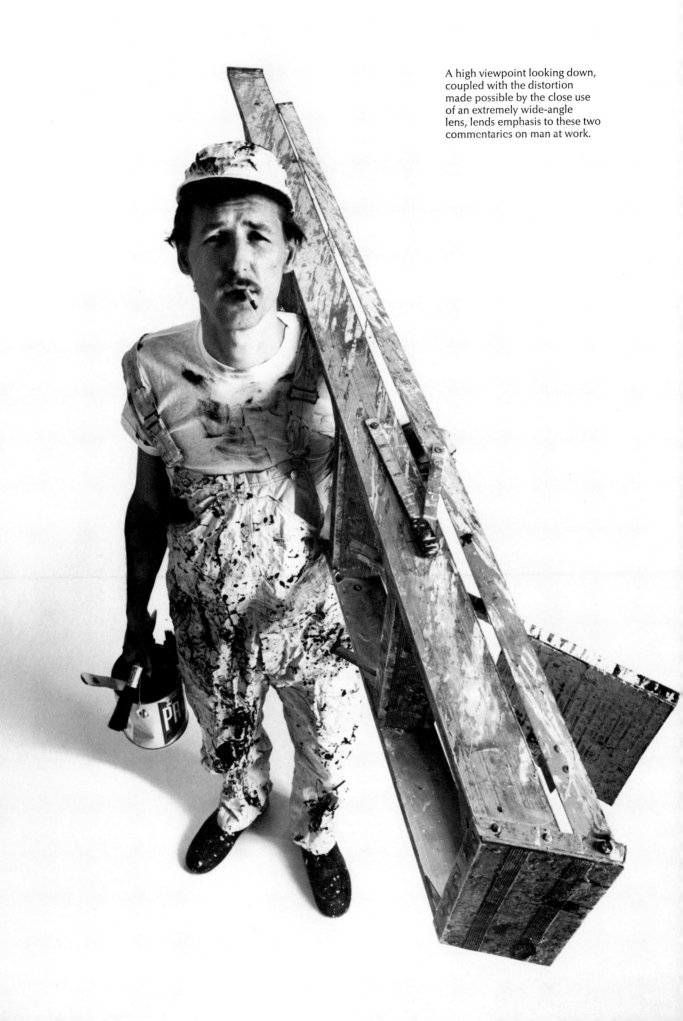

A high viewpoint looking down, coupled with the distortion made possible by the close use of an extremely wide-angle lens, lends emphasis to these two commentaries on man at work.

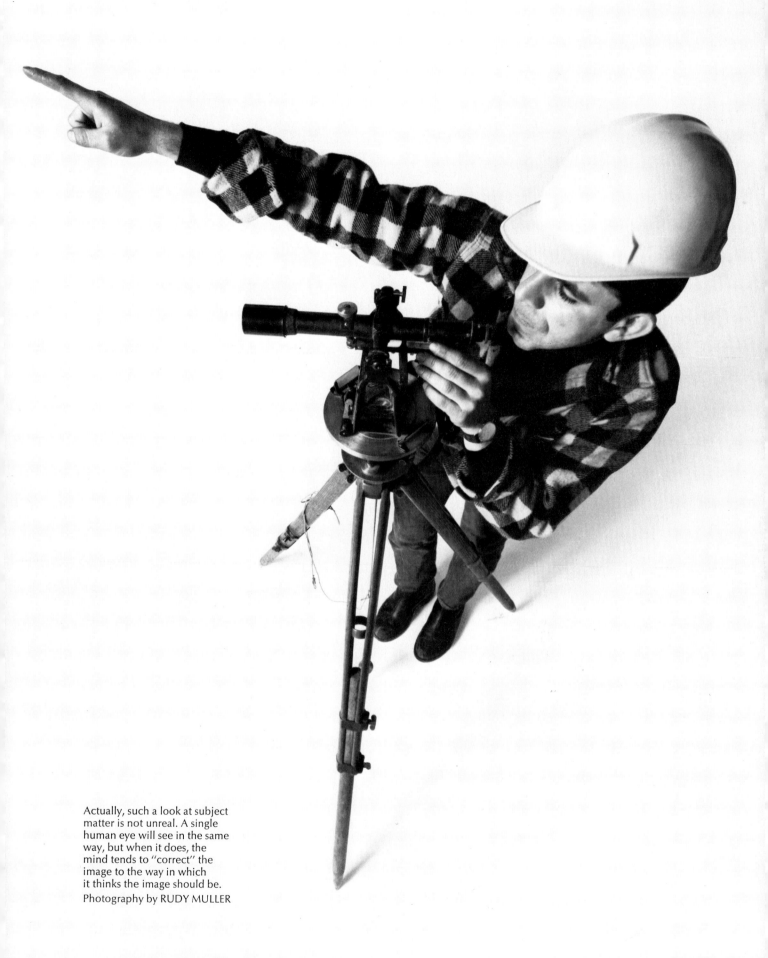

Actually, such a look at subject matter is not unreal. A single human eye will see in the same way, but when it does, the mind tends to "correct" the image to the way in which it thinks the image should be.
Photography by RUDY MULLER

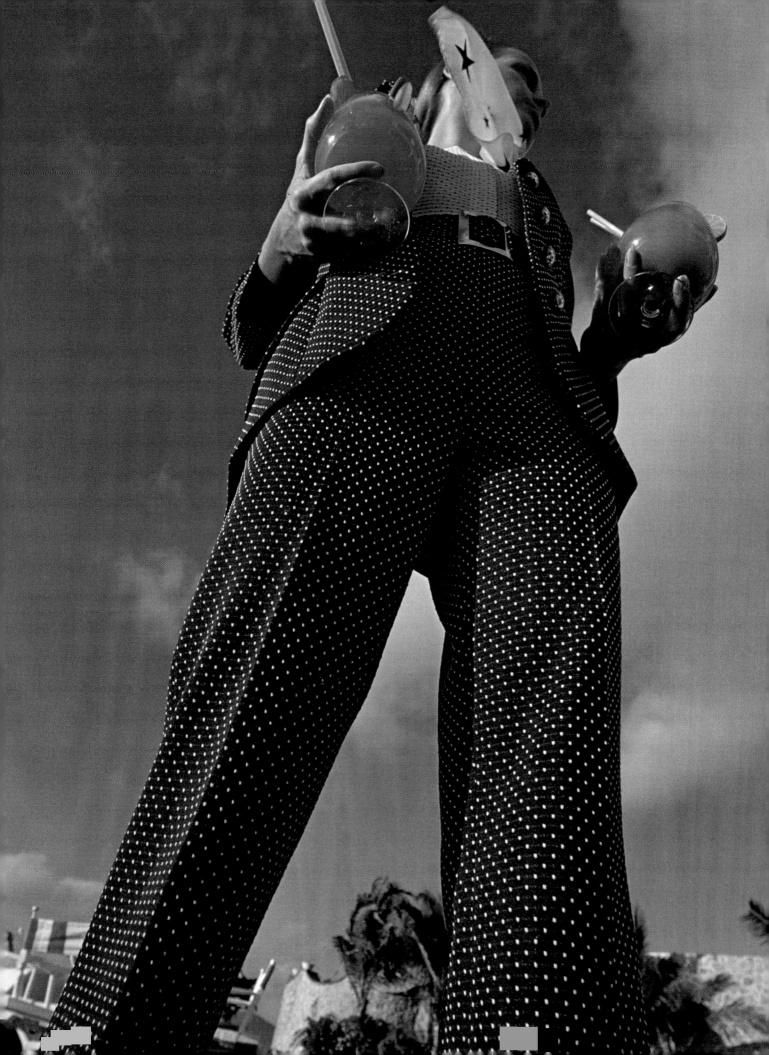

Photography can change the apparent size of objects and it can change the size of one object relative to another. A small object can appear to be large and a large one small. If both small and large objects are in a given scene, the camera can reverse the apparent sizes. And further than that, the camera can change the relative size of parts of objects.

This is true because objects close to a camera are recorded as larger than those farther away. The same effect is achieved with the human eye, but the impression is not a permanent one and is affected by the mind's knowledge of the actual size of objects.

Thus, emphasis on an idea, or subject matter, can be placed simply by its distance from the camera relative to all other objects in the scene. If placed close, it will become more important because it is larger. Or other objects can be placed very close to the camera and the subject farther away, thereby lending emphasis to its smallness.

A wide-angle lens is often used to lend emphasis to a portion of a single object as in the illustration by WILLIAM RIVELLI on the opposite page. The depth of field of such a lens is great enough to render the whole object with reasonable sharpness in spite of its closeness. Lenses of longer focal length do not have sufficient depth at close ranges.

Overleaf: In the picture on the left, the jewel appears to be bigger than it is because, in reality, the orchid blossom is smaller than the viewer knows. Knowledge of size is not possible without a known object for scale.

Overleaf: Emphasis has been added to the photograph on the right through the arrangement of objects as seen by a very short focal length lens. There has been an apparent size change of objects relative to one another, plus an optical distortion caused by the subject matter itself.
Photography by EDGAR deEVIA

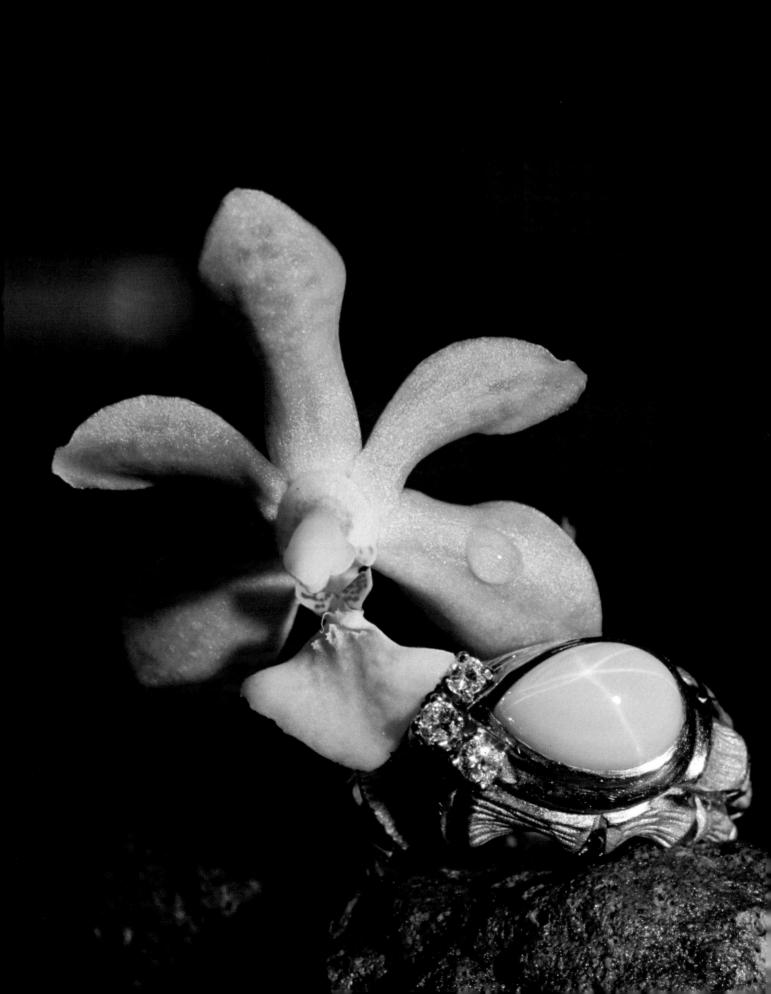

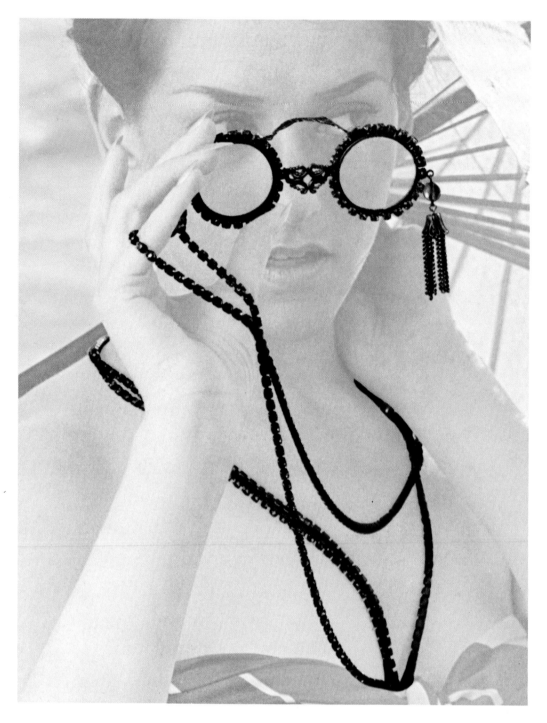

Since light is the very essence of photography, it is logical to assume that emphasis may be achieved by control of light. And since density in the photograph is an extension of the light intensity in the scene, emphasis may likewise be achieved by selective control of densities. Emphasis on the glasses and chain in this picture is gained by allowing them to register full value. The remainder of the scene was held back by a mask during the making of the color print.

An interesting means of emphasis—a way of calling particular attention to a specific portion of the picture—is by immobilizing or simulating motion. In the former case, lighting by electronic flash lamps will freeze the portion in motion, and in the latter a slow shutter speed will blur it. In either case, the part in motion is different, therefore attractive.
Photography at right by ALBERT GOMMI for Kellogg Company

On the following spread: An almost primitive means to pictorial composition is the repetitive pattern formed by a large number of objects all of the same size and shape. It does not follow that if one is good, a hundred is a hundred times better. But there are occasions when the impact of a repetitive pattern can lend emphasis to a subject which might otherwise be commonplace.
Photography by CHARLES COLLUM for Oak Farms

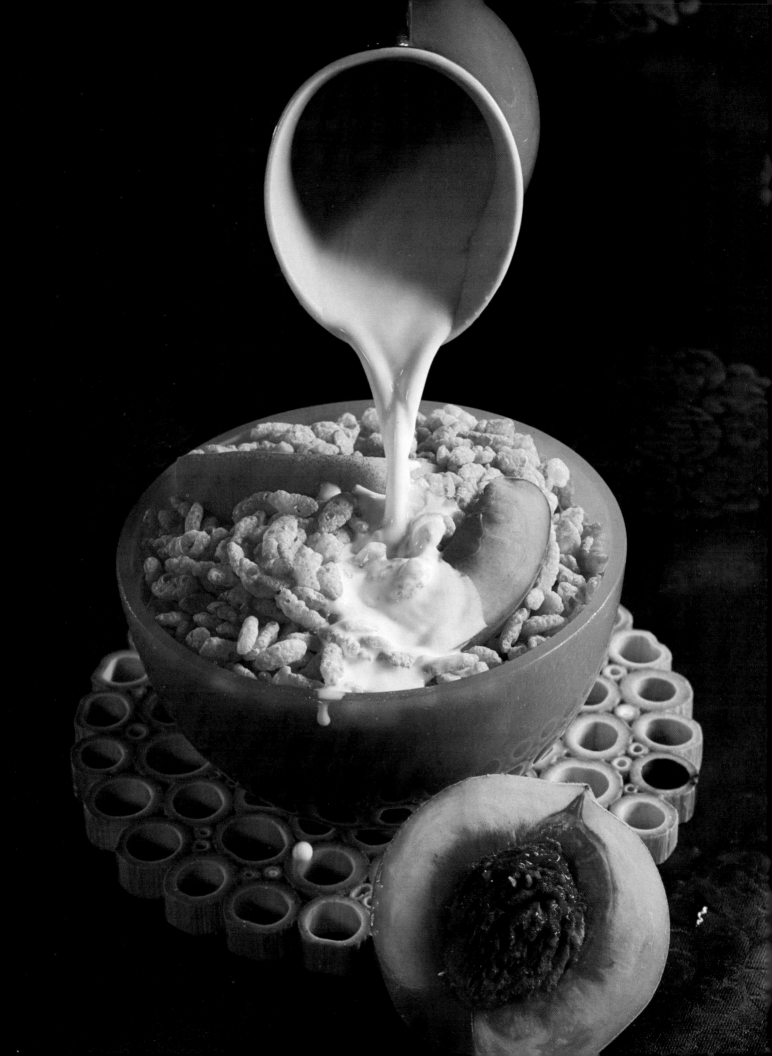

Industrial Advertising

For some strange and long forgotten reason, industrial advertising is regarded as different from the consumer kind. Illustration too often tends to be of the founder's portrait—factory facility type. Or the reader is treated to an over-retouched, overlighted view of a machine which apparently does nothing but sit there and smirk.

While it is obvious that an industrial page may not sell machinery or factory supplies in the same manner as a sudsy page moves soap, still it should be realized that the industrial reader is the same person who also reads consumer advertising; that he is a person, not a factory; and that his eye must be caught and interested from 9 to 5 when he is industrial, just as after hours when he's consumer.

The common excuse for mediocre perfor-

mance in illustration on the industrial page concerns the comparatively low cost of space. The reasoning seems to progress along the lines that the effort in filling space should be related to the cost per square inch. If that reasoning were followed throughout all of advertising, a $10,000 page would rate an all-out effort; on the $1,000 page, any image would do; and on a $100 page, compliments of a friend. Upon reflection, that reasoning *is* followed.

There is a lot of drama in industry, and the stuff from which great illustrations can be made. If the advertising space is in black-and-white, fine. There can be great drama and great illustration in black-and-white. And in color, there is a world of inspiration behind every factory door. Match this opportunity with talent, and industrial advertising will sing.

The product is printing ink. The premise is the
promotion of its use in four-color printing. The
solution, an imaginative, almost abstract use of
color which is the end product. No printing presses,
no ink grinders—no founder's portrait.
Photography by HENRY RIES
for General Printing Ink

Industrial advertising, like country cooking, does not need to be fancy to be good. But to be tasty and successful, both need high quality ingredients. One can hold the sauce and forget the spice; what is required is a sound basic idea and reasonable skill in its execution. Too often in industrial advertising the potato just sits there undressed, uncooked, and unloved.

All of the graphic techniques common to consumer advertising are available to its industrial counterpart. There is no real reason, unless it be despair, that the industrial product need be ugly rather than beautiful. It does not even need be ungraceful in spite of its being a two-ton press, or a block-long machine tool.

Stripped of its mystic incantations, advertising is essentially communication among equals interested in similar subject matter. Dig deep beneath the phlegmatic exterior of a machinist and one will find a delight in the sensual smoothness of polished steel. If one can uncover the important attribute of any industrial product which appeals to its potential owner, he has discovered the basic premise for successfully illustrating it.

Catalogs, Brochures, and Literature

In the advertising textbooks, the about-to-be-customer is impressed by an advertisement, sends for literature, goes to his dealer, and bingo! In reality, he does so if the advertisement whipped him into sufficient enthusiasm to make the effort, if the literature sustains his enthusiasm and gives him the information he needs, and if the price is right and the dealer has the item in stock!

Illustration in catalogs, brochures, and other sales literature must, of course, be descriptive. It must be honest but flattering, and should have the attributes of advertising illustration—it should sell the idea and the product. It is not enough to simply show a highly retouched shape in silhouette, or squared off in a rectangle of nothing.

It is a long time from advertisement to literature perusal; any residual effect the former had is long gone by the time the latter arrives. It is worth the effort to make the effort. The printing, and particularly the distribution of printed pieces, is an expensive business. Lack of imagination and high standards in the illustration increases the cost per sale. In particular, the product should be at its very best. Words in a piece of literature can be brilliant and clever, but it's the illustration which makes the sale.

These rugs come right off the page. They describe the line and are as close to the feel of rugs as an illustration can make them.
Photography by LIONEL FREEDMAN
for Downes Carpet Company

An Experiment with Sarah Coventry Jewelry

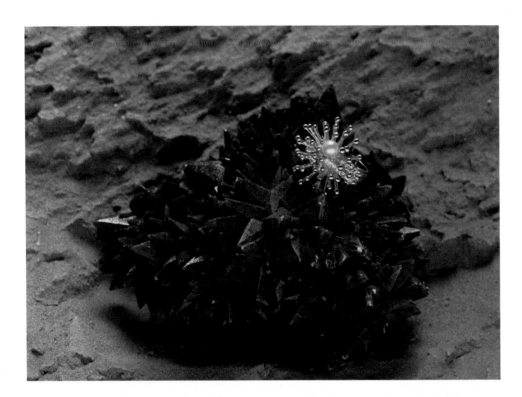

Here are potential catalog pages, each on a separate theme. The settings are illustrative in character and serve to display the product in an unusual and attractive way. If such a treatment seems a bit much for a large catalog, this sort of illustration can be used as section breaks, or otherwise dispersed throughout the book.

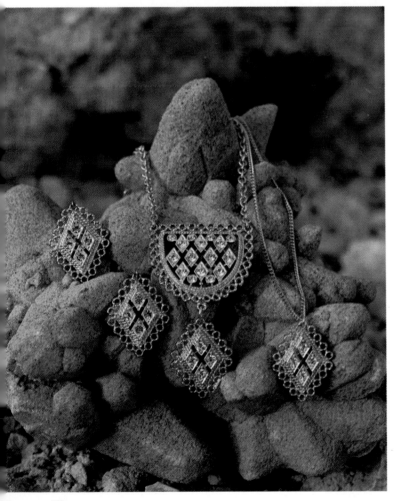

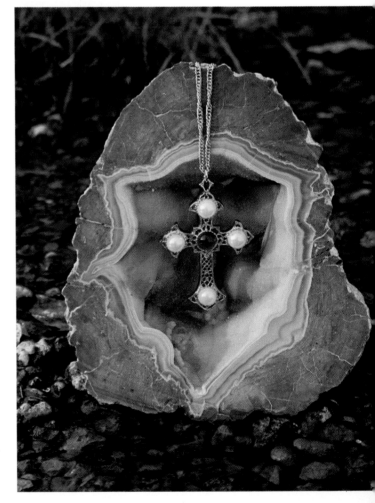

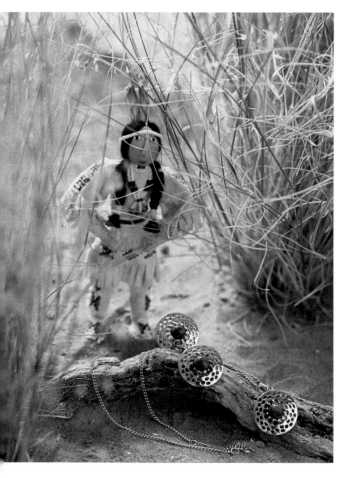

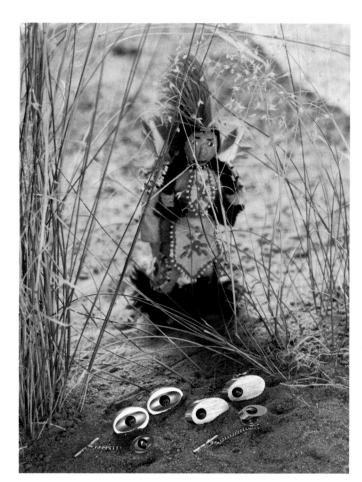

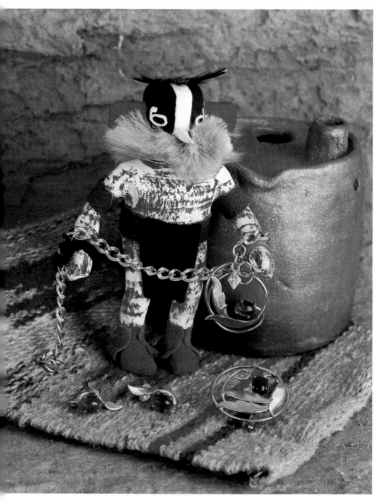

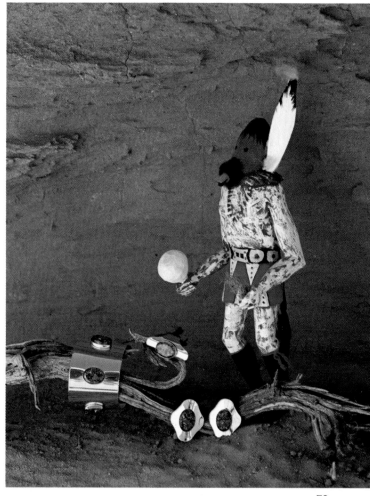

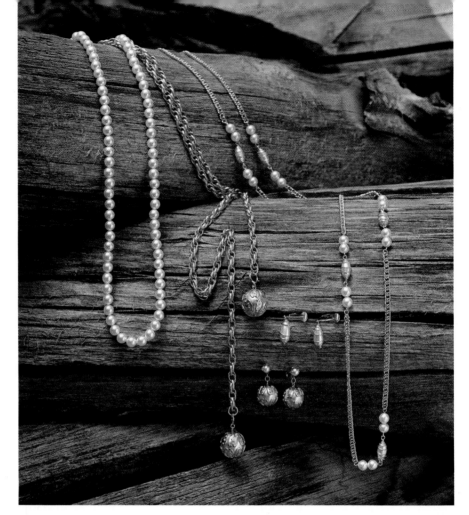

All of these jewelry illustrations are reproduced from 2¼ x 2¼ Ektachrome transparencies. The originals were made to the same scale as the reproductions, thus all photomechanical color separations could be made to the same scale with happy, economic results. If they had not been, they could have been duplicated to scale with the same result. Or the whole thing could have been done with color negative material, and prints made to fit the layout. A little forethought made duplication unnecessary.

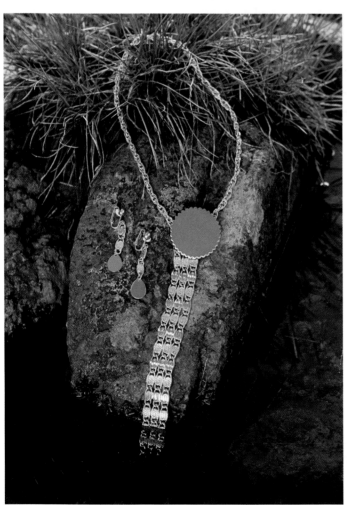

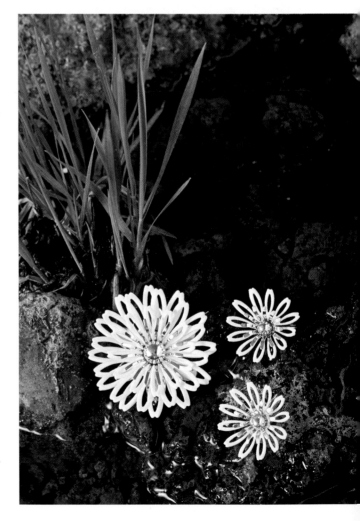

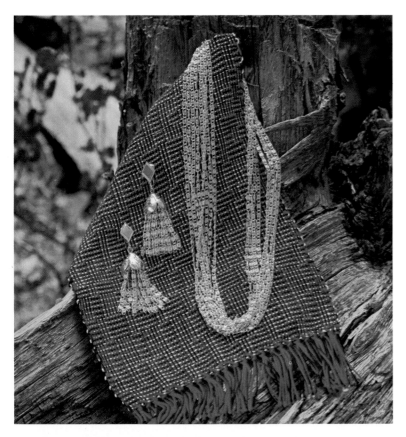

Outdoor locations are interesting sources of small sets for such product illustration. Almost any attractive area abounds in interesting nooks and crannies which serve as sources of inspiration. Variations in a given location will be plentiful to the discerning eye, and a surprising number can be utilized in a comparatively short time. There can be a simple theme running throughout the series, or a catalog can be broken up into several sections, each with a theme. Three ideas—mineral, Indian, and vegetable—are shown here.

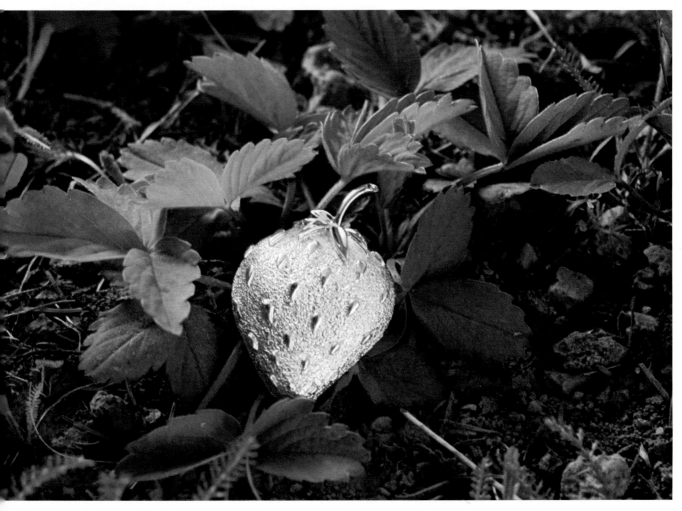

These illustrations from a jewelry catalog are somewhat more formal than those on the pages immediately following. The product was arranged underwater in an aquarium for a highly effective and dramatic setting. How much more intriguing these photographs make the product compared with the usual treatment of bedding the jewelry down on velvet or colored cardboard.

Photography by CHARLES COLLUM
for Corrigans, a member of Fine Jewelers Guild

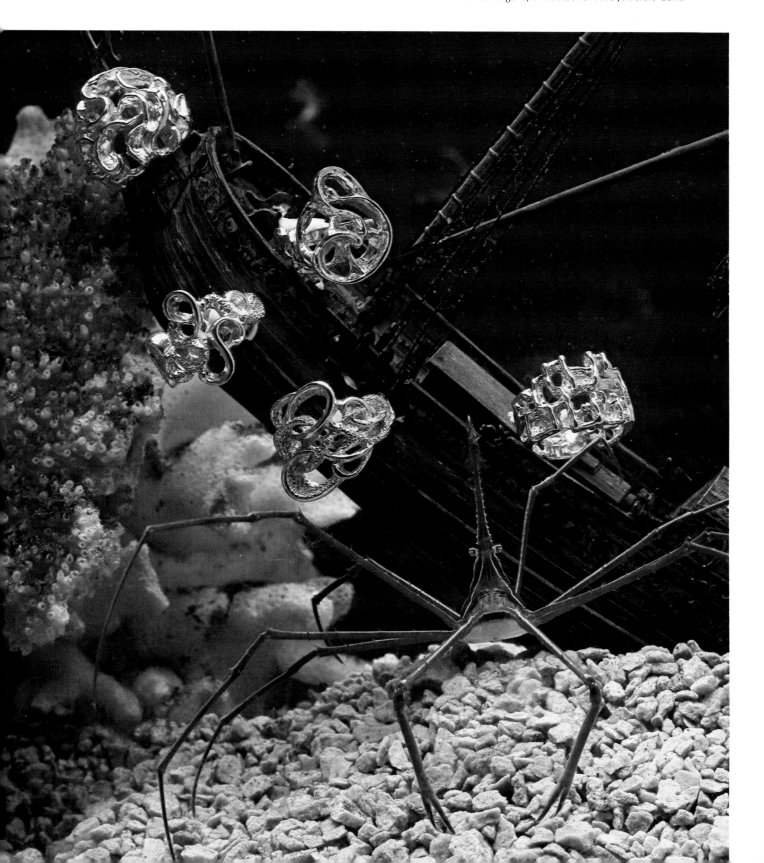

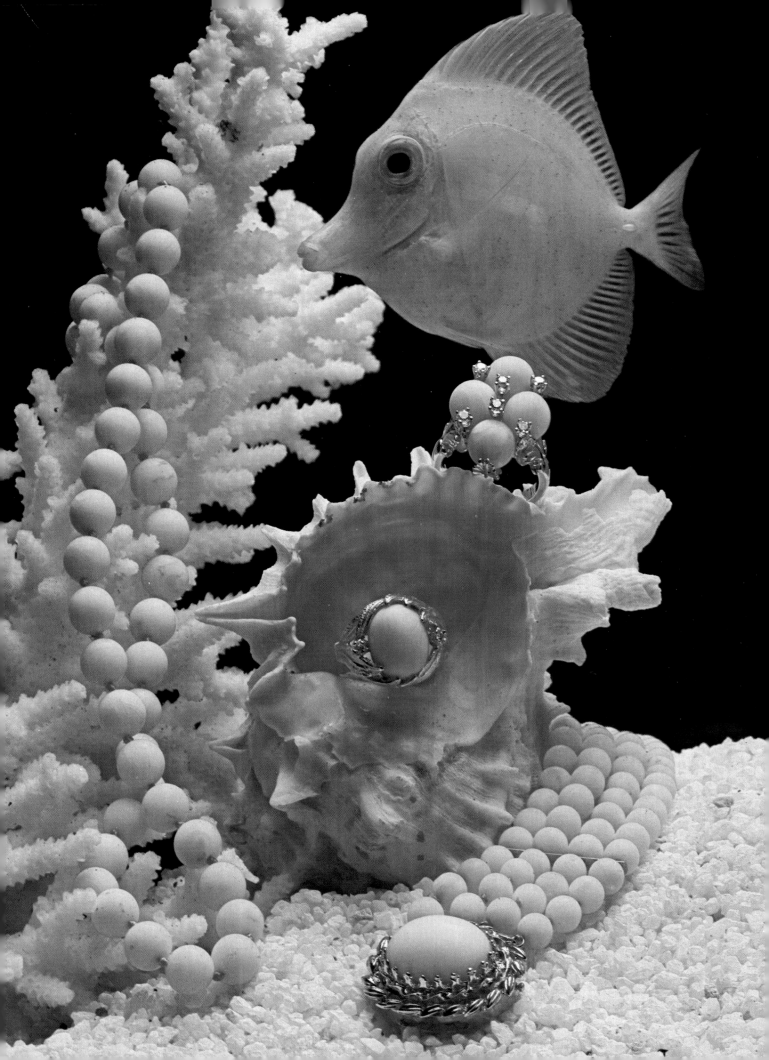

The illustrative problem in an industrial catalog is somewhat different than that in many consumer catalogs. The specifications and technical characteristics of the product are of first interest to the reader. In many cases he already knows what the product looks like. This would certainly be the case with twist drills and reamers. Yet imaginative photography can dress up the catalog to advantage and, more importantly, contribute to the word picture of quality, reliability, and other adjectives beloved by catalog writers.

These experimental illustrations were originally color transparencies. Their color was essentially a steely black-and-white. In reproduction, three process inks were used in a duotone fashion to heighten interest. The picture at the right utilized yellow, cyan, and black; while the one below was printed in magenta, cyan, and black.

Photography by ED NANO

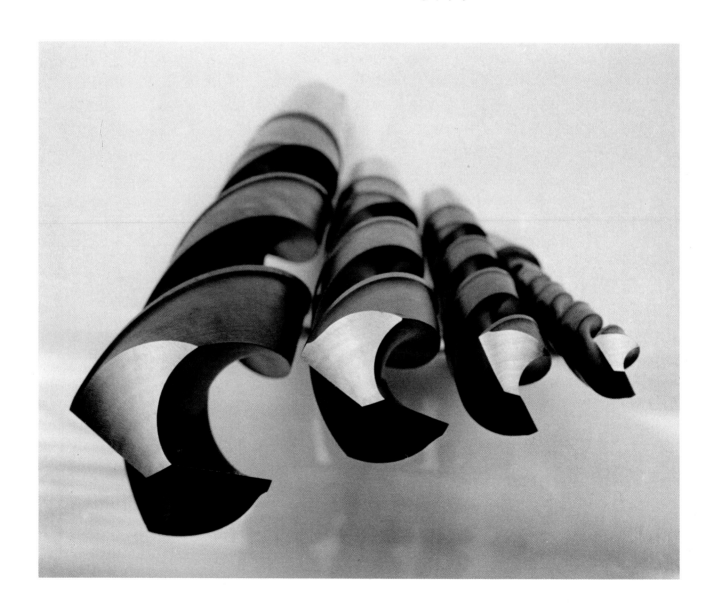

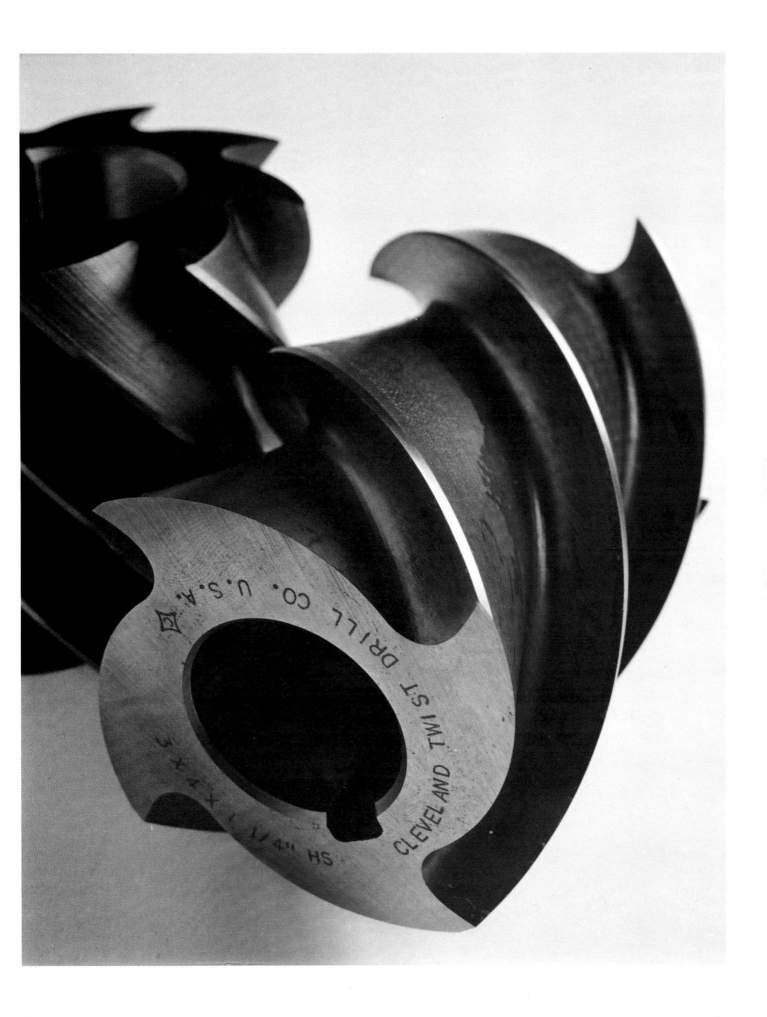

CLEVELAND TWI ST DRILL CO. U.S.A.

3 x 4 x 1 1/4" HS

The success of the large mail order catalogs in moving goods is well known. While the major companies selling by catalog also have retail outlets, catalog volume is vital to their continued business health. Their use of photography is exemplary and worthy of close study by all who sell by catalog.

The product is always front and center on a mail order catalog page. It is presented at its best and with as much technical photographic perfection as possible. The picture is the product, and no effort is spared to present it appealingly with an aura of quality. Images from larger format cameras are still the rule, although considerable experimentation with hand-held cameras has been taking place during the past few years in an effort to achieve the spontaneity and informal character this type of photography seems to impart.

At one time, all mail order catalog pages simply presented the product in a sharp, outlined way. But current productions utilize a more illustrative treatment. Furniture and other household goods are shown in room settings, and the models displaying clothes are shown on location in interesting settings. Photography for mail order catalogs is becoming less catalog and more space advertising in character.

The production problems in putting together a large mail order catalog are immense. Every possible means of making the operation economically efficient must be utilized both for the photographic and photomechanical steps. Here is a step-by-step report on a comparatively simple page from the fashion section of a Sears Roebuck and Company catalog.

Photography by WILLIAM BECKER STUDIOS

Layout as prepared by the art department of the client.

Main illustration
enlarged to scale,
with drop-out masks
in position
to accommodate
additional material.

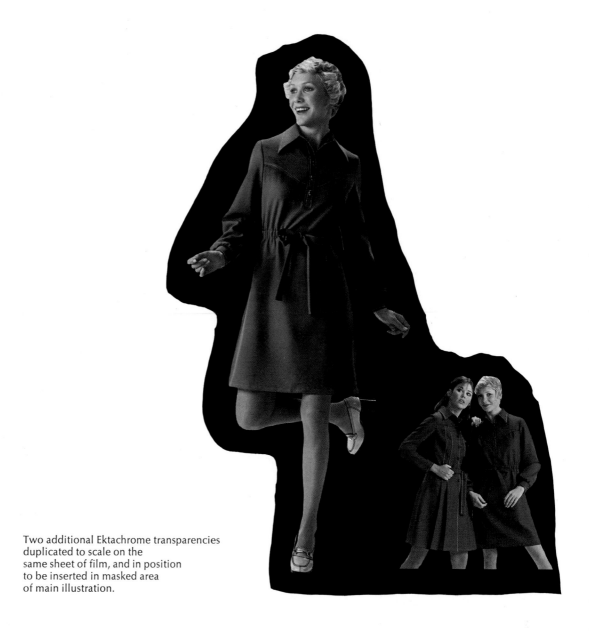

Two additional Ektachrome transparencies
duplicated to scale on the
same sheet of film, and in position
to be inserted in masked area
of main illustration.

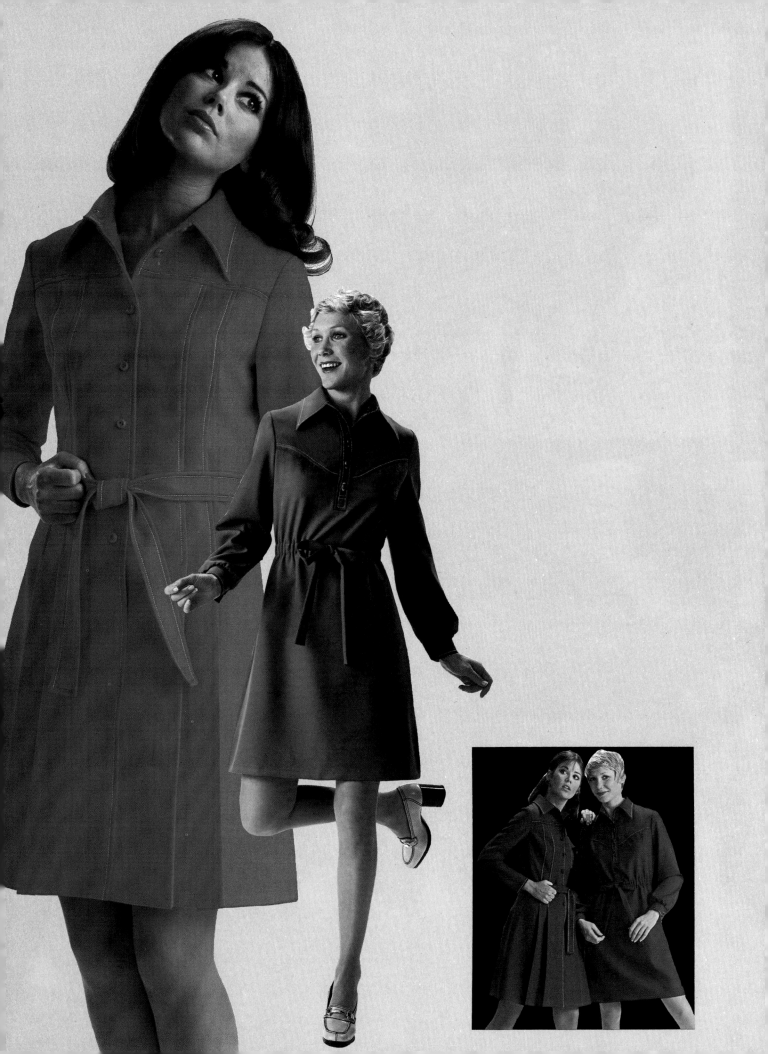

Flower Songs

When the seedsman really wants to sell a lot of a given item, or the nurseryman has a large stock of a plant he wants to move, they both know that a color photograph in their catalog will do the job.

Photographing flowers is a lot like photographing pretty girls; it is easy to be carried away by subject matter. Perhaps the single greatest fault in the technique of picturing either is in the use of harsh sunlight. This type of lighting tends to burn out the detail and textures in highlight areas, and results in photographs with excessive contrasts.

Flowers should be cross- or backlighted to establish form and texture, and light reflected into shadow areas to reduce contrast for good reproduction qualities. The light should be soft, as is found on cloudy-bright days, or sunlight may be used if diffused by fiberglass, silk, or other means. Flowers in the studio should be handled similarly with diffused artificial light.

These two photographs are quite similar in character, yet the one on the left is an editorial illustration for Better Homes and Gardens, the one on the right, a page from a Sears Roebuck catalog. Certainly a demonstration that catalog photography is no longer an item on a sea of white.

Photography by ALDERMAN STUDIOS

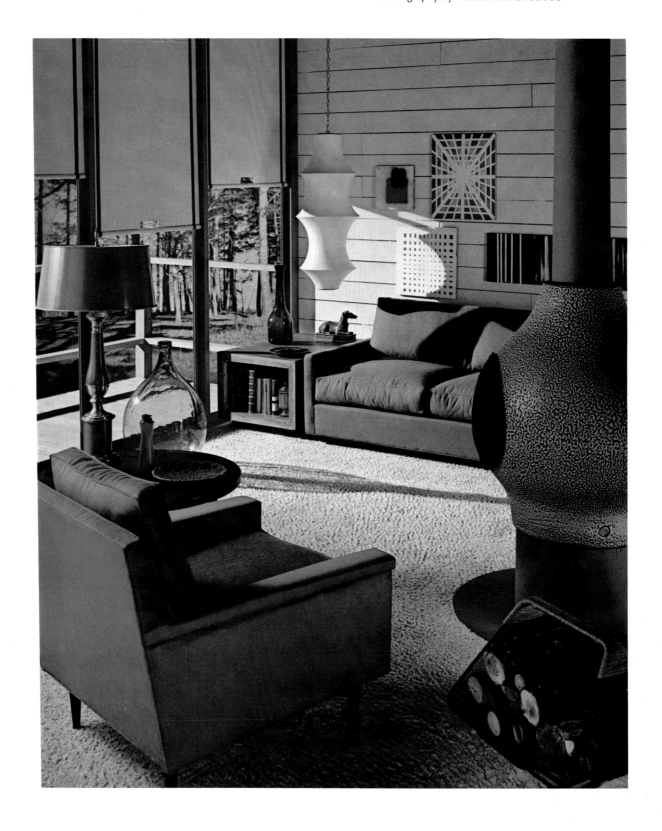

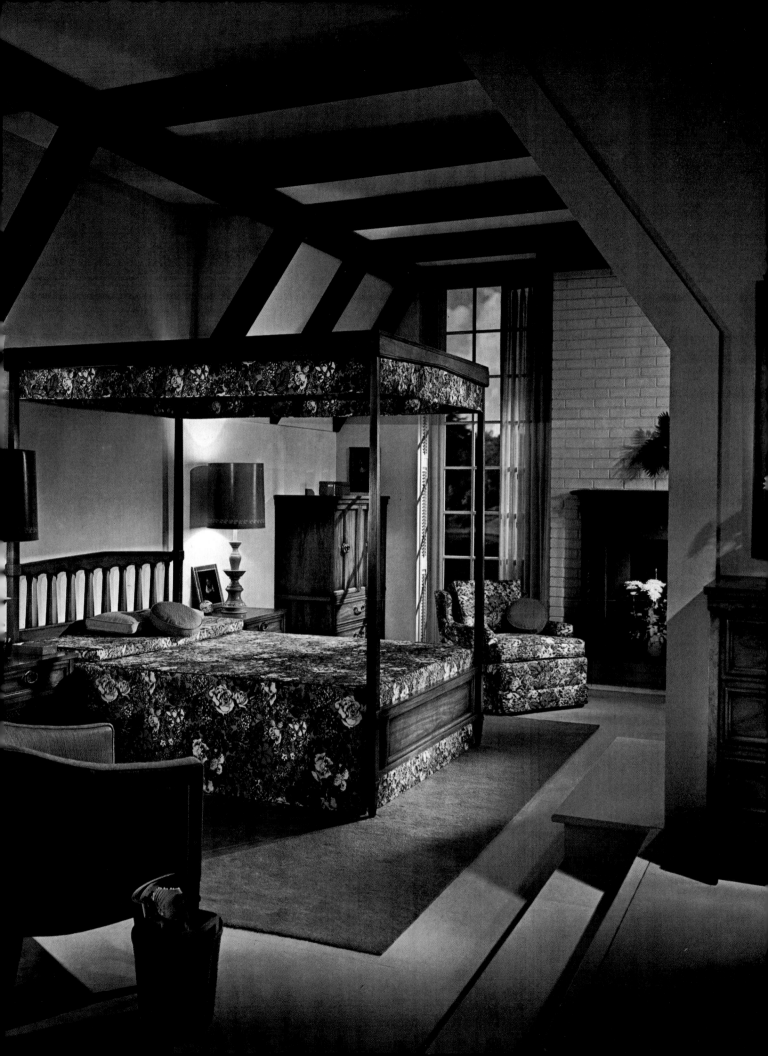

How to–

Instruction books have become the butt of many a joke, and their lack of clarity a source of frustration for everyone whose purchase involves any product other than one of enormous simplicity. It does seem that instruction books are an afterthought, prepared by apprentices, and distributed with a certain resentment.

If the "well-satisfied-customer-is-the-best-advertisement" is part of the business philosophy, a well done instruction book should be part of the package. And well done implies well illustrated. In this case, never mind the mood, the appeal, the promise—get in there and show it. The illustrations on these pages will hold up even with poor reproduction. Add labels, and anyone can understand the parts.

Photography by JAMES MILMOE

The Annual Report
Burnishing the Corporate Image

The annual report is management's letter to the boss. It is the big occasion to win friends and influence shareholders. It is just as importantly an occasion to present a bright and impressive picture to the financial world as a whole. Its legal reason is numbers.

But numbers are only numbers, whether dispensed in columns or charts, pie or otherwise. The real opportunity is to reinforce or initiate the kind of corporate image management feels it should have. It is a creative challenge of first magnitude.

Communications of almost any character are quickest, most easily assimilated, and longest lasting when the message is presented photographically. But the bird's-eye view of the plant proves nothing but mere existence. It is when the photographic language is utilized with imagination and respect that the presented images convey the corporate personality.

Good photographs are corporate messengers, even as the words which sometimes surround them. No manager would condone bad grammar and juvenile English in his communications. Nor should he regard with indifference the photography which often commands more attention and occupies more space than the words he respects so much.

While his readers may be financial experts and unemotional businessmen with their eyes on profit and loss, they are nonetheless people first. And as people, they are preconditioned to recognize and accept photographic images of quality. Those who regard good illustration as a superfluous frill simply don't get the message —or send it either.

Many designers and art directors of annual reports have welcomed photography created by the 35mm camera as though the equipment is the only way to more persuasive and humanizing illustration. It is true that the mobility of the camera contributes to informality. But it should be realized that the casual approach to subject matter is not a signal for unprofessional use of the equipment. And that there may be subject matter within the annual report which can be better interpreted by larger cameras and more complex techniques. Photographic procedures should be predicated on the necessities of creating the picture, not on prejudices based on generalities associated with end use.

It is strange that many executives will labor days over the financial language of a corporate booklet, but feel that five minutes is more than sufficient in which to be pictured. A good portrait cannot be made in five minutes. And a good portrait can do more than many a sweet written word to humanize corporate manage-

Continued on page 101

An illustration calling the stockholders' attention to a market represented by home sewing in the annual report of M. Lowenstein and Sons, Inc.
Photography by WILLIAM RIVELLI

The Annual Report

Visual proof of unusual projects in which the company is engaged always makes an annual report more attractive and therefore better read. Illustrations such as this are worth many words of explanation. Readers of annual reports may not be able to determine why they are impressed with some pictures and not by others. But the producer of the report knows; the impressive ones are those made with great seriousness and respect. The unimpressive ones are quickly made snapshots.
Photography by
ARTHUR d'ARAZIEN
for General Electric
Company

The Annual Report

Photography by WILLIAM RIVELLI

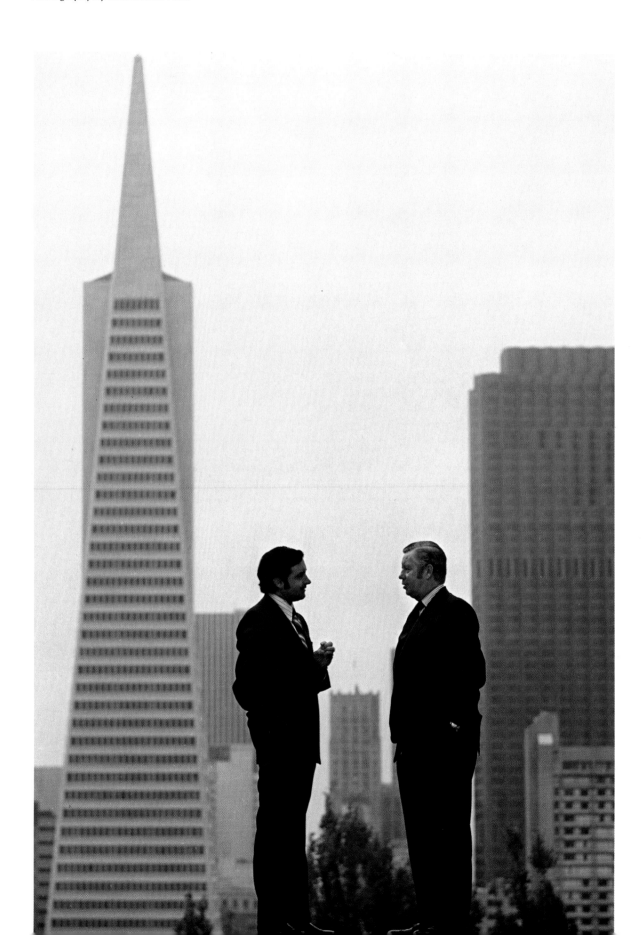

ment, or leaders in any field. A good portrait is an introduction to the public. The impression it makes cannot be improved upon by personable conversation.

On the other hand, this attitude is predictable. The language of photography is not their forte, and their attitude is bound to be affected by the memory of a previous Sunday when one of the children snapped Dad in a fraction of a second.

Perhaps there is the rare occasion when a perceptive photographer can capture a sympathetic and revealing image in the first moments of the available opportunity. A more usual result of a busy and uncooperative subject is a starchy facial map, a totally unreal report on the person—this to the detriment of both the man and his organization.

The quality of a portrait is not the achievement of the photography alone. Great portraiture is the result of a sympathetic partnership. This is not a natural condition for the busy executive, and he must be enlightened by his advertising and public relations managers. After all, they are the experts in projecting an image, and executive portraiture *is* corporate communication.

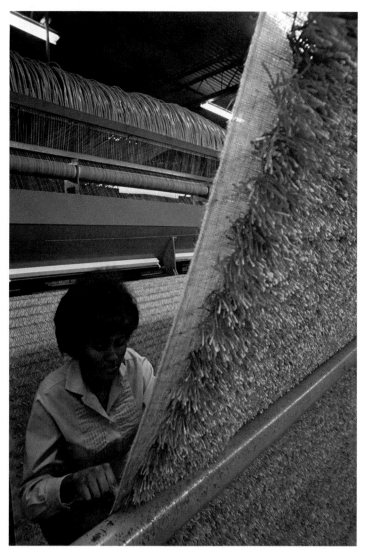

The Annual Report

An excellent way to exciting annual reports is to turn loose an imaginative photographer. Give him an outline of necessary areas of coverage, but also give him the freedom to illustrate what fascinates him, for everything will be new and intriguing. Several days of his fresh and enthusiastic exposure to a factory will yield pictures unthought of by those who pass by every day.

Photography by WILLIAM RIVELLI

The Annual Report

The designer of an annual report often has the problem of visually saying the same thing year after year. And since the publication strives to impress its readers that the corporation is up to date and progressive, the same old thing is self-defeating. An unusually close-up look at a product or process will often achieve newness, or the use of unexpected angles and lighting will help make the report more exciting.

Photography by WILLIAM RIVELLI

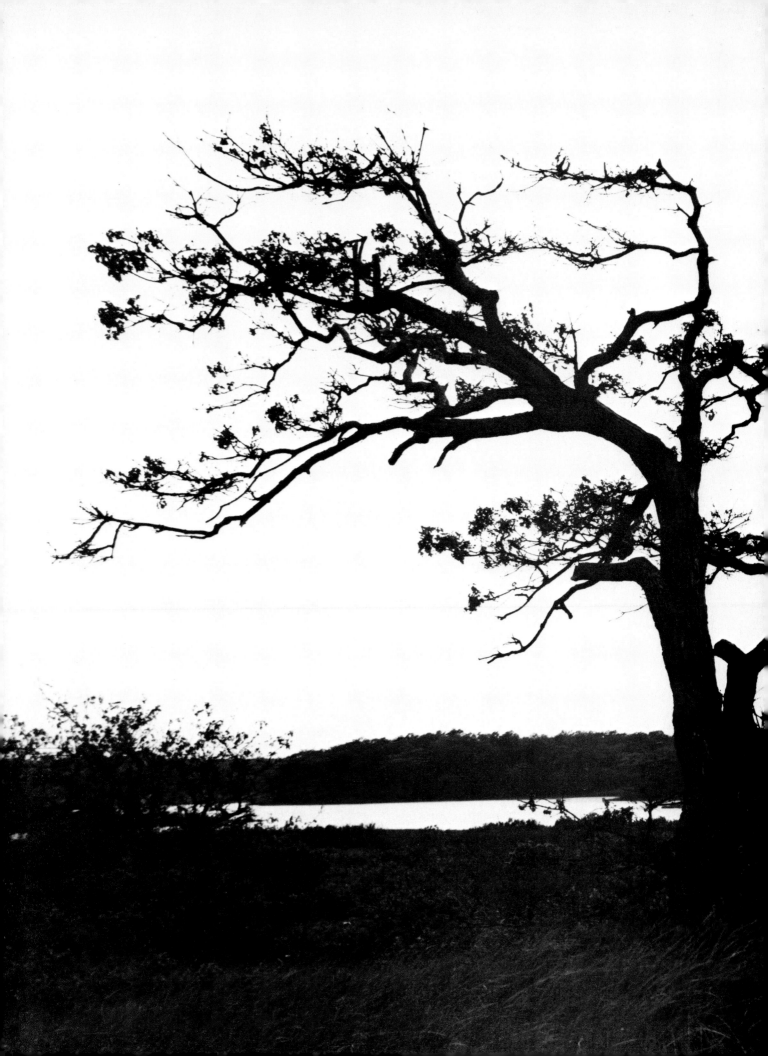

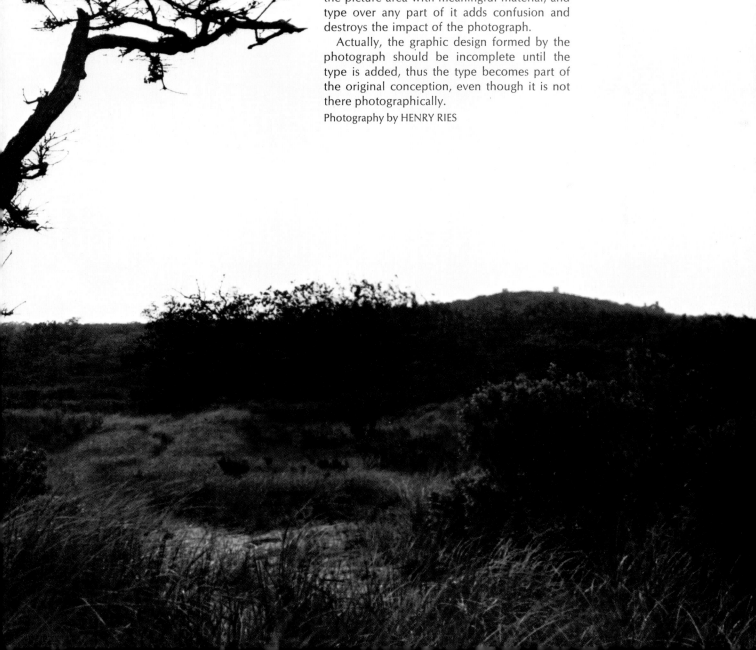

The Annual Report

In the design of annual reports, or literature of any kind, type can be surprinted in appropriate areas of photographs so the page or spread serves a dual purpose. This is most successful when the photograph is made with this use in mind because, normally, the photographer fills the picture area with meaningful material, and type over any part of it adds confusion and destroys the impact of the photograph.

Actually, the graphic design formed by the photograph should be incomplete until the type is added, thus the type becomes part of the original conception, even though it is not there photographically.

Photography by HENRY RIES

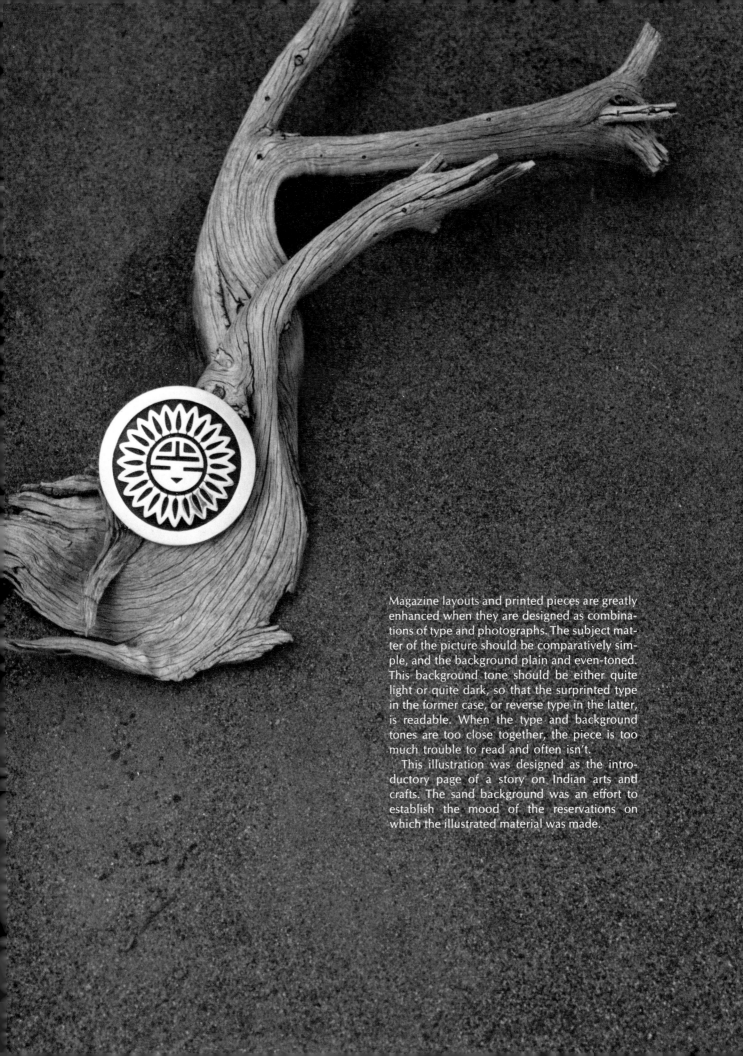

Magazine layouts and printed pieces are greatly enhanced when they are designed as combinations of type and photographs. The subject matter of the picture should be comparatively simple, and the background plain and even-toned. This background tone should be either quite light or quite dark, so that the surprinted type in the former case, or reverse type in the latter, is readable. When the type and background tones are too close together, the piece is too much trouble to read and often isn't.

This illustration was designed as the introductory page of a story on Indian arts and crafts. The sand background was an effort to establish the mood of the reservations on which the illustrated material was made.

This photograph is not a well-composed picture in itself. Its design is complete only with the addition of type. As the title page of a story involving orchids as photographic properties, it set the mood for the pictures and text to come.

Type surprints or reverses are often used in space advertising, and these uses, too, are most successful when the photograph is made for the purpose. If words and picture are to be combined, the result should be synergetic, not confusing. And if both are in color, the color of the type should relate harmoniously to the components of the picture. Magenta type on a picture composed of greens might shout, but its message is discord.

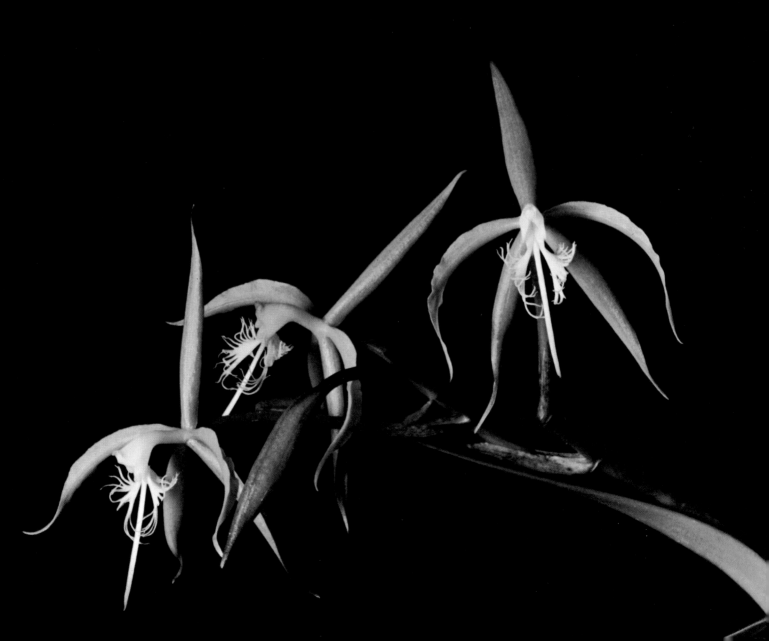

Cattle Drive...

A picture story for corporate house magazines

Photography by DICK KENT

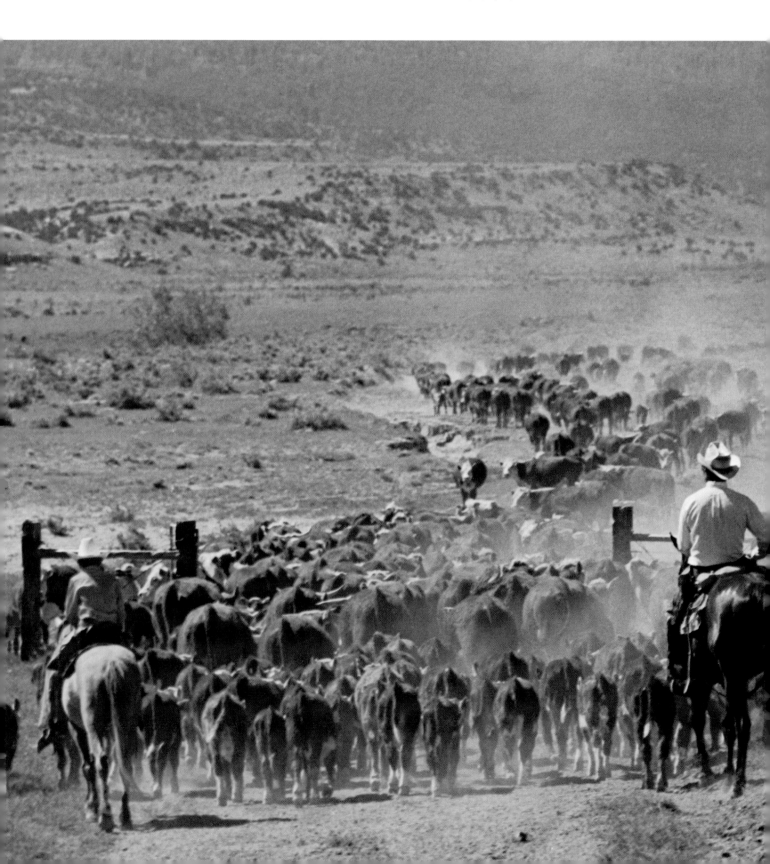

Anyone examining a large sampling of house magazines must come to the conclusion that their editors are continuing optimists and their publishers unaware of human nature. Issue after issue, these publications are filled with a sort of egocentric corporate provincialism, their subject matter being thinly disguised advertising and promotion.

Admittedly, advertising and promotion is the purpose of these magazines, except in the case of internal publications where the reasons are those of personnel relationship. But if there is

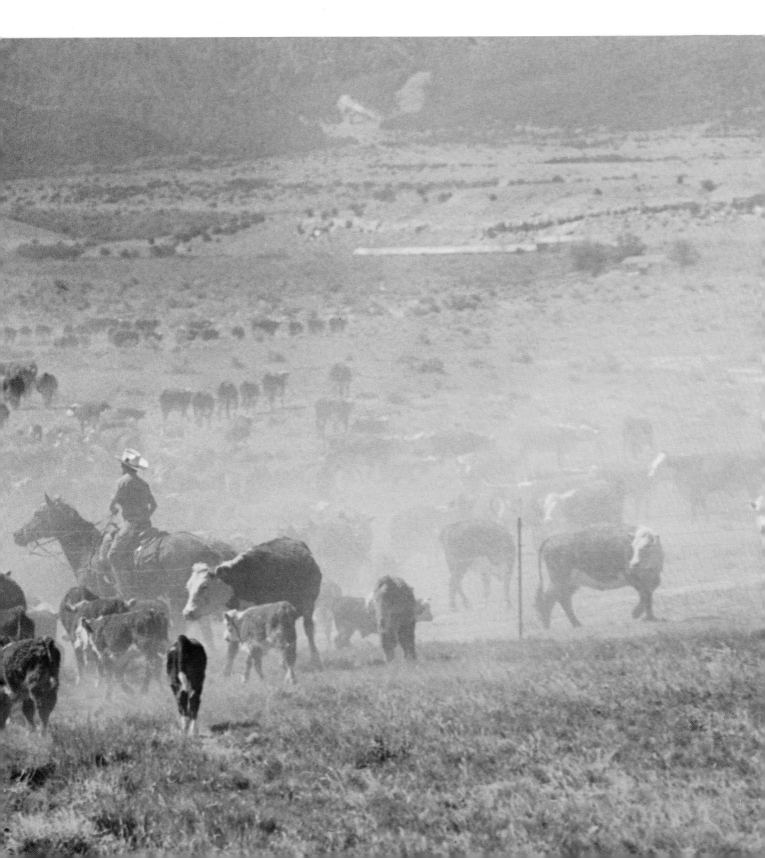

Cattle Drive...

to be any readership, and therefore value to them, there must be a supply of consumer meat along with the corporate potatoes.

House magazines compete for time and attention with commercial publications. One would not expect the latter to long endure if the content were all puffery and advertising. Even television puts content between the commercials.

The techniques of photojournalism are ideally tuned to the needs of the house magazine. Photographic stories can make the publication exciting, and it is a place where the editor can compete with anyone, for all he needs are ideas. Even one really well-done story an issue will make his publication regularly welcome. This one good production per issue can give him a front and back cover, and an insurance policy against being ignored inside. With intelligent planning, he may also gain material for the future. If his budget dictates black-and-white coverage, fine; there is no reader block to black-and-white. Color is better, but all is not lost without it.

The most economical and logical way for the editor to work with photographers is to arrange for their services by the day. Time necessary for good coverage depends upon subject matter and weather if the assignment is out of doors. An extra day to take advantage of fortuitous light conditions is often a good investment which pays off in extras of considerable value for the future as well as the present. Photographic libraries built from a series of photojournalistic assignments have a way of becoming very valuable tools for continuing editorial use. The 2½ days spent on this cattle drive story resulted in hundreds of pictures, many of them useful for the future.

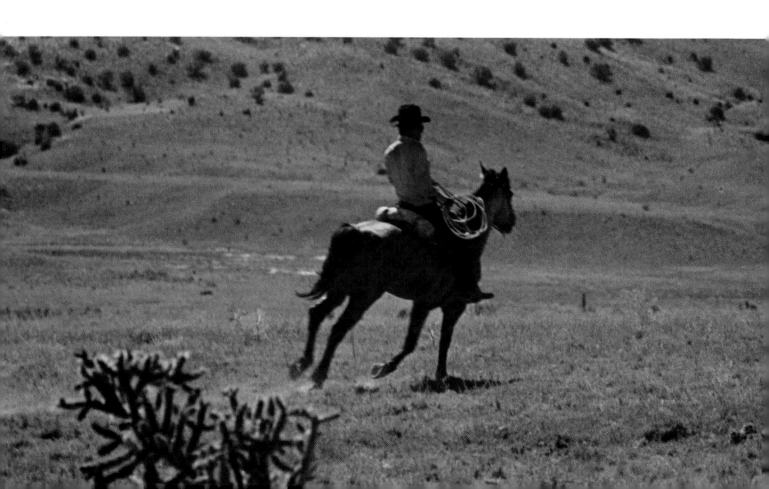

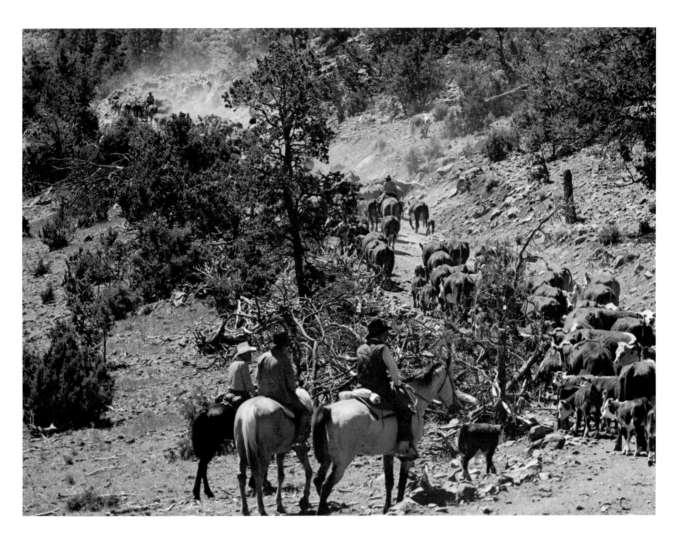

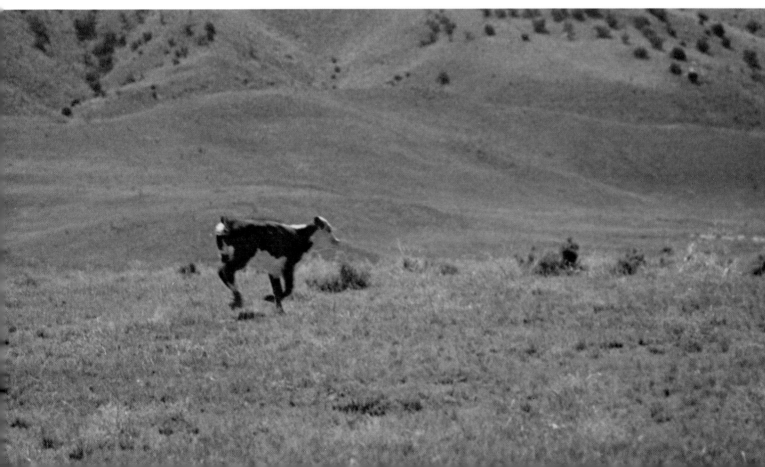

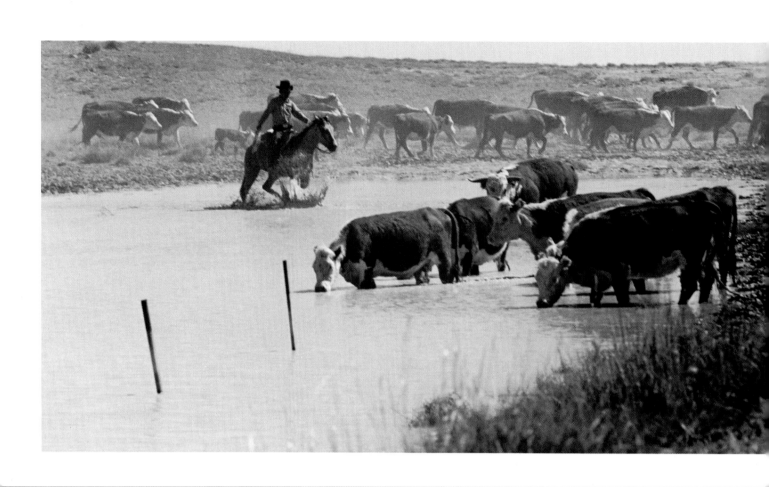

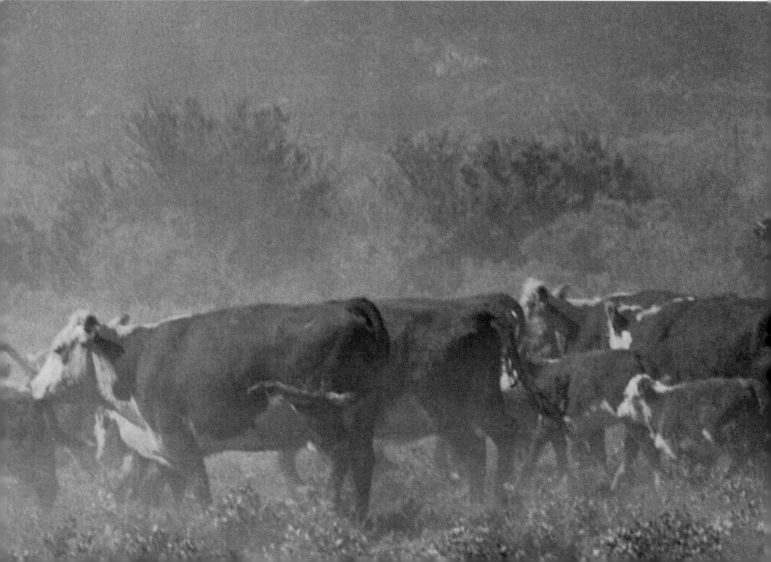

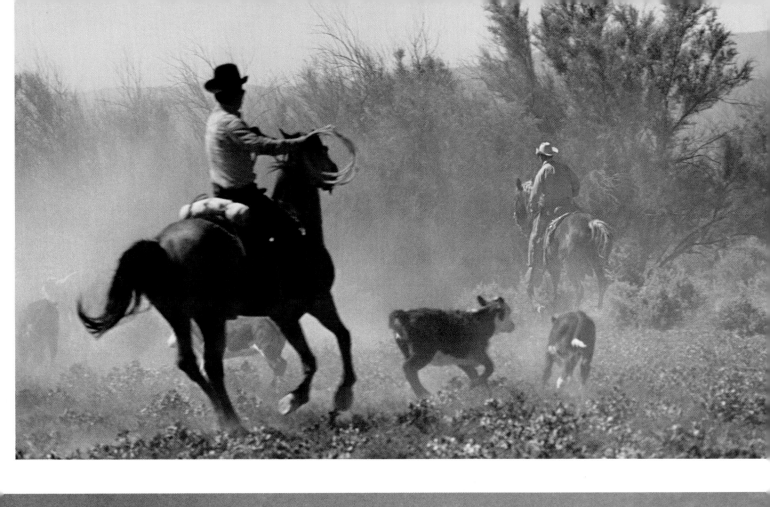
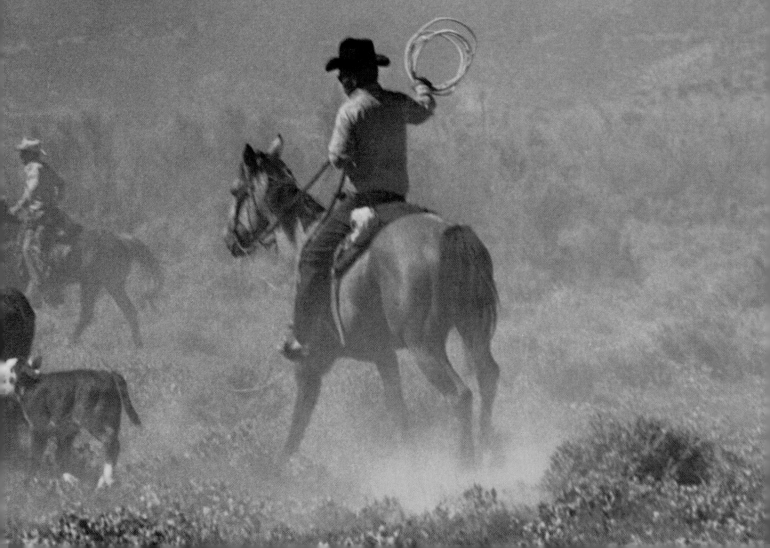

Posters

A really great poster needs nothing but a word to say it all, and there are times when it doesn't need that. It is the ultimate of what an advertising illustration can be, for it can stop the eye with its design, set the mood with its content, and start the sale with the desire it creates.

The essence of poster art is speed, which suggests that photographs created for posters be simple ones. This is particularly true for outdoor advertising where the potential customer is passing by at varying rates of speed, usually fast. The message and design can be more complex where the poster is used at point-of-sale, for here the customer is contained within a store and his movement is restricted.

The large camera is the tool of preference for posters. There are those enamored of small cameras who claim that the miracle works, that 35mm images can be blown up to 24-sheet posters. They have done it all right, but unfortunately it shows. Smaller posters are viewed at closer range, and the use of very small originals still demonstrates the lack of crisp sharpness obtained from large formats. Perhaps the message of the poster is transmitted, but there is the matter of whether the advertising man is really involved with quality. If he is, he will want to use the tools of quality.

A point-of-sale poster for Howard Johnson, one of a series. Slight variations of the same illustrations were used on menus for the same purpose.
Photography by ALBERT GOMMI

Action, design, lighting all combine to do the things
posters are supposed to do: Catch the eye,
identify the product, and call for action—all requiring
but a quick glance from the viewer.
Photography by WILLIAM STETTNER

Photographic treatment of subject matter has
become the modern equivalent of the posters litho-
graphed from stone at the turn of the century.
They add interest to walls in offices, homes, and
college dormitories.
Photography by PAUL WELLER

The Call of the Wild

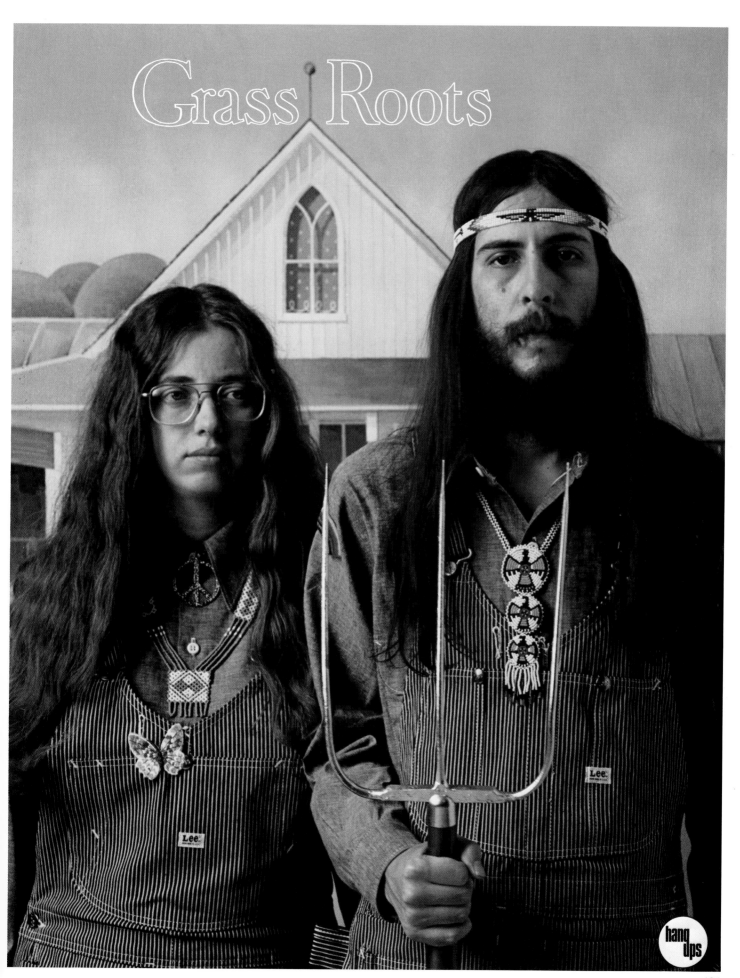

Grass Roots

hang ups

Getting it all Together

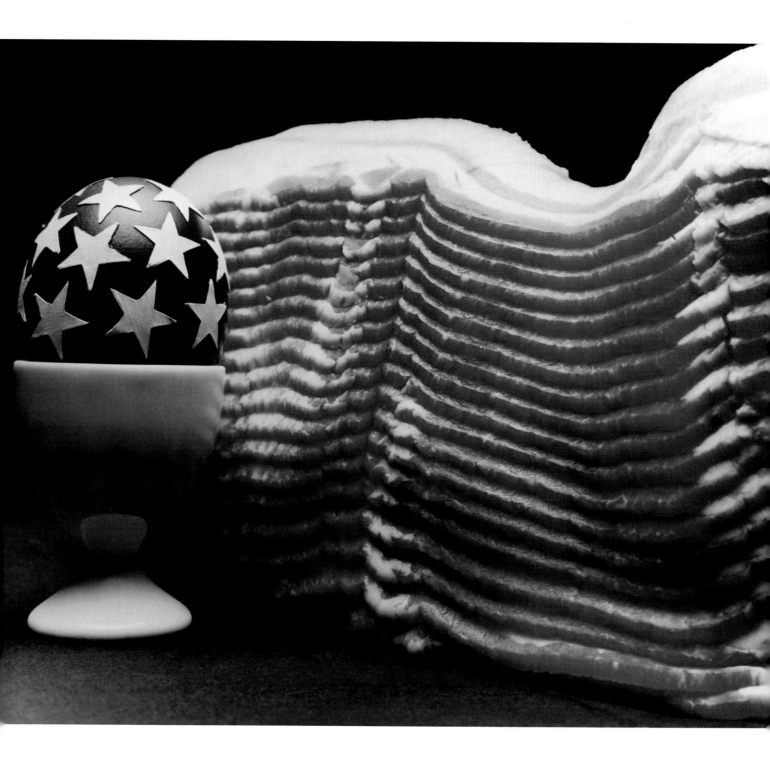

The poster at left was used for political purposes;
yet, without naming names, it remains an interesting
piece for the wall.
Photography by PAUL WELLER

The illustration above forms a clever poster,
although no other purposes are served but to amuse
and decorate.
Photography by ANTHONY CUTRONEO

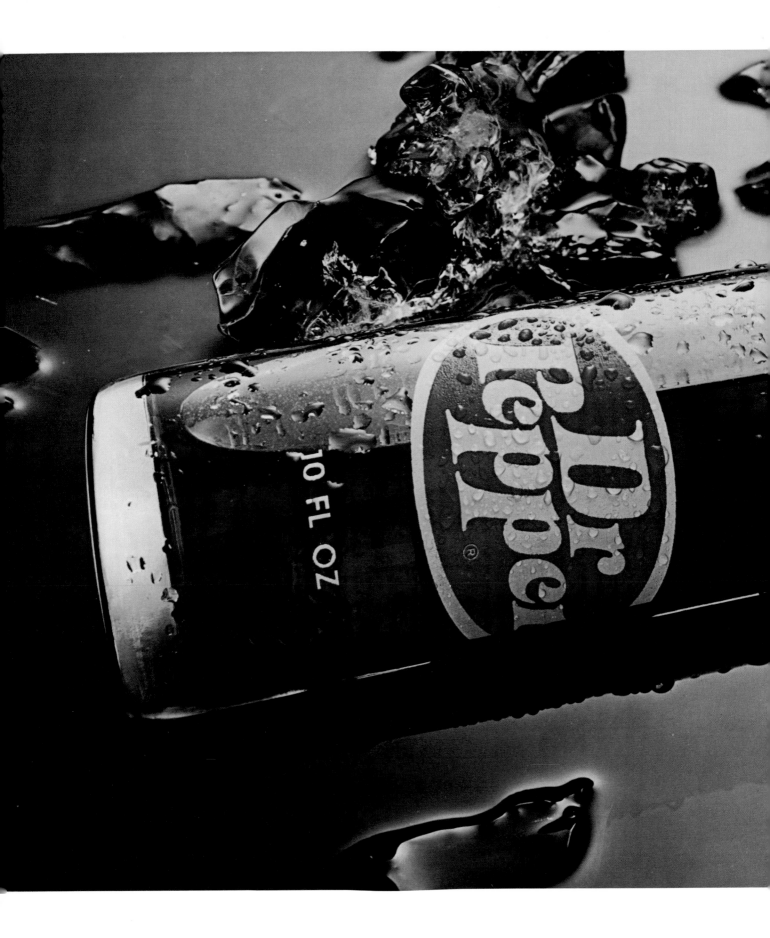

A 24-sheet poster must project its message quickly,
for often its effect is almost subliminal. A moderately
hot day is all that is needed to make this one
work to perfection. There is no need for words,
the picture is the message.

Photography by WILLIAM STETTNER

125

Book-stand Posters

Photography for
all book covers,
PAUL WELLER

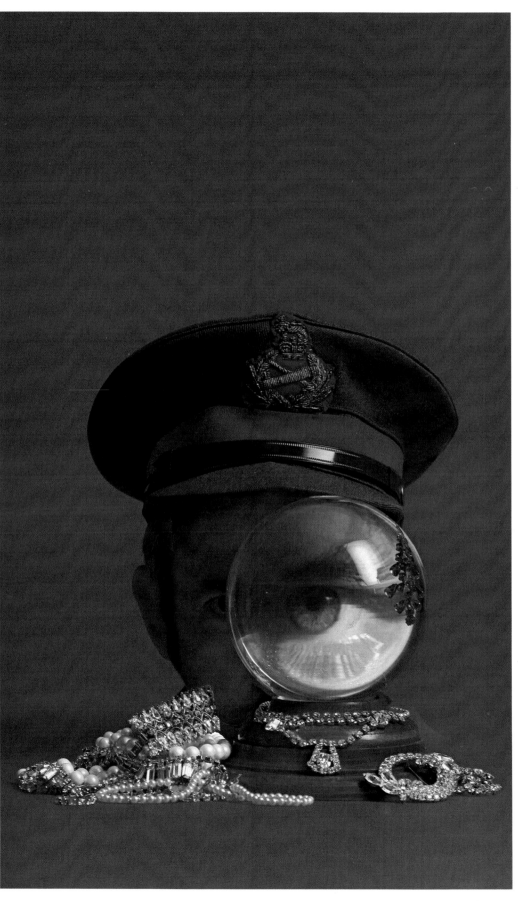

The book cover which fails to attract the eye covers a book which is going to stay in the store. Photography for such purposes, both paperback and hard cover, is really advertising illustration which at once stops the eye, intrigues the interest, and tells a story. Competition for attention on the book stand is tremendous and has resulted in a definitive proof that competition breeds quality.

Book covers rely heavily on symbolism for quick and concise storytelling.

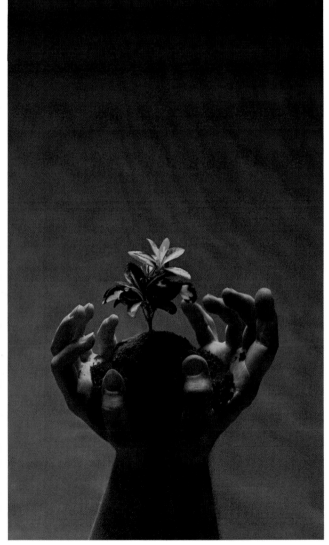

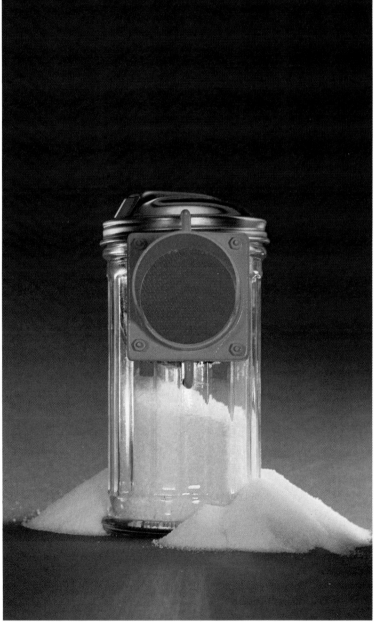

Photographs as Décor
A Spot of Beauty for the Business Environment

Not counting breakfast and the day off for the bad cold, most office people spend more waking hours at work than at home. Out in the suburbs or up in the apartment, there are pictures on every wall. But down at the office, the lucky ones may have a calendar which they largely don't need.

Things are improving. Somebody has been reading the dozens of articles and books about the relationship between environment and quality of work. Pictures are beginning to appear on office walls, beside the elevator, and just off the corner belonging to the water cooler. And too many hang unnoticed because they aren't worth noticing.

Photographs to hang on the wall are a little different from the illustration in a poster, or in an advertisement. Rather than shouting a quick message, photographs for the wall should release their content more slowly. The picture can be both more intense and more complex.

An attribute of art is its demand upon the viewer to do a little work. It lives because it is capable of inspiring a participation each time it is viewed. Where no such involvement is possible, a picture becomes a record, easily explored and quickly discarded—mentally by ignoring it if not physically by throwing it away.

The choice of photography to hang on the wall is as important as the decision to hang it. In general, the more abstract the pictures, the longer it will intrigue simply because it is more demanding. And further, something good is more likely to last than something currently popular. It follows that picture choosing is for those more artistically than politically inclined.

E. R. Squibb have decorated their offices and public places with dye transfer photographic prints in generous sizes. By selecting photographs of considerable artistic merit in the first place, they achieved a décor which reflects favorably on the corporate taste and enriches the lives of those who see them. These photographs will live as long as they last.

The photography was selected from the book *The Creation* by ERNST HAAS

The photograph on the next spread was one of those chosen.

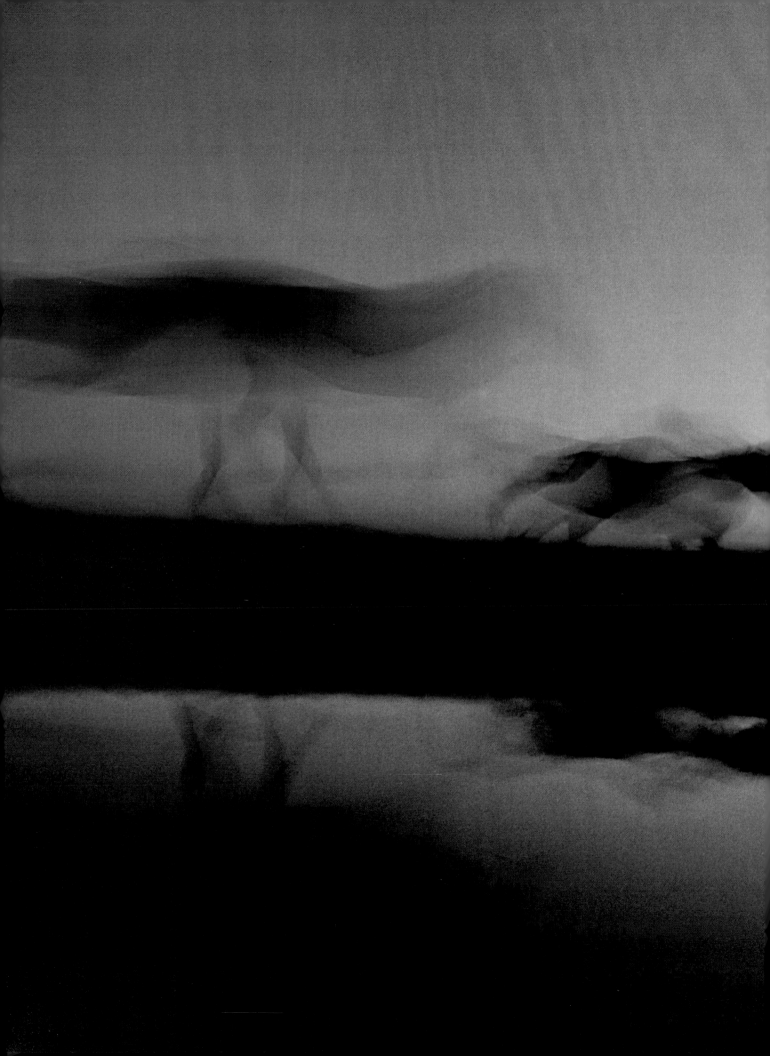

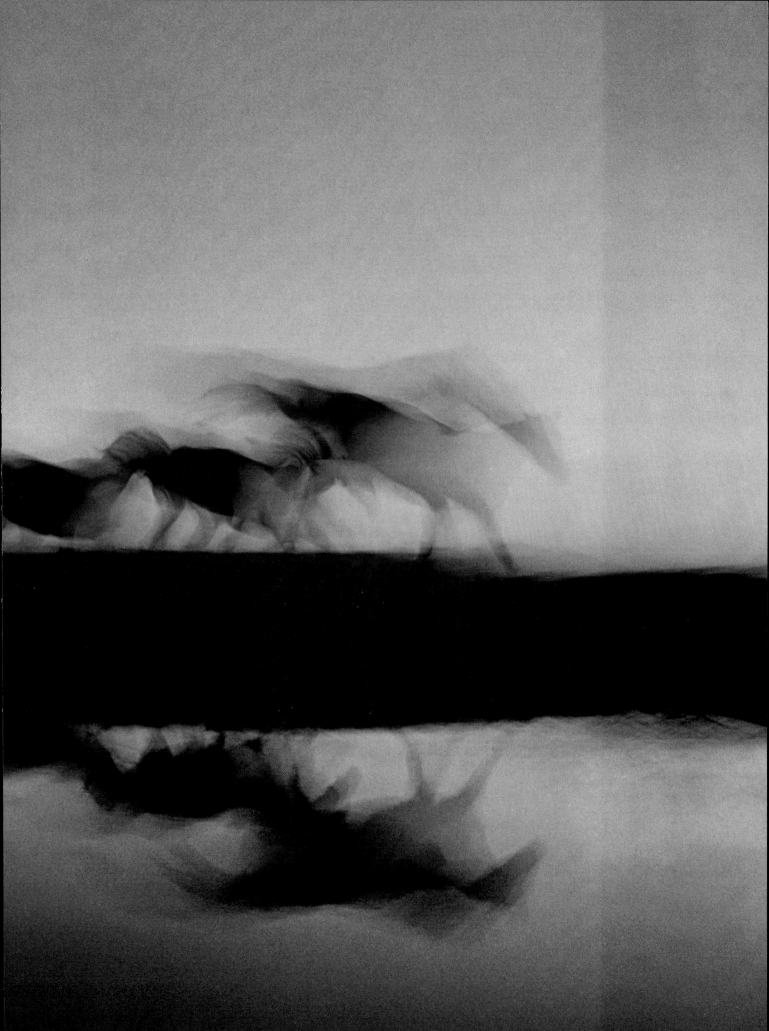

Those whose respect for photography as an art form lacks total enthusiasm claim that photography cannot be regarded as fine art because its images are too literal. There may be other reasons for this attitude, but this cannot be one of them. Photography can be as obtuse as desired, although that is hardly a desirable characteristic when the purpose is to communicate a selling idea. For pictures on a wall, however, highly abstract photographs can be decorative and intriguing. On the left is a close-up study of peeling paint, photographed literally but treated abstractly by JASON HAILEY.

On this page, the subject matter has been reduced to patterns of light itself—by HENRY RIES.

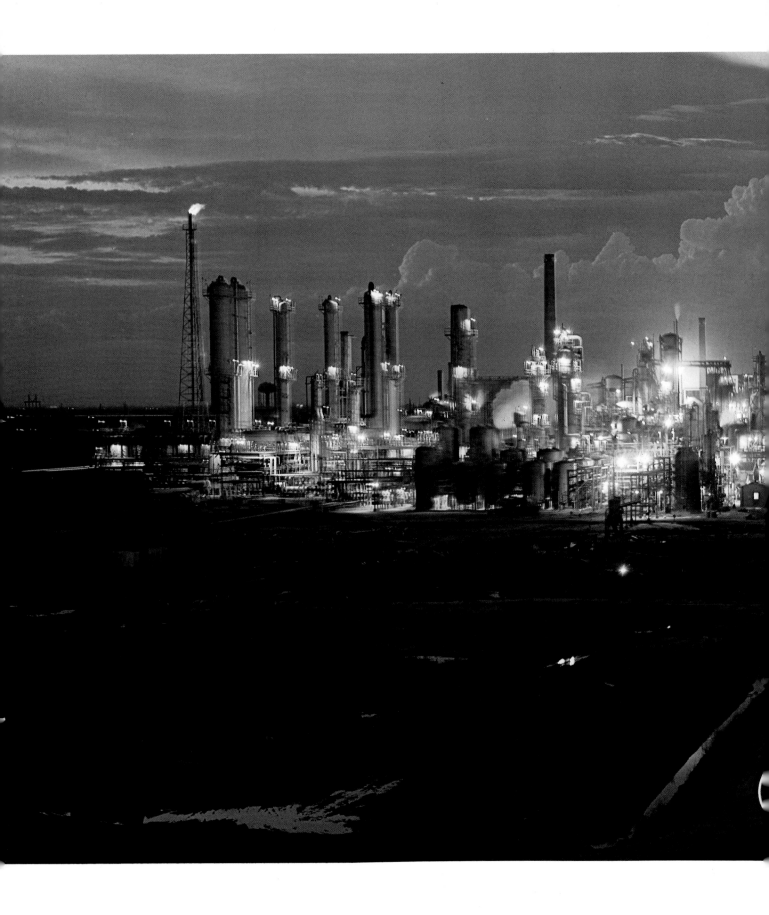

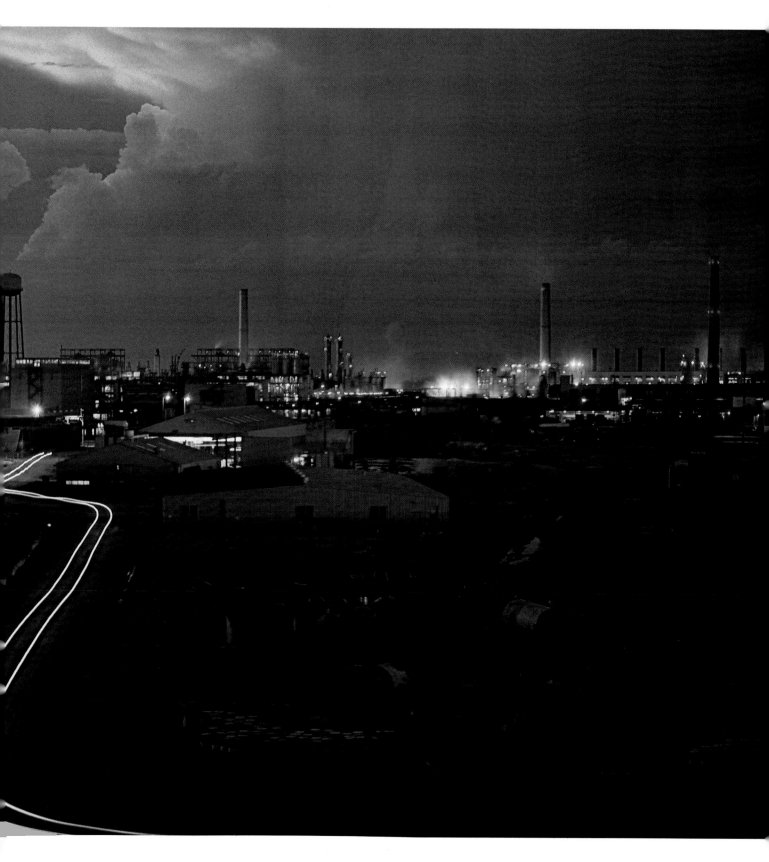

If there just has to be a photograph of the factory
in the lobby or on the president's wall, it would
seem desirable to at least make it an interesting one.
Nighttime, dawn, or sunset is almost always a
better time to lend enchantment to an otherwise
prosaic factory than in broad daylight with all
the scars and sores fully exposed.
Photography by ARTHUR d'ARAZIEN
for Union Carbide Corp.

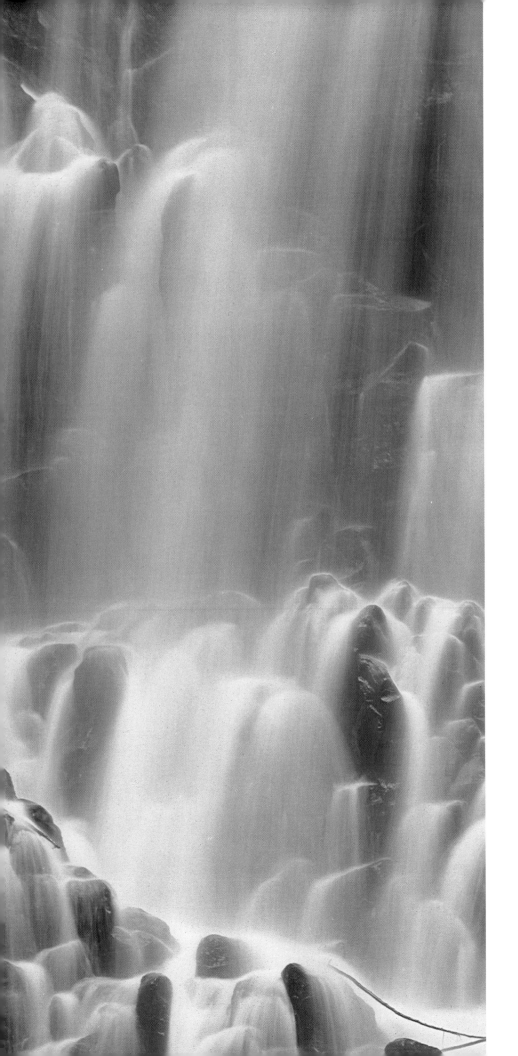

If one made a census of pictures languishing unheeded on the dreary walls of the world, he would discover a distressingly similar collection of enlarged picture postcards, pretty pictures of pretty places, recorded at high noon. When they were hung, they were as impressive to someone as the tinkle of a merry little tune. But without substance, they are soon investigated and allowed to die even as the eight-bar melody of a popular song.

There is much in nature to inspire the photographer, and an enormous opportunity exists to create pictures for the wall which will attract and delight for as long as people pass them. But nature is a spendthrift and needs an editor to select and interpret. A lasting impression of a scene is one which is abstracted from the whole and presented as a universal truth rather than a geological phenomenon.

The less literal, the less actual identity a picture of a natural subject possesses, the more apt it is to have lasting appeal. When one has seen Niagara Falls, he's seen it fall and that's it. But water falling to form more abstract shapes and tones will continue to intrigue. No one need ask where it is because it doesn't matter.

Photography on this and
facing page by DAVID MUENCH

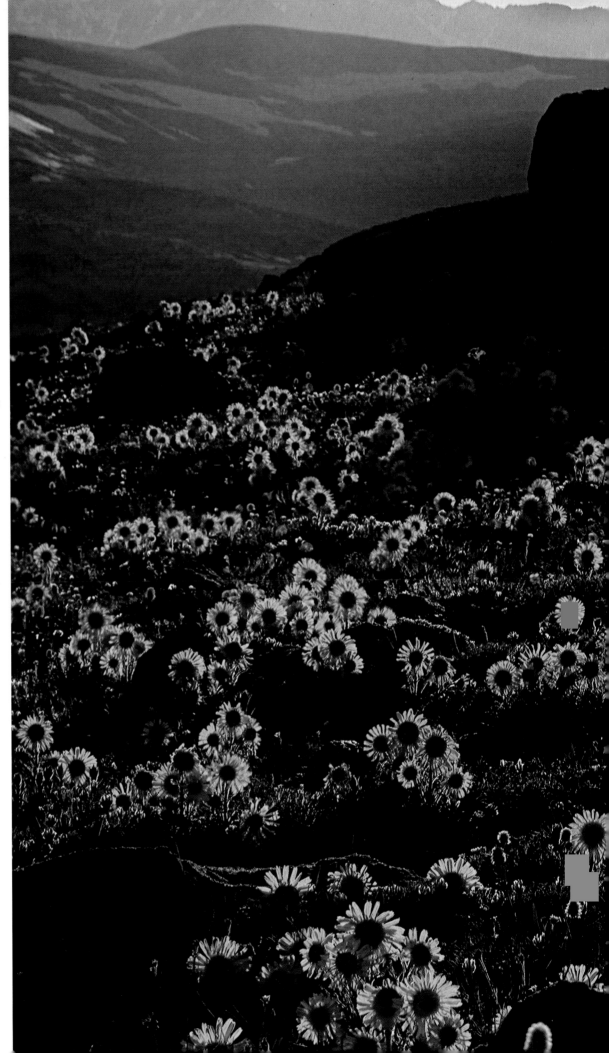

The time of day,
the direction of light,
the handling of tones
are all tools in the
photographer's effort
to create an effect
out of the raw
materials made
available by the
natural condition.
Pictures for walls
are worth their frames
and their space
when the combination
forming the whole
totals more than
its parts.
Photography by
DAVID MUENCH

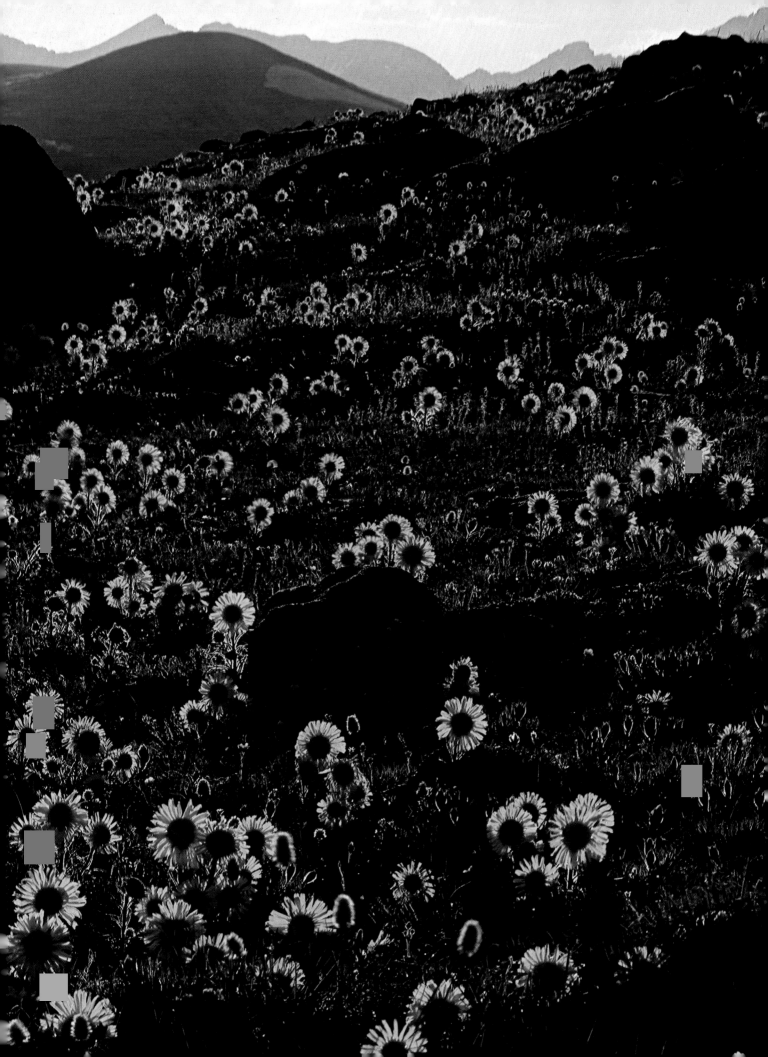

A Vocabulary of Photography

Cameras, Films, and Factors influencing the aesthetic
and technical qualities of photographic illustration

*It is, perhaps, time to define a variety of names
and terms which arise in any discussion of the
photographic image. No one would suggest
that the advertising manager or his agency col-
leagues should master the camera. However, a
small knowledge of its elements should be
helpful in making communications among pho-
tographers, agency people, and clients more
facile.*

In its younger days, the camera was classically
explained in terms of the human eye, with the
glass lens equated to its human counterpart,
and the film to the retina. However, in these
days of a camera in every household, things
have become turned around and the human
eye explained in terms of the camera.

The similarity is obvious, but alike they are
not. The eye is a sort of human scanner, zoom-
ing in and out of the scene in front of it, paus-
ing to focus on an object of interest, and pass-
ing on to the next. It sees sharply only when
mentally motivated to do so, and seeks out spe-
cific things on command. It can gather a soon-
to-be-forgotten glance at the whole, or study
at length a specific detail. But to see all there
is requires a series of studies, the integration of
which describes the whole in a memorable
manner.

The camera cannot do these things unless
directed by a human mind and manipulated by
human fingers. Even automatic mechanisms re-
quire the human touch in their adjustment.
Thus it is that the camera becomes a tool to
interpret the mind's information on how the
scene in front of it should appear. If this inter-
pretation is a literal one of actual shapes and
light values, photography becomes an exercise
in mechanics, and the photograph a record.

However, when the man behind the camera
adds a vision to his seeing, he places his own
imprint on reality. His picture becomes a per-
sonal message. While it is true that all pictures
tell a story, it is also true that worthwhile stories
are told only when triggered by worthwhile
thinking.

A photograph which simply records does not
serve to communicate anything new unless the
subject is absolutely unique. A snapshot of the
Grand Canyon which records its shape is unique
only the first time. Since the Grand Canyon has
long since been recorded for the first time, a
reason to photograph it must include a personal
statement by the photographer if there is to be
a viewer reaction.

Advertising people do not have a Grand
Canyon to illustrate, but they do have a product
which is new only once. It is the personal state-
ment added to the record of the product's
shape which makes the illustration effective.

To create additions to a mere record requires,
first, the vision of how the result is to appear,
and second, a camera with which to operate.

There are cameras in seemingly endless vari-
ety. For the purpose of this discussion, they will
be divided, unlike Gaul, into four classes.

Traditionally, the view camera is the profes-
sional's tool. It is a contrivance to hold a lens at
one end, a film holder at the other, and made
lighttight and flexible by a folding bellows. Its
lens-holding front and film-containing back are
made to pivot, swing, rise, and fall. Its skillful
use can correct diverging lines, or cause them to
diverge when they don't. Planes of sharpness
can be enhanced or decreased. There is control
of the image. And control is what the view
camera can do better than any other camera.
And in its usual largest size of 8 x 10, the quality
of the result will be unsurpassed.

*Since the word "quality" has been intro-
duced, it should be defined. And to do that,
one must decide what it is that is unique to
photography as a medium. The two attributes*

of photography unsurpassed by painting, etching, drawing, or any other graphic means is in its ability to render detail sharply, and to reproduce a wide range of tones in every portion of the scene, from the largest masses to the smallest. Other media can suggest both, but none can reproduce it. Therefore, technical quality in a photograph can be equated to the excellence of sharpness in that portion of the scene in which sharpness is desired, and the exquisite reproduction of tone ranging from detail in the darkest shadow to modeling in the brightest highlight. All of this accomplished without the interruption of continuity caused by graininess of the sensitized material.

It is not to be inferred that these technical characteristics are desirable in every illustration. For purposes of communicating an idea, it may be that none of them are wanted. But to define a beginning point, these are the criteria of technical excellence: sharpness, tone reproduction, and lack of grain in the image. There are other criteria such as density, color, and overall color and/or tonal balance. But these things are not unique to photography.

Since quality is thus defined, the image in terms of a full-page reproduction will be best when created in the 8 x 10 camera. Note that other and smaller cameras create images of equal or even superior quality in their size. But when enlarged to useful proportions, this is no longer true, for there is a grain in photographic films—if there were not, there would be no light sensitivity. The grain not only influences apparent sharpness, but also interferes with the flow of tone.

In general, this comment on quality refers more to color photography than to black-and-white. And there are many occasions which dictate the use of smaller cameras; and *their* advantages outweigh this consideration.

In addition to the control of the image made possible by the camera design, the large size of the image, plus the fact that the image is viewable on the ground glass in large size, makes tight compositions more accurate than is the case with other camera systems. This is of particular interest when type is to be surprinted in the picture area, or where several images are to be combined into one.

There is no one perfect way of doing everything. The 8 x 10 camera is fine for studio use, for architectural studies, for anything that stands still long enough to be fussed over. On the other hand, the camera is bulky, it requires a heavy tripod, and film must be loaded into individual holders. All this is a bother. Professionalism dictates that being bothersome is an insufficient reason for non-use. A more serious fault is the rigidity of thinking that the system encourages. One cannot follow action with such an outfit, nor may it be used in all of the more casual positions possible with more portable methods.

In summation, there is a place for the 8 x 10 view camera: when precise image control is needed; where precise subject placement in the image area is a must; where the subject is under control in a given area and the highest final quality is desired. The 8 x 10 is, physically and mentally, the most difficult system to employ, so why use it merely for quality? Perhaps a lower quality image might do as well? One uses the 8 x 10 for the same reason he uses the written word correctly—it is the professional thing to do. A company which confesses in print that it "ain't in business to do nothin'" isn't building a very lovely image.

The second camera system in professional use—by far, most frequently—is the so-called "press-type camera." It uses sheet films, usually 4 x 5, and can be either anchored to a tripod or held as a hand camera. In truth, this system is neither fish nor fowl, and offers little to the modern photographer and his client except size. The image is considerably larger than roll-film cameras produce, which makes it easier to view and judge. It offers a portability not possible with the 8 x 10. And it provides for ground-glass viewing when needed. If any of these attributes seem necessary for the illustration at hand, the photographer is apt to choose it.

Number three in this roundup of camera systems is the group using 120-size roll film, usually producing negatives and color transparencies 2¼″ x 2¼″ in size. It is in current high favor among illustrative photographers, and offers much help in the way of creative possibilities.

The uninitiated should not confuse the size of professional grade instruments in this system with price. Completely equipped, the photographer could have easily invested the cost of an excellent second home in his outfit. Precision is superb, and optical quality in the great variety of available lenses is of the highest. And because of this, photographs made with them are useful for most professional applications where

Continued on page 148

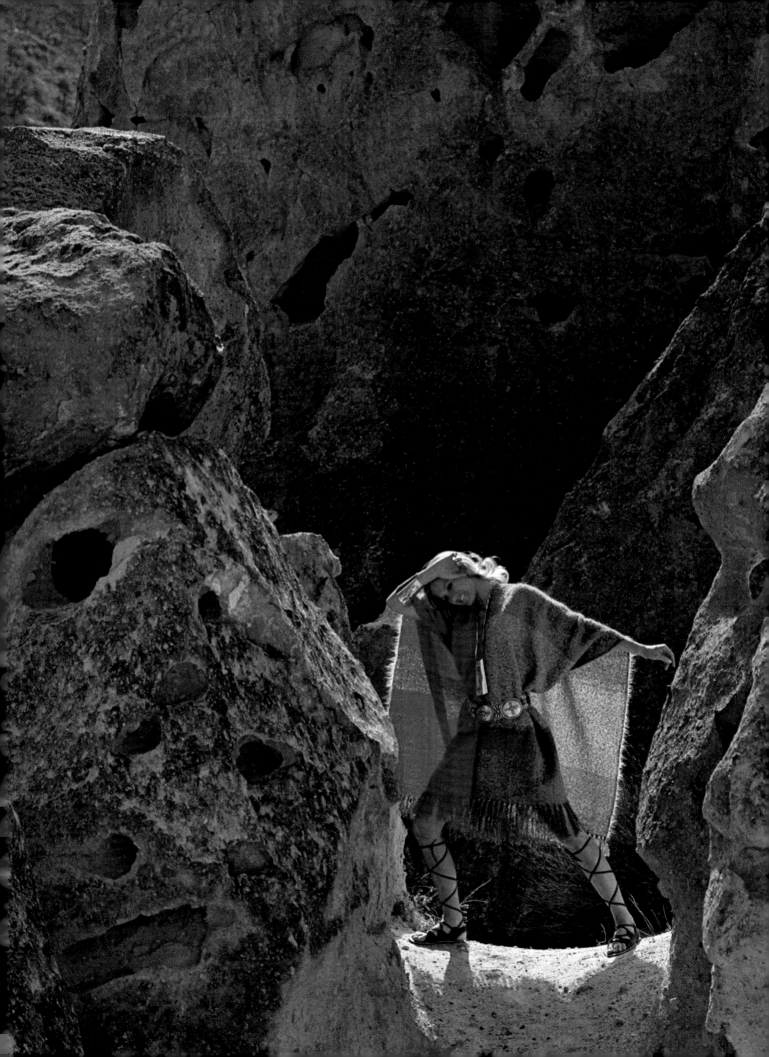

Within reasonable limits of the ultimate size of reproduction, the camera system chosen to execute an illustration should depend upon subject matter and the story being told. A 35mm camera format was used for the photograph on the facing page because its speed and simplicity in operation made it possible to capture rapidly changing poses and expressions. The full image was cropped to fit the page.

Photography by DICK KENT

The picture above was made in the 2¼-inch format with a single-lens reflex camera, and the full image is shown. The image is easy to study, and where tight compositions are to be carefully arranged, this type of equipment is convenient for location work.

The ultimate technical perfection in image quality is that delivered by a properly used 8 x 10 view camera. Where there is much fine detail, or where such quality is desired simply because the advertiser believes in doing everything in a quality way, the 8 x 10 is the indicated system.

However, there is such a thing as quality in content as well as quality technically. There may be occasions when a smaller camera tells the story better than a large one. This is particularly true when there are people or things that move in varying ways and combinations. Smaller camera systems may also be preferable where a feeling of spontaneity is desired. And finally, there are rare occasions when the traditional hallmarks of ultimate sharpness is not wanted because it actually interferes with the story.

Every subject matter has its ideal format and the accomplished photographer usually knows which is right. His counsel is preferable to a prejudiced and arbitrary decision based on a previous experience which may be quite different from the matter at hand.

This illustration on 8 x 10 for Owens-Corning-Fiberglas Corporation by VINCENT LISANTI

146

A Vocabulary of Photography

the 8 x 10 is not absolutely necessary.

The great advantage of the 2¼ camera is in its speed of use. One reason for choosing photography as a medium is its ability to catch the fleeting expression, the peak of the action—the exact moment. The professional is adept at focusing and composing rapidly with this type of camera. Because it can be hand held, and is not rigidly positioned, the photographer may move around his subject, creating many variations. And, of course, if models are part of the subject matter, they, too, can move around, thus encouraging the feeling of a natural condition.

The smaller the camera, the greater the depth of field for a given aperture; thus the smaller the camera, the faster the shutter speed for a given amount of available light. This, in turn, contributes to naturalness, since in moving around, the models do not need to freeze in a particular pose.

As previously noted, the smaller the color transparency the farther away one gets from the ideal perfect technical quality. Not because the camera systems produce lesser quality, but because a considerable degree of enlargement is necessary to make the transparency useful on the advertising or editorial page. The question arises: Is such a consideration a real one or simply a matter of definition, and therefore rather academic? In many cases, the difference is too small to be significant. Usually, it is the story in the illustration that counts, and anything which helps enhance the story probably outweighs other considerations.

There is simply no argument that roll-film cameras have opened up new avenues for illustration. Their mobility—in fact their very size—has made it possible to position a camera where the larger view types cannot even fit. They have so simplified the mechanics of camera positioning that a more precisely chosen viewpoint can be effected than is the case with view cameras. This is particularly so on location, for in the studio, things are made to happen in relation to the camera positioning, whereas on location the reverse is more often the case.

The roll-film camera encourages creative thought. If it were true that photography is merely a mechanical means of recording what is before it, then this statement loses its validity. But photography is a guided missile directed by a human, and very human things happen when the photographer is involved in his subject mat-

ter. As this human sees things evolve in front of his camera, his mind is encouraged to seek new directions. This may involve a slight or major change in position, a variation in lighting, a shift in the lens being used, or a rearrangement of subject matter. Whatever it is, it helps build the picture, step by step. The absence of mechanical limitations characteristic of the hand-held camera creates an atmosphere conducive to such a picture evolution. It is good for the photographer, and therefore good for his client.

If there is such an overwhelming enthusiasm for roll-film cameras, why consider the 8 x 10 at all? The reasons have already been mentioned. Where control of the image requires camera swings and tilts, there is no substitute. Where fine detail and textures must be rendered, particularly in color, the 8 x 10 does it best. Not that roll film can't render detail. The 8 x 10 merely does it better. And when many people must see and approve a color transparency, the 8 x 10 is easier to see. *See,* not look. All too often, important minutiae are overlooked in viewing a 2¼ x 2¼ transparency simply because of size. But the detail in an 8 x 10, being much larger, is more seeable. This is a human rather than technical consideration, but important because it is human. Size difference can be eliminated by making color prints from 2¼" images, about which, more later. Black-and-white images are always printed large in any case, so viewability considerations do not involve them.

The fourth system of professional photography centers around 35mm cameras. The best of these are very fine instruments and capable of creating a whole new world of images. They are even more portable than the roll-film cameras previously discussed. But more importantly, they are used at eye level. The photographer accustomed to using such an instrument can be seen snuggling his camera to his eye in a way suggestive of the thought that it has become part of him. Indeed, the 35mm camera has often been called an extension of the eye, for there is no spatial displacement between the eye and the camera. There is an intimacy between camera and photographer which shows up in the photograph.

The advantages of the roll-film camera are also the advantages of the 35mm one—only more so. It is the most portable of systems, the most mobile, and the easiest to use in a mechanical sense. It encourages creativity.

Its disadvantages are the same as roll film only much more so. The degree of enlargement necessary for reproductive usefulness is much greater than with any other system and, therefore, the quality of the printed page will be limited by the grain and resolution of the sensitized materials used, by the degree of unstopped motion in the subject matter, and by the accuracy of focus and stability of the camera during exposure. Some of these are human factors and theoretically controllable, and some are beyond control.

Again, however, the importance of the story in the picture can outweigh technical quality considerations. There is a place for the 35mm system in the illustrative world, a very large place. Particularly, it encourages the photographer to relate more closely to his subject matter. Where there is action, he can follow it better than with any other equipment. Where there are people involved, the camera becomes less intrusive. And because it is small and easily handled, it can go wherever the photographer's eye goes.

There is no best system of photography. There is only an optimum system for a particular photographic problem. Each way to a picture has its advantages, and each its disadvantages. One must know what he wants to say before he chooses his words.

If the full potential of photographic illustration is to be realized, the most important factor is to maximize the importance of the picture itself. Only a photograph is—only a photograph. A photographic illustration, on the other hand, is the result of a major occasion, and reflects the concern of those who need it and he who creates it. If the client knows what he wants to say, the photographer will know the words. The choice of tools should be his, predicated on the purpose, not on prejudice or whim or convenience, or even on price. For as the wise man said, quality lives on long after price is forgotten. *And since the cost of using a photographic illustration is many times greater than the cost of making it, cost consideration as a criterion for photographic method is without logic.*

Lenses and why there are so many

Closely linked to the ability of a photographer's particular camera to tell a story is the lens in it. If every published photograph were accompanied by a sound track telling the viewer where to look and what to see, there would be need for but a single lens, preferably one which included everything in front of the photographer's eye. This is, of course, not the end toward which photography has evolved.

The lens, first of all, controls the area of the scene to be photographed. One of normal focal length covers an area in the scene roughly the same as that viewed by the eye. As the focal length increases, the area viewed becomes smaller but the objects in that area are rendered larger than with the normal lens. As the focal length decreases, the area viewed becomes larger and all of the details in the scene are recorded in a smaller size than normal. Thus it can be said that longer-than-normal focal lengths magnify the center of the scene while shorter ones extend the edges of the coverage, but reduce sizes in doing so.

Scene coverage cannot, however, be predicated simply on the numerical expression for focal length. For this coverage is related to the film size of the camera, thus a lens of 50mm focal length is normal for a 35mm camera; but for normal coverage on a roll-film camera producing 2¼" x 2¼" images, an 80mm lens is required. And for an 8 x 10 view camera, one of 12" or 14" (360 to 420mm).

Lenses other than those thought of as normal are referred to as wide-angle lenses in shorter-than-normal lengths, and telephoto in longer. They are designed for specific formats, and usually cannot be interchanged from one camera system to another. In other words, a 50mm normal lens for 35mm cannot become a wide-angle for 2¼" roll cameras. Only a specially formulated 50mm lens can be used for wide-angle coverage on the latter.

Modern cameras are designed for quick and simple lens changing. One of their great virtues is the wide choice of really superb lenses available for the smaller cameras—from 20mm to 1000mm and longer for 35mm cameras, and from 40mm to 500mm for the 2¼" format (20mm for 35mm equates roughly with 40mm for 2¼). Additionally, special-purpose optics are available such as the "fish-eye" lens of about 7.5mm which creates a round picture on 35mm with a distorted coverage of 180°.

Thus, through choice of lens, the photographer can emphasize any portion of a scene by making it bigger and eliminating the unwanted, or by enlarging his angle of view and thereby covering more territory than the eye sees with

A Vocabulary of Photography

one glance. This function is performed by humans in a mental way in the former case, and by turning the head or shifting eyes in the latter.

Control of coverage area was the original reason for making such a wide range of lenses available. However, more appears to happen when a lens is changed than mere coverage. There is a change of emphasis which seems to change the perspective of object placement in the scene. If the photographer uses a focal length lens rather short for the camera format, he may include more extraneous matter than is needed to tell the story. The viewer's eye wanders around and the center of interest is diluted. When a longer lens is used, only the center part of the scene is recorded and there seems to be a change in the perspective. The change is merely psychological, for changing lenses does not change perspective.

However, the fact that different lenses yield different psychological effects is highly important. For with the capability of controlling the appearance of reality, the photographer can impress his own feeling for design and composition onto static objects. And when he combines this with his placement of nonstatic elements and such other variables which are under his control, he removes himself from a position of a recorder and becomes, instead, a creator.

Sharpness and depth, their presence or absence, is not only a matter of technical excellence; they, too, are creative tools and are helpful in the photographer's quest to tell the required story. Sometimes the blur of a moving subject helps carry a message of speed and action. Sometimes a slightly out-of-focus or diffused image conveys tranquility, mystery, and softness. The ability of the camera to deviate from the conventional helps account for its great scope.

The control of depth can be a tool of composition, for the eye is almost automatically directed to a photograph's point of maximum sharpness. By focusing in an intelligent manner, objects near or far, or both, can be subdued so that they act as a foil to the principal subject. In color photography, such out-of-focus areas can further enhance the picture by becoming masses of soft color. In black-and-white, tones of grey serve the same purpose.

Interestingly enough, the great depth of the small camera sometimes can be a hindrance where a very shallow depth of field acts in a positive manner in making a pictorial state-

ment. So once again it is obvious that no one way is the right way all of the time.

Sharpness is usually equated to excellence, and for good reason. The ability to render line and texture in a wire-sharp manner is one of photography's unique characteristics. The sharpness of an image in the size for which its camera was designed is a function of the lens and of the film—theoretically. In practice, it obviously depends upon the care with which the lens was focused and whether or not the camera holds the film in a proper and flat plane.

Again theoretically, a lens forms a sharp image of only the point in the scene on which it is focused. Objects in front of that point will become increasingly unsharp as they approach the lens, and objects in back of the point will do likewise. However, some of this unsharpness is too minute to be seen by the eye in the finished photograph, so that points both in back of and in front of the focus point will appear to be sharp. The distance between such a near and far point is known as the depth of field. Interestingly enough, the distance between the near point and the object being focused upon will be less than the distance behind it.

The depth of field of a lens depends upon its focal length and the f/stop or aperture opening at which it is set. The shorter the focal length, the greater the depth for a given f/stop. And the smaller the aperture (as indicated by the larger the numerical value of the f/stop), the greater the depth for a given focal length. Thus the possibilities for great areas of the scene to be sharp, both near and far, become greater as the camera becomes smaller because normal coverage, for example, requires a shorter focal length lens with a small camera than with a big camera.

Here, then, is a great triumph for the 2¼" roll-film camera over the 8 x 10. And for the 35mm over the 2¼. To explain: correct exposure is the product of the amount of light striking the film and the length of time it acts. The amount is controlled by the aperture (or f/stop) and the duration of the shutter speed. For a given film sensitivity, correct exposure is the same, irrespective of size and shape of the camera. For a given light condition, correct exposure for a sheet of 8 x 10 film might be expressed by the values of 1/25th of a second at f/8. A roll of 35mm film of the same speed will require the same correct exposure, and therefore the same values.

Continued on page 158

The usual purpose of a wide-angle lens is to cover a greater scene area from a given viewpoint than that recorded by what convention has defined as a normal. While its angle of view is most precisely expressed in degrees, its potential coverage is more apt to be intimated by its focal length. For example, this photograph was made with a 40mm lens fitted to a 2¼ x 2¼ format camera. The normal focal length in this size is regarded as being 80mm.

An alternative to a wide-angle lens is to increase the distance from camera to subject. But often,

as was the case here, there are physical limitations to the choice of distance. Lens of shorter focal lengths have a greater depth of field—or range through which objects are sharp—than longer ones at equivalent camera positions. In this picture, the great depth of field made it possible to show objects large and sharp in the foreground. The objects were large relative to other objects because they were close to the camera, not because of the wide-angle lens.

The photographic illustrator can take advantage of the ability of the wide-angle lens to bring relatively near and far objects into sharp focus to lend emphasis and size to a principal subject. In doing so, he can include a considerable area of background and still have his subject quite large. A longer focal length lens would also give him the choice of a large subject, but its narrower angle of view would reduce his background coverage.

On the facing page the salad which obviously is the principal subject is quite large because it is close to the lens, but a 40mm lens on a 2¼ format includes considerable background area for atmosphere.

Photography by EDGAR deEVIA

Above, the treatment of the scene with a 40mm lens on a 2¼ format brought both near model and background into sufficient sharpness for an effective treatment.

Photography by CHARLES COLLUM

Telephoto lenses are those whose focal lengths are considerably greater than the normal camera lens. They narrow the viewing angle and enlarge a part of the scene covered by the normal lens to fill the total film size. This enables the photographer to make larger images of distant objects without excessive enlargement of the negative.

When making the picture on the opposite page, water separated the photographer from his subject matter. A normal lens would have yielded a small image of the birds, yet he was unable to get close enough to make them bigger. A 250mm lens on a 2¼-inch format made this section of the scene larger with this result. The picture is cropped only on the sides to fit the page.

Above is a scene photographed in one case with a normal lens, and in the other, with one of longer focal length. The longer lens seems to "stack" the fences, making them appear to recede less quickly. But it really hasn't. If the viewer crops the picture on the left so that only the area shown by the other remains, he will find the picture is the same except for size.

Perspective does not change when the photographer changes lenses. Only the scene area covered by the camera changes; the shorter the lens, the greater the area. The image size of objects will change, however. The longer the focal length, the larger the image size of a given object.

Thus it will be seen that the photographer has the choice of including a lot of coverage with objects in the viewing area recorded comparatively small, or he can narrow his coverage with the objects in the viewing area recorded comparatively large. All this assuming that the camera position is the same.

He must take advantage of these facts, for it is always imperative that all of the film area be used for the subject at hand. Not to do so is to lose the optimum quality of which the format is capable. There is no point in using a large camera if much of the picture is cropped away and the remainder greatly enlarged. Perhaps one of the greatest faults of the 35mm system arises from this cropping and enlargement. The 35mm image is small; all of its diminutive dimension must be used for best quality. This means proper choice of lenses in the first place.

Photographed in the 2¼-inch format with a 50mm or wide-angle lens.

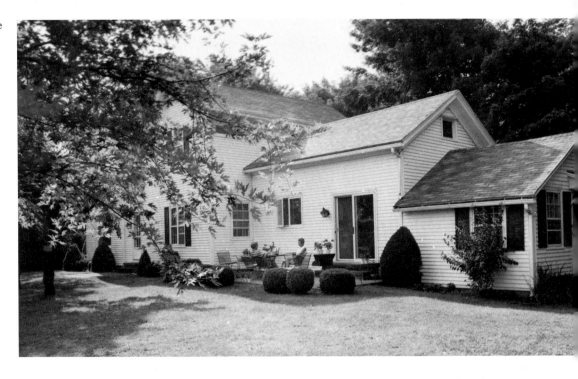

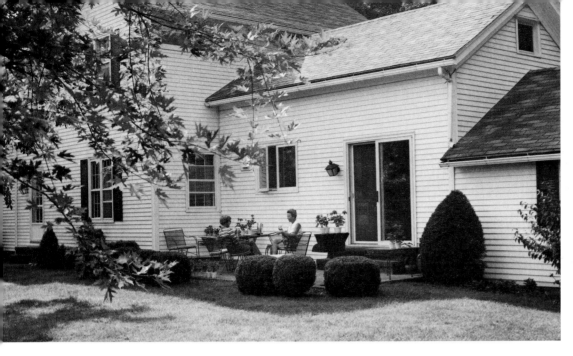

Photographed in the
2¼-inch format
with an 80mm
or normal lens.

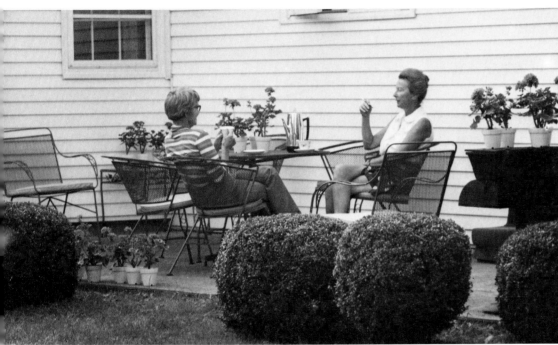

Photographed in the
2¼-inch format
with a 250mm
or telephoto lens.

A portion of the image
formed by the 50mm lens
enlarged to match
that of the 250mm lens.
The great enlargement
has degraded the quality,
but the perspective
is identical.

A Vocabulary of Photography

As far as exposing the film, size has no bearing. However, that 8 x 10 used a 12" (or 420mm) lens to cover essentially the same area as a 50mm lens on the 35mm camera. A 50mm lens has a much greater depth of field than a 420mm one; therefore, the overall sharpness of the 35mm will be greater—and if this is important, the picture will be better. The 8 x 10 can achieve the same depth as the 35mm, but the smaller aperture needed to accomplish this will require a longer time during exposure. If there is no motion in the scene, fine. If there is, moving objects will be blurred.

Because of the greater depth at a given f/stop for shorter lenses, the small camera can operate at higher shutter speeds and more easily stop motion in a particular light condition.

Correct exposure is effected by a wide combination of shutter speed-f/stops, the only requirement being that the product of the two be always the same. For example, if 1/25th of a second at f/8 is correct, 1/50th of a second at f/5.6 will also be correct, since the aperture marked f/5.6 admits twice the amount of light as the one marked f/8. Just so, an aperture of f/4 represents twice the light of f/5.6 and therefore the speed may be 1/100th of a second.

Film and other decisions

One would think that the photographer's choice of film would be no affair of his client's. And true it is. However, the choice of film affects the final result both artistically and in the way of quality as it has been defined. Just as it is helpful to the advertising manager or art director to understand the reasonings of camera choice, so, it is believed, would information on films.

The professional looks to black-and-white film for good tonal separation, fine grain, high speed, and high resolution so that his photographs will be as sharp as the rest of the system will permit. He cannot have them all in superlatives. For example, he cannot have highest speed and finest grain. The two work against each other in film design. Usually he chooses a workable middle ground where the film speed is fast enough for practical purposes and a grain size appropriate to the format.

There is a wide choice from which to choose. Some are "sharpest," some "fastest," some "finest grain," some "best tone reproduction." Almost all black-and-white films meant for camera use have enough of all these characteristics so that the photographer's client undoubtedly does not know nor care about the negative which produced his print. Mention is made of black-and-white to indicate that there is an intelligent choice necessary here, as in all of photography.

Color photography is a different matter. For in the case of color transparencies, the camera film is also the delivered product. And in the case of color negatives, a prior commitment by the client must usually be made for the making of color prints or enlarged color transparencies.

There is considerable confusion among the users of color photography about films, processes, and methods of producing color images. It might be helpful to describe and evaluate them all. Consider those films which result in color transparencies, hereby labeled color positive materials, and starting with the biggest first. Names shall be named for clarity.

For the 8 x 10 and other view cameras, Kodak Ektachrome Sheet Film has become a standard. It is color balanced both for tungsten light (the spotlights and floods of the studio) and for daylight in its two versions. Daylight film is also used for electronic flash illumination, or where window light is to be balanced by blue flash as exemplified by the room settings of the architectural photographers. It is of moderate speed, with good color reproduction, resolution, and grain characteristics. Its color balance will not always be exactly the same from one batch to another, for it is made to tolerances which make its distribution feasible. Most careful workers make tests to be certain of their starting points. Clients should know that some work has been done on their color photograph before they even knew they needed it.

A great advantage of an Ektachrome transparency is its readiness for photomechanical reproduction. After processing, there it is, to be judged, approved, and ready to go. And in the camera, it is subject to the control of the photographer, holding its pleasing quality when purposely overexposed for delicate high-key effects; and conversely, retaining its usefulness on underexposure to increase color saturation and simulate the effects of low-key. When handled in a normal manner, its reproduction of color is professionally excellent.

Correct exposure of color positive material is quite critical. A small deviation from normal,

not at all of concern in black-and-white, can change the appearance of the transparency considerably. Too much exposure and the transparency may be too light, the color unsaturated, the highlights burnt out to clear film. Too little and the shadow areas lack detail and the colors elsewhere are oversaturated. For this reason, the photographer usually computes his exposure with great care, and then exposes his film in groups of three, one as calculated, one with little more exposure, the third with a little less. This is not only insurance, it also provides a choice. Usually all will be useable, but the overall density of one may prove to be more pleasing than another. The differences are subtle but present, nonetheless. And the exact choice is a fine thing to have, one of the bonuses offered by photography.

Kodak Ektachrome Film is also available for 2¼" roll-film cameras and for 35mm. Additionally, there are two high-speed versions available, one for daylight, the other for tungsten. The grain size is a bit larger in the high-speed films as compared to the regular material, but they are over twice as fast and make color photography possible under low-light conditions. Some increase in grain is a small price to pay for a picture where otherwise there would be nothing.

The favorite of professional users of 35mm cameras is Kodachrome II Film, a material equally popular with amateurs. The final image of a Kodachrome transparency is made up of dyes instead of silver. It is therefore remarkably fine grained and its resolution is of a higher order than other color materials. Its only drawback is speed of processing, since equipment for processing is complex and not as quickly available as that for Ektachrome Film; processing requires a lapsed time of days instead of hours. Other than that, it is an ideal 35mm material. Some photographers choose Ektachrome instead of Kodachrome Film because its balance is different. A matter of taste.

Color negative films represent a wholly different situation, for the camera material is not the finished picture. Rather, it is an intermediate step just as with black-and-white. It has the advantages and disadvantages of a black-and-white negative-positive method; additionally, it has advantages and disadvantages of its own because it is color.

The camera material for view cameras is furnished as Kodak Ektacolor Professional Film,

Type S, and Kodak Ektacolor Professional Film, Type L. The former is designed for short exposures of 1/10th of a second or less, and the latter for longer time exposures. Note nothing has been mentioned about light balance. Because an additional printing step is necessary to produce the positive color image, exact color balance is postponed until that time.

The Type S material is also available for 2¼" roll-film cameras and for 35mm. In addition, Kodacolor-X Film is available in these two sizes. Kodacolor-X Film is also a color negative material and differs from Kodak Ektacolor Films in that it is not quite as fast in speed, and is designed for a tolerance for a longer interval between exposure and processing. Kodacolor-X Film is the familiar material offered for amateur snapshots; but such a label should cause no inference of any unprofessional capabilities. Where photography is to be performed on location with a considerable period of time anticipated before processing, Kodacolor-X Film is suggested.

Why use color negative materials at all? Why not make the transparency and be done with it? If all that is required is a transparency reproducing what was created in front of the camera, that's a pretty good idea—use color positive materials. But if the advantages of color prints and the control in printing them are of interest, then the negative-positive way should be seriously considered.

It is well known that in the making of black-and-white prints, part of the picture area can be made darker by manipulating masks in front of the enlarging lens. Just so portions can be made lighter. Obviously, just a part of an image can be enlarged to make the whole. All of these things can be done with a color negative. In addition, the color balance of the print can be controlled, in whole or in part, at this point. These are in the photographer's province. The important clue for the art director or advertising manager is in the word "enlarge."

All of the virtues attributed to the 2¼" x 2¼" cameras are true, but alas the result of a color transparency made in one is 2¼" x 2¼". This is small. Projection systems for throwing the image on a screen are not generally available, and even if they were, it would be difficult to set up a projector for every step in the communication ladder of photographer-agency-client. This does not make for an impossible situation. It can be lived with. It has been lived with.

A Vocabulary of Photography

But how much better to have a 16 x 20 print to examine. It is there in front of one, on paper, the way it will be seen when printed! And if retouching is necessary, a large print is a fine surface on which to do it. Prints can also be used for comprehensives and for decoration after the advertisement or brochure is printed.

The advertising business is communications, yet one of the difficulties in the advertising business is communicating within itself. In this it is not unique. But large color prints versus small color transparencies—no contest.

If, for some reason, color prints are not wanted, the negative-positive way to color can produce the "print" in the form of an enlarged color transparency. This end result is of particular validity when photomechanical reproduction is to include scanning for color separations. With the transparency material used for the final image instead of color paper, the effect is that of making 8 x 10 transparencies in a 2¼" roll-film camera. A fine miracle.

There are apparent disadvantages to this way to color. The obvious one is the time and expense of making the print. At least an extra day must be allowed, and in most cases, more. The film must be processed, color proofs made, one or more frames chosen, and finally the print made. It is true that there is a time element, but it would also seem that the security and assurance of having an illustration is also of value, perhaps more than equal to a day or two.

A second means of producing a print involves the use of a color transparency as an original. This method, the Kodak Dye Transfer Process, has been around for quite a long time, and its practitioners work to the highest standards. Dye Transfer prints are superb for every print requirement and have the happy advantage of being possible even though a color negative was not made originally.

Means of control have been worked out by color print houses which produce Dye Transfer prints of most impressive beauty. Just because the process has been available for more than 20 years does not make it antiquated. On the contrary, the time has contributed to quality. There are no disadvantages to the Dye Transfer Process except the same as those inherent in any color print method—time and expense. And in this particular case, more of both.

This quick review of some of the many variables, controls, physical laws, and possibilities of photography certainly cannot be construed as instruction toward a reader becoming a photographer. However, it is hoped that when a photographer shows up with a little camera with 25 lbs. of lenses and two cases of extra equipment—all to expose a little piece of film—he is not doing it to be funny. Nor is the man who still hides his head under a black cloth in the back of a big box with a bellows trying to hide his shame at being old-fashioned. There is a place for both, and often the same man will be both, although at different times.

Light and Lighting

Photography depends upon light for its very existence. Very early in its history, it was described as being the Pencil of Light. Obviously, light is of more than passing interest.

The photographer must be concerned with the quantity of light, with its direction, with its quality, and when photographing in color, its color. And when there is more than one light source, he must ascertain their relative intensities or balance.

Light quantity matters because correct exposure of the film depends upon it. The controls of exposure are the lens aperture controlling light quantity, which is calibrated in numerical f/stops, and shutter speeds controlling duration, expressed as seconds or fractions. The product of the two is the exposure given the film, and this product will be the same for a given scene light intensity whether a fast or slow shutter speed is used because the aperture must be changed inversely to match.

The choice of the shutter speed-f/stop combination depends upon subject matter and what the photographer wishes to do with it. Where he wants a maximum depth of field; that is, where he wants both near and far objects to be as sharp as possible, he will choose a small aperture, or f/stop. For the smaller the aperture, the greater the depth for the situation at hand. Thus, his choice of f/stop will determine the duration of exposure which will usually be relatively long; i.e., a slow shutter speed.

On the other hand, there may be action in the scene which he wishes to stop by using a very short exposure duration; i.e., a fast shutter speed. In this event, his shutter speed will determine the f/stop which in this case will be one indicative of a wide aperture. When he needs to stop action with a fast shutter speed and at the same time wishes a great depth of field, he's in trouble.

The direction of the light concerns the photographer because how the shape of an object is recorded depends upon how light falls on it. If the object is round and all of the light falls on it from directly in front of it, it will appear flat. There must be tone gradations on a round object if it is to appear round, and such gradations occur only when the light falling on it is other than 90 degrees. Both horizontal and vertical angles of light falling on subject matter influence the ultimate illustration; and, obviously, both are significant only as related to the camera position. Lighting controls apparent texture and shape of objects as well as affecting the mood and drama of the scene.

The quality of light concerns the photographer because variations among light sources ranging from crisp, hard shadow-causing light such as sunlight in clear air and studio spotlights, to the soft, diffuse light of cloudy days will yield different photographic effects. And it is necessary to either choose a lighting condition to suit the subject matter or alter an existing condition to fit the need. Just any old light will not serve every purpose.

And finally, not all light is of the same color. Since color film can be balanced for one defined light source only, the photographer must recognize the color characteristics of his light, and either accept it or change the film balance by the use of color compensating filters.

There are many light sources used in photography, the most obvious ones being daylight and sunlight which are not the same thing. In the studio, there are incandescent lamps called spotlights which throw a narrow beam of sharp shadow-causing light, and there are floodlamps where the result is a broad beam and a softer type of light. Indirect lighting sources yield light of a still softer quality.

Flashbulbs and strobe lighting units give the photographer still greater facility in matching the illumination to the task at hand. Anything which casts light can be a photographic light source—candles, kerosene lamps, automobile headlamps, or the moon. The ability to use light to create a photograph which will stop the eye, set the mood, and put the subject matter on a stance of best foot forward requires much study, experimentation, and observation. When the shutter clicks, things are not as simple as they seem, or as one might hope.

The ratio between the brightnesses of the brightest highlight and darkest shadow is a measure of scene contrast. There is a finite limit to such a ratio which a piece of film can record, and this film capability is less than the possibilities in both nature and in the studio.

In the studio this scene brightness ratio can be controlled by the way in which lights are used. The photographer can also control his scene range or brightness ratio out of doors where the subject matter is small enough to be shielded with diffusion screens, and the shadow areas brightened with reflectors.

But when the subject matter is a large area such as in the illustration at right, a good presentation requires the soft light of a cloudy day to reduce the scene range to film capability. Note the result on a sunny day in the small picture below. Here the scene range is excessive for good representation. At right, the scene was photographed on a cloudy day when the soft lighting characteristic of such conditions kept the scene range within photographic possibilities.

Color and Light

All things depend upon light for their color. And since the color components of light and their ratios vary with the light source, the color of things is not always the same. Colors can be defined, but their visual effect is finite only when the light by which they are viewed is also defined. It follows that photographic rendition of any color will also vary with the light source by which it is illuminated.

Artificial light sources used by the photographer range from the incandescent lamps meant for household lighting which are comparatively red, to electronic flash, or strobe, which is comparatively blue. Between these extremes are lamps designed for photographic studio use. Natural light varies all day long. Sunlight is red in the morning and evening, bluer at noon. The daylight of a cloudy day is blue compared to sunlight, as is the light in shadow areas even on sunny days, since the shadow areas are lighted by skylight.

The photographer refers to reddish light as being warm, and bluish light as cold. And his reasoning becomes obvious when one notes that there is that sort of emotional reaction to the color of light. Thus, photographs are also referred to as being warm or cold. Witness the warmth of a sunset or the coolness of a scene set completely in shadow.

To gain order out of what would otherwise be chaos, photographic color film is balanced for either daylight or tungsten. The former will yield colors normal, for all practical purposes, in the middle portion of a sunny day, and the latter with the electric lamps designed for photography. Light can be adjusted to this definition of normal by using filters over the lens. Light can be readjusted by filters to change normal light to another balance. The light source can be altered with color gels, which are essentially filters, to change the color of the scene. And light sources of other than normal composition can be used purposely for their effect. Light is a mighty tool.

The light directed at a portion of this scene was altered by using blue gels over the lamps, while the center of interest was lighted normally. Thus the photographer painted his scene with the color of his choice.
Photography by ARTHUR d'ARAZIEN
for Carrier Corporation

The illustration on this page is blue and cold because the subject matter was positioned in a shady area where the illumination was skylight. In short, the picture is blue because the scene was blue.
Photography by ALBERT GOMMI

The sunrise illustration, on the other hand, is reddish yellow and warm because the sunlight was reddish yellow at that early morning hour. Both were photographed with natural light, but the light was different on each occasion.
Photography by CHARLES COLLUM

Here are two photographs made during a time interval of twenty minutes. While the sun shone, the light was warm. But when the sun dropped behind a mountain, the scene was then lighted by skylight only and resulted in a much colder picture. The color of objects depends upon the color of light.

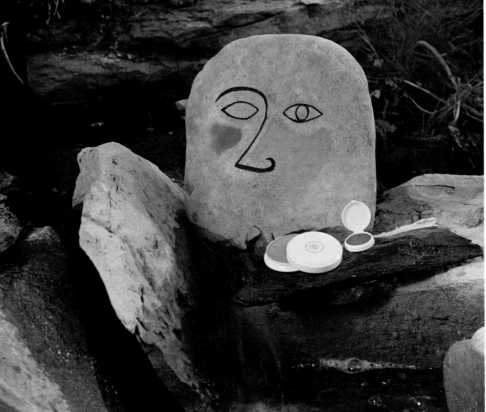

The facing page is illustrative of a scene, half warm, half cold. The late afternoon light of the sun is warmer than normal; therefore, the objects it illuminates are also warmer than normal. The shaded portion of the scene is lighted only by skylight and the objects therein are colder than normal. Both portions of the scene are the way they are in the scene.

Photography by CHARLES COLLUM

These two illustrations were made with identical lighting, and their color was identical to the eye in each case. But different color filters were used over the lens, thus changing the light as it entered the camera. Very subtle or drastic changes can be made at the photographer's option.
Photography by ARTHUR d'ARAZIEN for Carrier Corporation

Special Effects

The photographic image can be tortured, twisted, and altered to the point where the subject is no longer recognizable. Such efforts are sometimes labeled as being creative, probably because there is nothing else to call them. This might be fun, but it is not communication.

However, this is not to say that there are not many valid approaches to an illustrative problem other than a straightforward one. For example, there is the two-for-one proposition through double exposure. Control of the two images may well result in a story not possible by usual techniques. Special lenses can produce multiple images; even magnifying glasses used in place of the normal lens can result in strange, and occasionally valid, effects.

Color film of the incorrect balance for the conditions can help emphasize a point, while special films such as infrared-sensitive materials can further remove the image from reality. Color filters can convert a scene to something violently different from that expected, while a whole family of special effects can result by photographing images in reflective surfaces such as mirrors.

Illusions of speed can be created by using a slow shutter and a moving subject, thus blurring the subject; or the camera can be panned to follow the moving subject, thus blurring the background and retaining sharpness in the subject. Other techniques also exist.

In the darkroom a new world of altered images becomes possible. The image may be converted to lines, textures can be added, the grain of the film enhanced, and images combined from two or more separate films, and colors changed to anything desired.

The combination of images may be of particular interest, since backgrounds already available can contribute an atmosphere to the subject matter currently being photographed. Such combinations also may be effected by projecting the background and using the image as the studio set. In either case, two pictures separated in their making by both time and place can form a single unit.

There are dozens of possibilities both in the camera and in the darkroom, and several techniques can be combined to create still further variations. When such special effects further the story and enhance the purposes of the picture, they are helpful in extending the versatility of the medium.

Special effects are of great assistance in telling some stories, particularly where more than a single moment is to be depicted. But a brilliant piece of technical trickery should not be condoned as a substitute for a sound illustrative idea. If the picture is to convey a point, there must first be a point to be conveyed. The ingenious trick may catch the eye; but if it does nothing more, it can fail in its total purpose.

In making the photograph below, the edges of the image were diffused with a mask placed before the lens. The mask had a hole in the center, thus retaining sharpness in that part of the picture. Colored masks could have been used instead, thus tinting the edges.
Photography by JOEL STRASSER

The dramatic black-and-white on the next spread was created by multiple exposure and by then reversing the image to form a negative image. The feeling of continuing motion in the baton helps add an extra dimension to the illustration.
Photography by HENRY RIES

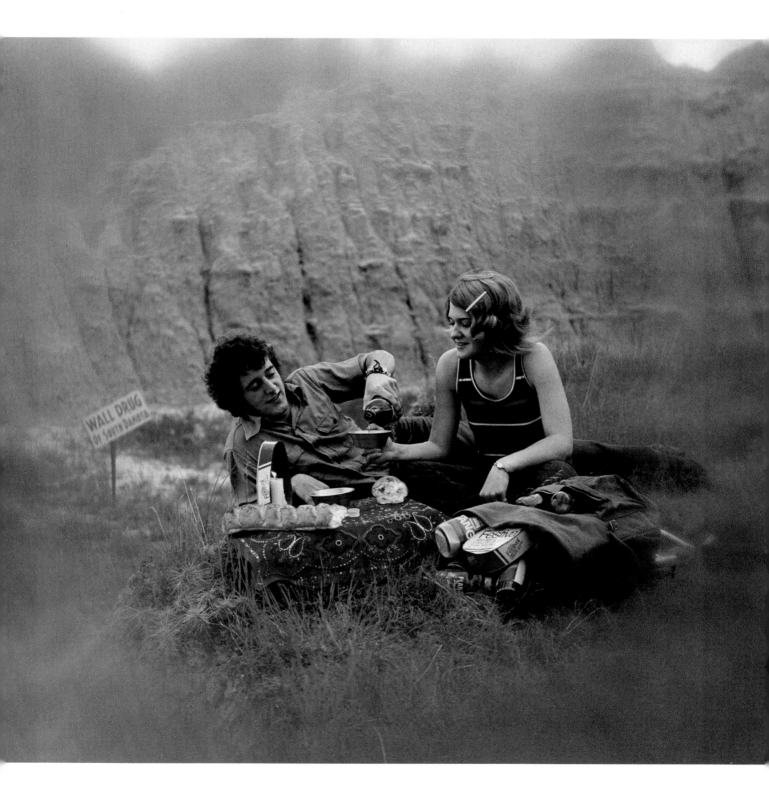

173

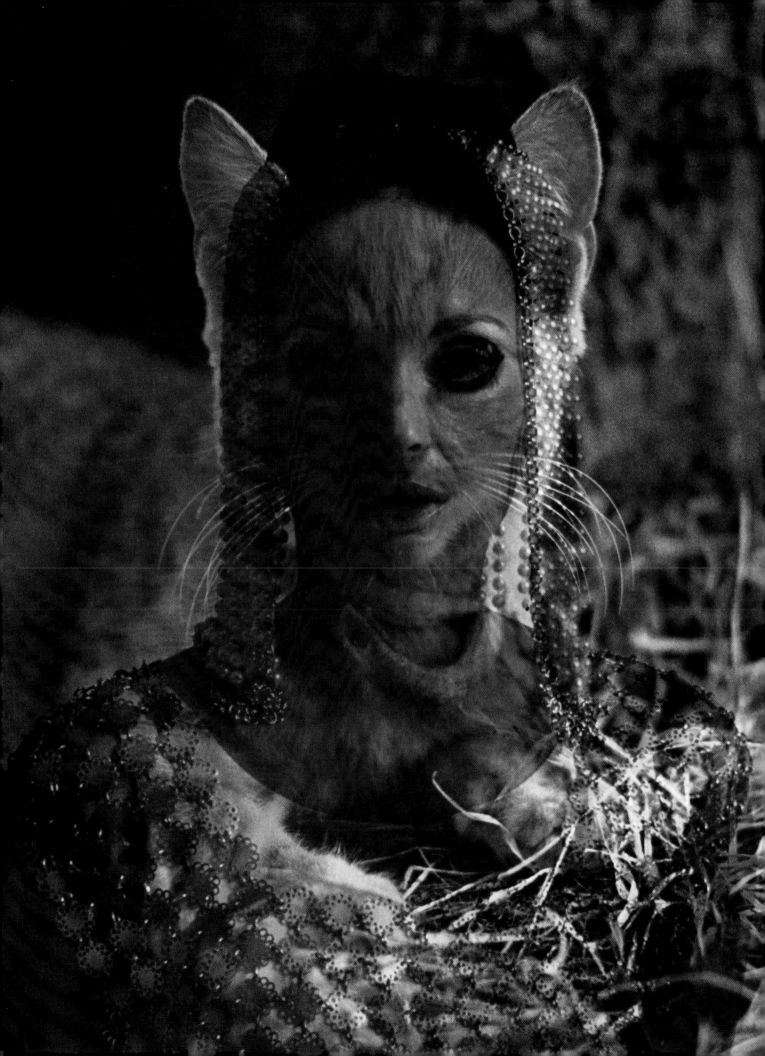

Two photographs were used to make the Dye Transfer prints from which each of these illustrations was reproduced. The two separate images were made to scale in each case, and with the end result in mind. They were then sandwiched together to form a single picture.

Photography by ROBIN PERRY

Changes in both scale and color balance were effected when the illustration at left was created by double printing in the darkroom.
Photography by RALPH COWAN

Multiple images were also used to make the photograph below, but they were recorded by several exposures in the camera resulting in a single transparency.
Photography by HENRY RIES

The illustrations on this spread were the result of multiple printing in the process of making an enlarged duplicate Ektachrome transparency. Obviously, the original photography must be planned with the final effect in mind.

A zoom lens is one in which the focal length can be changed by a simple manipulation of the lens barrel. If such an adjustment is made while the shutter is open, the image size will change during exposure, resulting in radiating streaks whose colors and densities are dictated by the original subject. When this is combined with a stationary image, either through double exposure or by double printing, an extraordinary feeling of motion and lapsed time is created. This is an exceptional example of this technique.

Photography by
JON ABBOT

182

When a special black-and-white film sensitive to infrared light is used with a suitable light filter, the exposure will be made by the infrared rather than by the visible portion of the spectrum. Such photographs are often quite dramatic and serve to emphasize bright buildings against dark skies. Green leaves and grass are recorded in light tones to further enhance the illustration.

Photography by JULIUS SCHULMAN

The tone-line process, as can be surmised by the name, converts continuous-tone photographs into line images enclosing rather even-toned areas. If the negatives resulting from the process are printed on color paper, filtration will yield any color effect desired. Here a black-and-white photograph has been converted into an effective poster-like image.
Photography by RAY HOLDEN

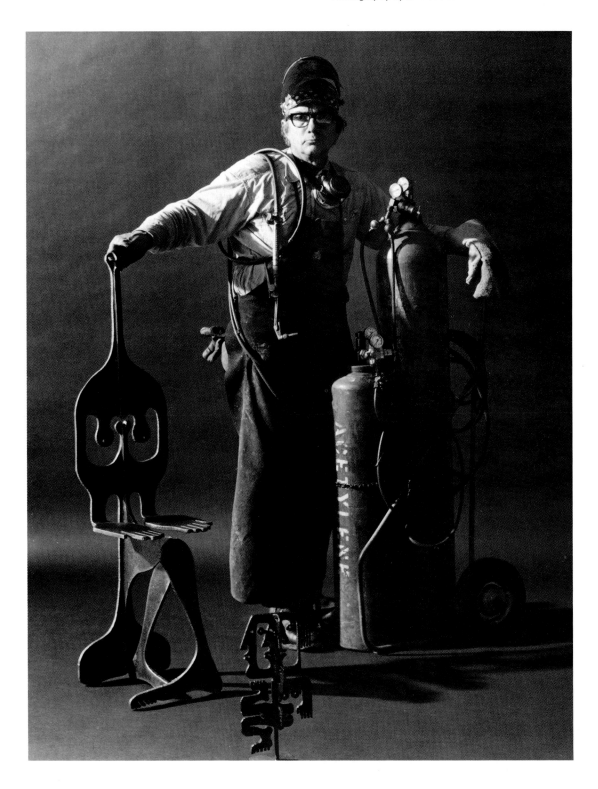

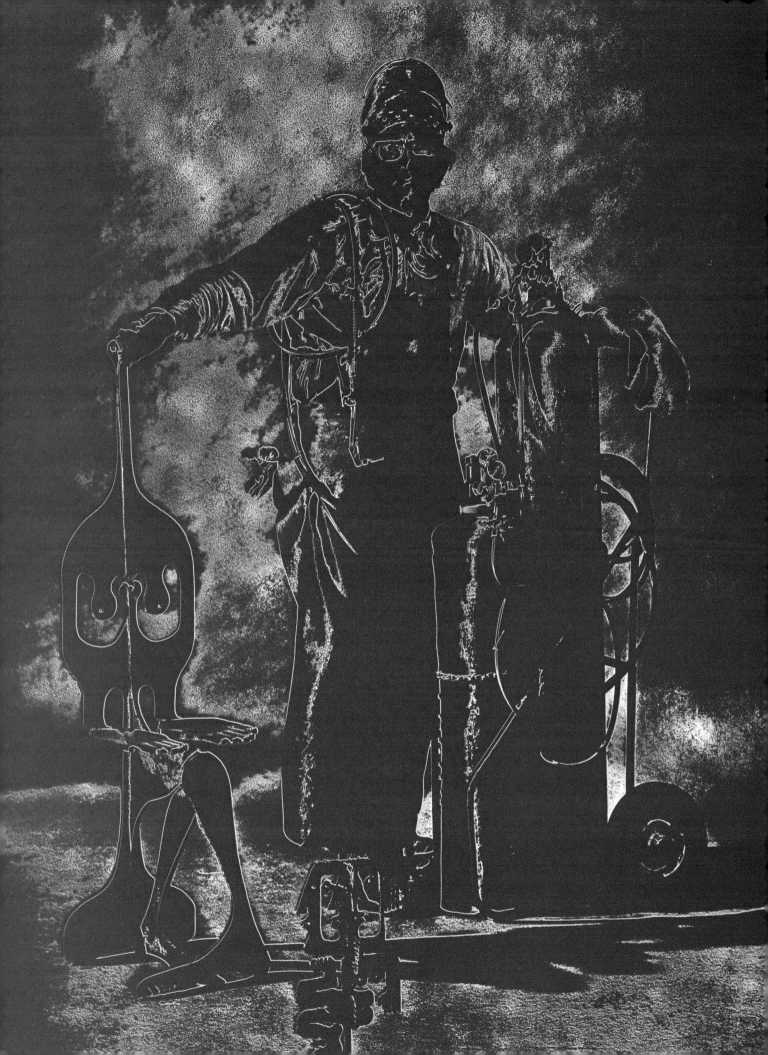

Copy Preparation...

...or what to do before the plate-maker arrives

To the writer, copy is the important part of an advertisement,
the worded part. To the art director, copy may be what his rival
down the street did to his best idea. But to the engraver and lithographer,
copy is what goes in front of his reproduction camera.
And for the purposes of this discussion, copy is a photograph on its way
to the plate-maker, ready to illustrate the advertiser's message.

Time and money can be saved, and disappointment avoided, by the proper preparation of a picture—or copy—before photomechanical reproduction. By doing everything possible at the print or transparency stage, the client allows the engraver or lithographer to concentrate on the problems over which he has some control, and not put him in the position of compounded difficulties not of his making.

Black-and-White

More sins have been committed in the name of a "reproduction print" than one might like to contemplate. A good reproduction print is a good print for anything, particularly to look at. It should have detail in the shadows, modeling in the highlights; it should have a non-ferrotyped glossy or other smooth surface, and it should preferably be about 1½ times bigger than the anticipated plate size. The size, of course, is not critical. More than 2 times is apt to be too large, and less than same size, too small for best reproductive results.

If black, undetailed shadows are wanted, then of course there should be no detail. And just so the highlights. There may be aesthetic reasons. But usually, a fully detailed reproduction is wanted; and obviously such a reproduction is impossible if the print does not have it. So the first step is to really see the picture and determine if it has the desired detail. If it doesn't, the print should be made over. If the negative doesn't have it, *it* should be made

over, for then the trouble is incorrectable and is a fault of the original photography.

Sometimes the lack of highlight detail can be helped by retouching, particularly if the bright spots are merely distracting and the lack of detail does not lessen the picture's descriptive accomplishment. In such cases a touch of dye or pigment may be all that is needed. Retouching can also help separate objects from their backgrounds. And its skillful use will mitigate other minor faults. If retouching is necessary, a print twice reproduction size is suggested. Retouching, however, is no substitute for a good print to start with. An over-retouched print reproduces over-retouched. If a drawing is wanted, start with a drawing!

Retouching cannot help a print made to the wrong contrast. A picture which is too flat, or too harsh or hard, is the result of faulty photographic printing or a bad lighting of the original scene. Retouching only helps make the picture look retouched. Incidentally, it is better to be a little too flat than too hard. The contrast will be increased in reproduction so the too-flat picture will get better, and the too-hard one worse.

Prints should be mounted so they will not crack. Usually dry mounting tissue will do the job. A hinged overlay is further protection against damage. Marks from scratches and breaks in the emulsion can often be eliminated by the plate-maker, but at an added cost which is unnecessary where respect for the image and care in handling is practiced.

Where more than one picture is to be used on a page or spread, real economies may be effected by making the prints to scale and pasting them into position on a layout. They can be same size, or up to 2X depending on the overall size of the spread, and if there is to be any retouching. Where it is not practical to paste prints into an in-position layout, economies are still possible by making all individual prints to the same reproduction scale. These scaled prints should be made from the original negatives. Obviously, this increases the photographic cost. But it reduces the reproduction costs more, for the assemblage of the separate parts must be made sometime, and it is more expensive to do so photomechanically later than photographically at the start.

Color Transparencies

The point made about really seeing the black-and-white picture applies even more to color, because one can become mesmerized more easily by a color photograph. Not only should the picture be examined on a standard illuminator, but it should be the *same kind* used by the plate-maker. It is also suggested that the transparency should be viewed with the face of the illuminator unmasked. In other words, there should be a lighted border surrounding the transparency, and the room lights should be on. *Not to do so—to view it in a darkened room with no lighted surround—is a false condition, for the printed piece will certainly not be viewed that way.*

In viewing, note the contrast of the picture and examine highlights and shadows, as for black-and-white. If there are distracting highlights, retouching will be helpful. Retouching can also help separate unseparated objects. Over-retouched color can also ruin the photographic result as in black-and-white.

The competent commercial photographer will usually allow a little extra transparency space around the illustration to use for bleed. This extra space is either thus used or cropped. Loss in original size is slight and no problems arise. But where the picture was not made specifically for the job at hand, cropping may be quite drastic. It should be remembered that this reduces the transparency size relative to the reproduction. A small piece of an 8 x 10 may have no more area than a 35mm slide, and is apt to have less quality of definition when enlarged. Thus severe cropping may adversely affect quality. By all means, crop for dramatic effect. But do not carry things to the extreme.

Where the range or contrast of the picture is greater than is possible to reproduce photomechanically, Dye Transfer prints can be made and density corrections introduced—*if* detail is present. If the shadows are just plain black, nothing can be done but start over. Likewise the highlights. Dye Transfer prints are also suggested if other retouching is necessary and a retoucher skilled in transparency work is not available. Generally speaking, it is a simpler matter to work on prints.

Where there are to be a number of color transparencies in a spread or printed piece, significant economies can be effected by making the original photography to the same scale. Thus the photomechanical camera which color separates them does not require adjustment from one to another. The engraver or lithographer calls this "same focus." Unfortunately, the photographer will call it a big headache at best, and sometimes impossible at worst. It most certainly limits original photography. The solution to this difficulty is to make duplicates of the original transparencies, and make the duplicates to scale.

Duplicate Transparencies

Almost everyone in the field of communications who uses photographs has learned that a photograph copied from another photograph loses quality. This loss usually is manifested by an increase in contrast in the copy which shows up not only as an increased overall range from highlight to shadow, but also as increased harshness in each object in the picture. Since such an upset in contrast also upsets color balance, copies, *in the past,* have been unsatisfactory unless made with great skill and with special techniques. Even then, a copy of a color transparency could be called a duplicate only during a period of verbal carelessness. It was the state of the art *until now.*

Copy Preparation...

A new material is now available to photographers, professional color laboratories, and the graphic arts. It is labeled with an obvious name: Kodak Ektachrome Duplicating Film 6120. It is not the same as material previously available under the same name but a different type number. It is a whole new ball game.

First of all, it solves the problem of assemblage. Color transparencies of different sizes—or of same size to be reproduced in different sizes—can be scaled to size by duplicating them on this new material. They can be enlarged and reduced to any reasonable scale. Economies of "same focus" are immediately realized. Cropping of each can be effected in the duplicating step so that each reproduction transparency will then include the area wanted.

Further economies can be had by stripping the images in position onto a glass or plastic supporting base. And where the pictures are to butt one another on the page, the transparencies can be cut and actually edge-welded together to form a single composite piece of camera copy (copy, as in photomechanical; not copy, as to emulate). Naturally, both of these methods require skill on the part of the stripper or welder, but that is why there are professional services available. In any event, the combinations are necessary someplace along the line. It is usually more economical to effect them at the copy preparation stage rather than later on. If an art service is not conveniently located, the lithographer or engraver will undoubtedly be able to do this work. Many have not in the past because film of this quality has not been available, so the point was academic.

Duplication offers other blessings, particularly in the case of 35mm, whether they be Ektachrome or Kodachrome transparencies. These small pictures are usually judged by projection. This is hard to do. Usually one is at some distance from the screen, and the brilliant image enchants with its beauty and hides its faults. The result is that one's emotions overcome one's sense of technical critique, and the fact that a picture is too dark, too light, or, perhaps, a little unsharp comes as a shock at proof time. One can be very much more certain of what the reproduction will look like when he examines a transparency equal in size to the final result, than by trying to be certain about a 35mm image. And the communication between art director or advertising manager and the plate-maker can also be more certain—not to mention the better time the plate-maker will have in matching proof to copy. One cannot help but have considerable sympathy for the etcher, proofer, and everyone else at the plate-maker's if he has ever seen these men trying to compare an 8½ x 11 proof with a 1 x 1½ film image.

It is realized that the rather loose way the word "duplicate" and its derivatives are used is semantically incorrect. If one alters the original in any way—in density, in balance, in size, or by cropping—the result really isn't a duplicate. On the other hand, the result must be labeled in some fashion if it is to be discussed.

Duplication also introduces a corrective stop before plate-making. The color image not only can be enlarged, but it can be made warmer, cooler, or otherwise changed in color balance.

Continued on page 192

Any 35mm color transparency can be enlarged to form a more convenient piece of color copy for photomechanical reproduction. In the process, the picture can be cropped, the color balance changed, and the image otherwise altered.

This double-exposed zoom background illustration by JON ABBOT

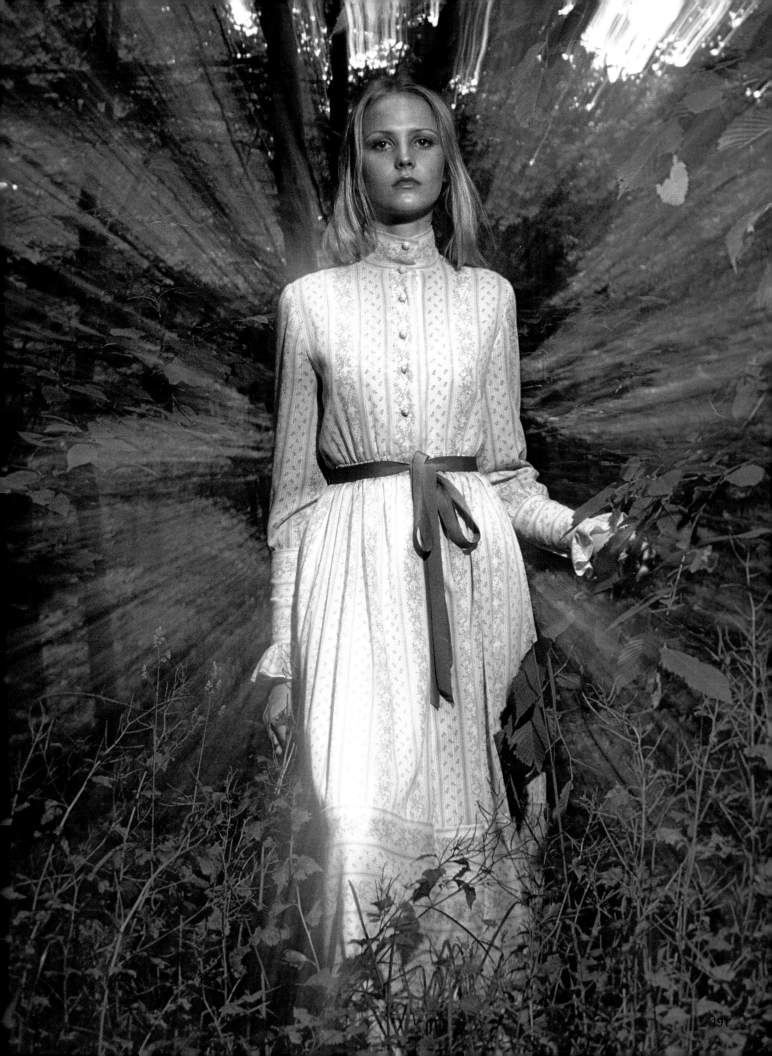

Copy Preparation...

Density corrections can be made, both locally and overall. In short, duplication introduces some of the same controls for color transparencies as were previously available only with the negative-positive way of making black-and-whites, and color prints and print films from color negatives.

Duplicate transparencies can be made from any size originals within the limitations of an 18 x 22-inch maximum film size. Advantages of duplication exist beyond the manipulative possibilities and economies through copy preparation. Wear and tear on valuable originals can be eliminated through the use of duplicates; and one illustration can be in many places at one time by having the required number that's needed.

There are advantages to the use of color prints as photomechanical copy over those of transparencies. Of course, prints aren't quite as exciting to look at because they do not have the sparkle and zip of a color image viewed by transmitted light. However, the reproduced printed result is more easily anticipated from prints, and that result is going to be viewed as a print anyway. So all that is lost is the thrill, and that doesn't last.

The same economic advantages accrue from prints made to a scaled size as from transparencies. However, stripping is unnecessary in the case of prints, and butting is very much easier. All one must do to assemble prints made to scale is to paste them down in position on a layout. Naturally, this must be done with care and with the precision common to the graphic arts.

The contrast range of a print will be less than the same scene photographed on transparency material—which is all to the good. For the compression of contrast must take place someplace between scene and reproduction. With a transparency, all of the compression comes in the photomechanical step—and as a surprise—while with the print, much of it is evident at that point, and the final proof of the reproduction will more nearly match the copy.

Nonetheless, there can be blocked or burned-out highlights and nondetailed shadows in color prints, even as in black-and-white. And all remarks made there apply here. Detail in the shadows can be restored by making another print, holding back the shadow areas. And highlights can be unblocked by print-making techniques. Neither highlights nor shadows can be reproduced if they are not in the negative.

Retouching is not quite as difficult on color prints as on color transparencies, but the retoucher must be certain that his dyes reproduce the same photographically as they appear visually. Professional retouchers know about this sort of thing.

Where more than one illustration of a similar subject is to appear in a piece of literature or layout, both their densities and color balances should be adjusted to be compatible with one another. To adjust these variables after seeing photomechanical proofs is quite a bit more complicated—and therefore more expensive—at that time. Such adjustments, or need for them, become readily apparent when photomechanical camera copy consists of scaled prints mounted in position on layouts of spreads or forms.

The more nearly a piece of photographic art approaches the desired reproduction, the less expensive and the more satisfactory the end result will be. Pennies invested in copy preparation will grow to dollars saved in printing or engraving bills. This enables the client to use more color, the photographer to create more illustration, and the printer to print more effective advertising.

Several transparencies can be enlarged to scale and combined to form a single piece of color copy for reproduction. This technique is frequently used in the field of mail order catalogs.
Photography by
WILLIAM BECKER STUDIO
for Sears Roebuck and Company

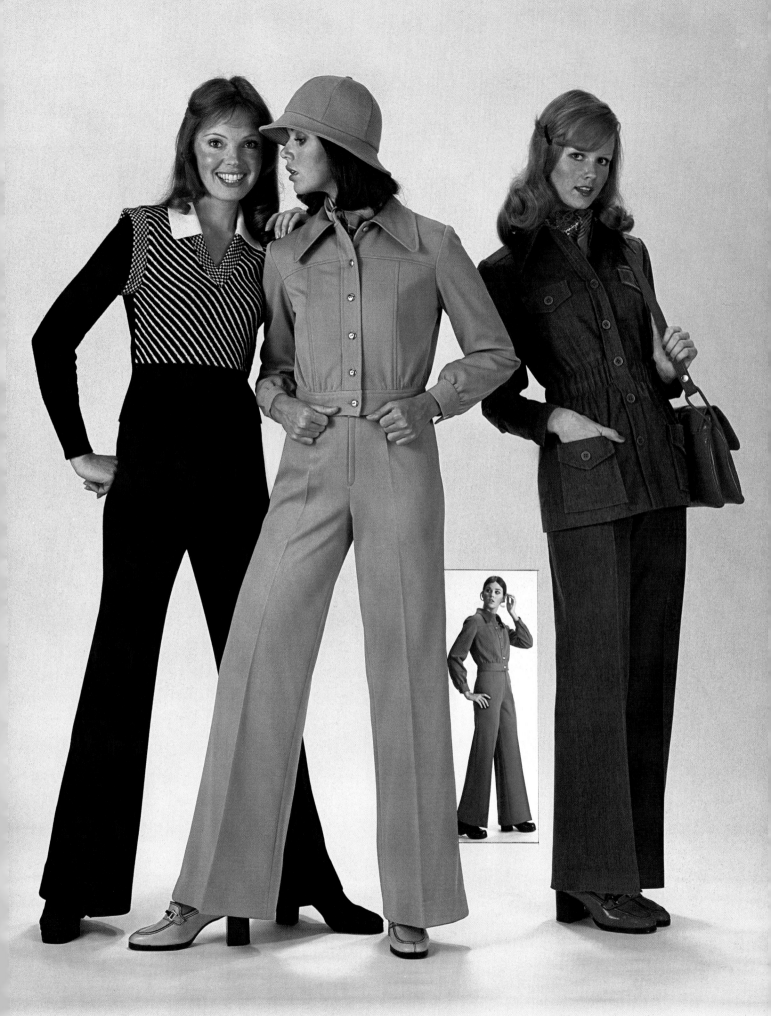

All of these images were originally 35mm color negatives. Photostats of color print proofs from these negatives were used to make a layout. Reproduction quality Ektacolor prints were then the final assemblage used as camera copy for photomechanical reproduction.

Photography by JON ABBOT

Photomechanical Reproduction of Color Photographs

Just as film and an idea are only a start toward a picture, the photograph itself is merely the beginning of graphic communication. It is the multiplication of the photograph by the thousands or millions which turns it into a working tool.

There are a variety of processes from which photographs emerge as printing plates. If neither quality nor cost is of consideration, the advertising man need know nothing about any of them. But on the occasion when highest quality at minimum cost is of importance—which is to say, every occasion—a knowledge of photomechanical reproduction is a necessity. The art director and advertising manager need not concern themselves with photomechanical techniques, but they should be fully informed on the factors and practices which can either aid or hinder the goal of good reproduction.

Most people in advertising already know about the three major printing processes in general use. But in the interest of completeness, it will be wise to review them very briefly.

Letterpress

The oldest, and once most widely used, way of printing is letterpress, made commercially feasible, one might say, by Gutenberg's invention of movable letters. In letterpress, a surface raised from its support is inked, and the ink transferred to paper by contact. A stone-cut print as produced by the Eskimo, a woodcut as carved by an illustrator, and a linoleum print as made by a school child are all printed by letterpress.

In letterpress, photographic images are converted into raised dots—comparatively large ones in the shadow areas, smaller ones in the highlights. The size of these raised dots determines the area of ink transferred to the printed surface, and since the number of dots per square inch is the same overall, the size of the dot also determines the amount of blank paper between the dots. Thus, the size determines tone. Four-color letterpress requires the use of four plates; one each for magenta, yellow, cyan, and black inks. These may be printed four-color "wet"; i.e., sequentially, without a drying period between each; two-color "wet," in which a drying period elapses between the first and second pair of impressions; and one-color "dry," where each color is allowed to dry before impressing another.

Photolithography

Photolithography is a more recent development. It evolved from the method used by Currier and Ives, Toulouse-Lautrec, and other artists of varying quality to multiply their images. Lines were drawn on a smooth stone surface with grease crayons. The stone was then dampened with water, inked, and the ink, in turn, transferred to paper. Those undrawn areas of stone wet by water repelled the ink, whereas the greasy parts accepted it. This was—and still is—the lithography of the print-maker.

The lithography of commerce depends upon photographic means to put the image on the printing plate with illustrations in the form of dots, as in letterpress. But unlike letterpress, both dots and letters are at the surface of the plate. Just as in the lithography using stone, the dots and letters accept ink but the surrounding areas do not, because they are dampened and

repel it. Since the surface is physically much weaker than the raised printing surfaces of letterpress, the ink from the printing plate is transferred to a blanket, and actual contact with paper made with the blanket.

Gravure

Gravure printing is best understood by realizing that it is really letterpress in reverse. Both letters and the dots forming the illustrations are etched into a printing cylinder, forming wells or depressions in the surface. The cylinder is inked and the surface cleaned off. When paper and cylinder surface meet under pressure, the ink is transferred from these wells, forming the printed image.

Rotogravure differs from sheet-fed gravure in that paper is fed into the press from rolls and printing effected on a continuous web in the former case, and on individual sheets in the latter. The former is faster and therefore more economical. The latter permits the use of a wider choice of paper stock, and offers the possibility of higher quality.

Reproduction quality defined

All three of these printing methods have one thing in common. The quality of the final reproduction depends upon the quality of the original. Actually, by definition, quality of *reproduction* is independent of the quality of the original. A fine reproduction of a ghastly picture will reveal a ghastly picture. An acceptable image made from a bad original is not reproduction. Rather, it is the result of the skill and taste of the plate-maker who has *converted* the original and *created* acceptability. This is time-consuming, uncertain, and expensive. Ideally, there should be judgment, recognition, and skill on the part of those making the plates. But they should not be asked to be illustrative creators.

A good job of photomechanical *reproduction* occurs when the printed picture looks like the original. And a good job of *illustration* occurs when the original is a good job photographically. Thus the photograph for the repro-

duction one likes is the photograph he likes in the first place.

It is important that the client of a plate-maker knows what he likes in the first place. Which is to say, what he likes photographically. Unfortunately, it is true that people look at things without really seeing them. All too often, the client carefully examines only the photomechanical proof, and to his dismay, discovers that he really didn't like portions of the original photograph. He *sees* things for the first time. Always, this is the wrong time for surprise, and often too late. As simple and as elemental as it might seem, the first step to a quality reproduction is a careful seeing of the original. Really seeing rather than casual glances.

Proper viewing conditions a prerequisite

Good seeing requires good viewing conditions. Therefore, step two on the road to quality is the choice of light under which the photograph is to be analyzed and judged. Both light quantity and light quality are important—the former with respect to color, and the latter as it influences the apparent density.

When color transparencies are the subjects under consideration, they should be viewed on a standard illuminator designed for the purpose. It should be the same kind everywhere: at the photographer's studio, at the agency, at the client's office, and at the plate-maker's.

It is not possible to communicate properly among a group of people unless everyone is tuned in on the same wavelength. The proper illuminator—and the *same kind* of illuminator—at every spot provides this common denominator. Such a proper viewer will provide a light having a color temperature of 5000 K (a label for light of a certain quality). This quality and the quantity emitted by such a viewer have been standardized by the American National Standards Institute.

In the case of prints and proofs, similar standards are suggested not only at the beginning, which is the judgment of the print, but also at the end, in the pressroom at the printer's.

Continued on page 199

Viewing Conditions

Just as the color of an object depends upon the light falling on it, so the color of its image in a photograph depends upon the light by which it is viewed. It is important that all of the people involved use the same lighting standard when sitting in judgment. While the dramatization here involves the viewing of color transparencies, the need for standardization exists equally for prints and photomechanical proofs.

The client thinks the picture has a cool balance, the plate-maker thinks it is warm, and the truth of the matter is someplace in between. There can be no certain communication without a mutual language.

The photographer views his work by the light of a standard viewer . . .

. . . and approves of his reasonably accurate rendition of subject matter.

The art director holds it to window light . . .

. . . and sees the picture as being much colder because of the skylight illuminating it.

The plate-maker may have still different viewing conditions . . .

. . . and he sees the picture as being considerably warmer than those who preceded him.

198

Photomechanical Reproduction of Color Photographs

All this may seem like a bother, but it is dictated by the physical nature of color and light. If there are to be complaints, there should be, as logically, letters to the editor on the rising of the sun.

So, to repeat: step two is standardization of viewing conditions to ascertain what is being seen, and to expedite communication among interested parties.

Recognize what is seen

Step three is to recognize what is being seen. Those who would judge photographs for photomechanical reproduction must learn to recognize photographic characteristics. There is a tendency for reproduction processes to increase what might be found objectionable in the original, and to make objectionable those aspects which might be considered photographically acceptable.

For example, the matter of contrast, or the brightness ratio between darks and lights. Usually, it is desirable that the darkest and brightest objects or areas of the subject show detail. If the range (or "contrast") of the original scene is greater than the film can record, the photographer must favor either one end or the other. Thus, it is conceivable that either the shadows, or darkest areas, will be black and without detail, or white, and likewise without detail. No plate-maker can add detail where there is none.

Where the photograph is in the form of a color transparency, it is viewed by transmitted light. This tends to extend the range of brightness values discernible. However, when the reproduction plate is printed, it is printed on opaque paper and the image viewed by reflected light. Under the latter conditions, the possible range is shortened. The plate-maker can compress the transparency range onto paper to a highly useable extent, but he cannot attain the impossible. It follows, therefore, that the original photography should be performed with this matter in mind.

Where a color print is the original from which the reproduction is to be made, the image is judged by reflected light, and is closer to the end result. For this reason, a print is easier to visualize as a reproduction than is a transparency. Also, some compression of brightness values can take place at this stage, leaving less for the plate-maker to effect. This does not mean that a print is better than a transparency. It means what it says—a print is easier to judge and the result visualized.

The characteristic of sharpness

A second photographic characteristic to be judged is sharpness. There is no such thing as a photomechanical sharpener. If the original is unsharp, the reproduction will be, too. And if the reproduction is a magnification of the original, the reproduction will be even less sharp. One would think this obvious, but examination of much advertising literature proves that the obvious is overlooked.

Also overlooked is the effect of magnification of certain unsharp areas of otherwise sharp photographs. Sometimes the effect is a desirable one; sometimes it becomes a serious fault. It should be adjudged at the photographic evaluation stage rather than be discovered as an unhappy spot in the proof.

Determination of sharpness becomes easier as the original photograph becomes larger. Thus the large color print, or 8 x 10-inch transparency, is easy to examine, and sharpness, or lack of it, is readily apparent. It is suggested that transparencies in the 2¼ x 2¼-inch size be inspected with a good magnifying glass, or projected. So, too, with 35mm transparencies, where projection is even more important. Care should be taken to rise above the very human tendency to be overwhelmed by the beauty and color of a projected transparency and coldly appraise the picture for its virtue or lack thereof. Remember, too, that the reflectance of the usual beaded projection screen is much greater than that of printing paper. The range of values displayed on the screen will not be attained on paper, even as the transparency when seen on a viewer.

Continued on page 202

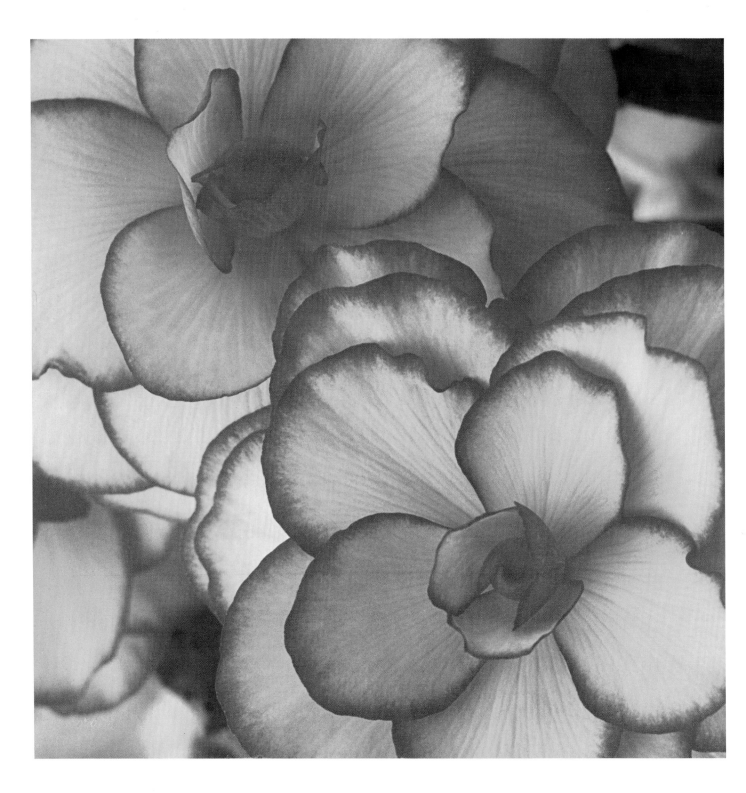

Sharpness in a photograph is a matter of lens quality, the ability of the photographer to focus his camera, the aperture, camera immobility during exposure, and the characteristics of the film being used. As a practical matter, sharpness in the ultimate reproduction is also dependent upon camera size. The reproduction above is from an Ektachrome transparency 2¼ inches square, and the one on the right, from an 8 x 10 Ektachrome transparency.

The latter illustration by ALBERT GOMMI for Kellogg Company

Photomechanical Reproduction of Color Photographs

Color balance is important, and the judge of photographs must learn a sort of absolute value in this matter. Where there are several color photographs, all of one subject, it is easy to note which is "warmer" or "colder" and decide on a preference. But where there is only one, then the judgment becomes based on remembered knowledge of the original subject, or of taste.

Color balance a changeable possibility

It is not too difficult a task to change the overall color balance of a photograph during the photomechanical process. A cold picture can be made warmer, and vice versa. But, here again, it is important to have standardized viewing conditions and good communications. A transparency, for example, can be too warm when viewed by the tungsten lamp on a desk, too cold when held up to a window, and still be just right on a standard viewer. The possibilities of bad communications are vast. The words "a little" and "quite a bit" are not really descriptive either. When one says something is too warm or too cold, he should be prepared to define how much.

Grain size a factor

The grain in a color transparency is not discernible where the transparency is in the size produced by the camera. If it is an enlargement of a small transparency, then grain might be apparent, depending on magnification. Large color prints from small color negatives or transparencies sometimes do show grain. This, too, becomes a matter of judgment.

Generally speaking, grain in a photographic print tends to become more apparent as a result of photomechanical reproduction even when the size relationship is 1:1. If an 8 x 10 print is to be reproduced same-size, and the grain is objectionable in the original, the chances are that it will be even more objectionable in the reproduction. If a 16 x 20 print is to be reduced in reproduction to 8 x 10, and the grain is just slightly objectionable, or not at all, forget it.

Reduction in image size reduces grain, too. But the result of the reduction may not be the same as if the reproduction were made 1:1 from an original made with the 8 x 10 camera. It is the original that counts.

Grain is usually something to ignore when the picture was made in a 4 x 5 or larger camera. It will usually be apparent in large reproductions from 35mm transparencies, or from parts of those in the 2¼-inch size. It is not often a serious matter. Actually, there are those who find it pleasant and seek to enhance it. However, grain is a characteristic which affects the final result and deserves consideration.

When the judge of a color photograph finds some characteristics of which he disapproves, he should know which can be changed during plate-making, and which cannot. He should also know if he has discovered something important or whether he is merely irritable at that moment and his displeasure is expressed in nit-picking. He can ask the plate-maker to change color balance, or even the color of individual objects; he can have shadows opened up and bright portions darkened to a certain extent. But he cannot expect the plate-maker to give him detail in shadows which are completely black, or in highlights which are so overexposed as to be clear film or paper. He cannot ask that the picture be made sharper (although a size reduction might make an unsharp picture barely acceptable). And he cannot expect a change in grain except as dictated by the original size of his photograph.

The most satisfactory relationship between client and plate-maker exists when both speak the same language, and when the original photograph is what is wanted. The very fact that the plate-maker can modify the image is descriptive of an unusual skill gained from much practice and experience. This skill is what is being purchased. The materials of plate-making are comparatively inexpensive. The time of the plate-maker is not. The more the client demands in the way of changes thought up beforehand, and alterations which become desirable upon in-

Continued on page 204

A subject will not be reproducible in a desirable fashion in print if it is not reproduced also on its transportation system—the photograph. Photography cannot always reproduce it accurately unless light is carefully controlled. Color photography in particular is somewhat limited in its ability to capture a wide range of light values.

The human eye compensates rapidly as it scans the scene. The camera can be adjusted to compensate also, but only for one series of values at a time. Thus, the eye sees detail in very bright parts of the scene by adjusting to its brightness, and then quickly readjusts for the dark parts as the area of seeing is changed. The camera sees them both at once. And if the brights and darks are beyond its system's capabilities, something has to give.

Sometimes lack of shadow detail is not important. Sometimes highlight detail can be ignored. But if either or both *are* important, then compensations must be made by adding light to the darks, subtracting light from the highlights, or both.

It thereby becomes fundamental that good reproduction of subject matter on the printed page starts with the way in which it is lighted in front of the camera. Since light is the very breath and heartbeat of photography, it becomes obvious that an understanding of light and its handling is basic to a good printed reproduction.

The sunlight has been diffused and a reflector used, thereby shortening the scene range to within photographic capabilities.

Photomechanical Reproduction of Color Photographs

specting the proof, the greater the demands on time—the commodity really on sale.

"Gossip" is for kids

It should be kept in mind, also, that there is more than one man involved in the making of plates. There is the man contacting the client, the cameraman who separates the colors, the plate-maker who puts the images on metal, the etcher who must compensate for differences between the dye images of photographs and the ink images of printing, and the proofer who puts the thing on paper. Special instructions, particularly when they involve extensive modifications, become the ingredients for an adult game of gossip. What is fed in at the beginning may not always come out the same at the end.

Retention of photographic quality

A point of major importance is the retention of photographic quality in the reproduction. All major forms of plate-making are, in themselves, essentially photographic. It follows that a photograph reproduced by photographic methods should display all of the characteristics of a photograph. However, changes and modifications involve considerable work by hand, in either local or overall control of the dots. Up to a certain point, such handwork is not noticeable. But where there is more "mechanical" than "photo" in a photomechanical process, the reproduction reflects the shadow of the man behind the plates.

Some handwork is inevitable in every photomechanical process, even though no corrections are made other than to marry the printing press inks to the camera's dye images. This is kept to a minimum under the ideal conditions of being requested to reproduce what is there by photographic processes. It is modification—the "little more this" or the "little less that"—which causes the trouble. And what causes the most trouble, expense, and loss of photographic quality is the change of mind, or keen observation after the fact—at the proof stage.

Separations by scanning

The art director or advertising manager is usually interested only in the result. How the plate-maker color-separated his photograph, or how he put it on metal, is of little interest. Electronic scanning in the separation of original color photographs should be an exception, however. For the scanner can introduce corrections in the color separations which eliminate much routine handwork which, in turn, contributes to a more photographic end result.

There is no point in describing the operation of a scanner other than to compare it to a TV picture, which is also the result of an image having been scanned. The electronic scanner essentially converts the photographic image into parallel lines with much the same effect as the photomechanical screen changes an image into dots. As it does so, it directs the electrical impulses representing each of the primary colors of the image to a different channel, whereupon the electrical impulses are changed to light energy and imposed on photographic film. A fourth separation for the black printer is made at the same time. Essentially, this is similar to television transmission and reception.

The lines resulting from electronic scanning are considerably closer together, however, than is the case with TV. Modern scanners produce images of either 500 or 1000 lines per inch. The result of the operation is a set of four-color separations on photographic film which are then used in the same fashion as separations made with a camera by the lithographer or engraver. Because of the very large number of lines, these separations can be considered continuous-tone. The dots for printing are added in the next step in plate-making, as usual. At this time, only color transparencies are customarily scanned.

The scanner does not replace the plate-maker's skill. Nor does it necessarily reduce costs dramatically, because the color separations it produces are only one step in the process. It helps in all directions, however, particularly when what is wanted is as close a match as

possible to the original photograph. Needless to say, there is no value in using such a grown-up marvel when one's photographic standards are still in adolescence. Again, it's the original that counts.

Anything will reproduce!

Returning to the consideration of the photograph, one discovers misinformation and sacred cows concerning what will reproduce and what won't reproduce. It can be said that *anything* will reproduce—print, transparency, a grease drawing on wallpaper. Whether the reproduction is worthwhile, of course, depends upon whether the original was worthwhile.

Transparencies or prints as copy?

There are strong feelings among those whose concern is photomechanical that transparencies reproduce better than prints. And there are strong feelings in the other direction. Certainly the photomechanical result from a good transparency is to be chosen over a reproduction from a bad print. If the reproduction from the print is equally as bad as the original, the plate-maker has had a triumph of accuracy! It is realized that this was mentioned before. It is also realized that it is worth repeating. But the converse is true, too.

The advantages of a transparency are several. The transparency is the film that was in the camera; no further steps are necessary which may involve time and expense. Small transparencies can be projected, if this is considered important. A transparency makes possible color separations by the electronic scanner. Only one of these is a strictly photomechanical advantage, and then only if the scanner is part of the plate-maker's usual procedure.

The advantages of prints are also plural: a print is already an image on paper. It will not have the magic glow of a transparency, but neither will the printed result. (And how many of the public are going to see the transparency?) Being on paper, it is easier to see and judge. In all probability, it will be several times larger than a transparency and its virtues and sins more readily apparent. The print is usually more readily retouched if retouching is a necessity. If the print is made to size, it can be combined with an overlay of type and the piece viewed as a completed job. It is even possible to combine several photographs into one, thus eliminating the complexity of doing it photomechanically.

The most important advantage of a color print is the possibility of manipulation in its making. The color balance can be adjusted to that desired, as can the density in whole or in part. In short, the making of a print can be an additional—and intrinsic—part of the creative process of photography. A color print which has realized its full potential likewise achieves the ideal of perfect copy for photomechanical reproduction—a picture which can be handed to the plate-maker with the simple instruction "this is what I want, reproduce it."

High-speed presses, paper manufactured with greater efficiency, better inks, improved materials and photographic methods in plate-making have all contributed to making full-color printing more feasible for advertising. When coupled with the greater return and impact from color, it is not surprising that its use has become commonplace; often an absolute necessity. Yet, commonplace or no, the business of capturing the image on the camera's ground glass, and its multiplication into the millions, is a complex journey filled with opportunities for making it cheaper and poorer on one hand, best and more expensive on the other, proudly adequate and efficient in the middle.

If there is a secret to success in the procurement of good reproduction, it is to know what to look for, what one likes, and how to communicate this information. In a field depending so greatly on craftsmanship and taste, it is the people, not the process, who are important. Which lends truth to one photoengraver's favorite saying: "The problem is not the problem; the problem is people." Amen.

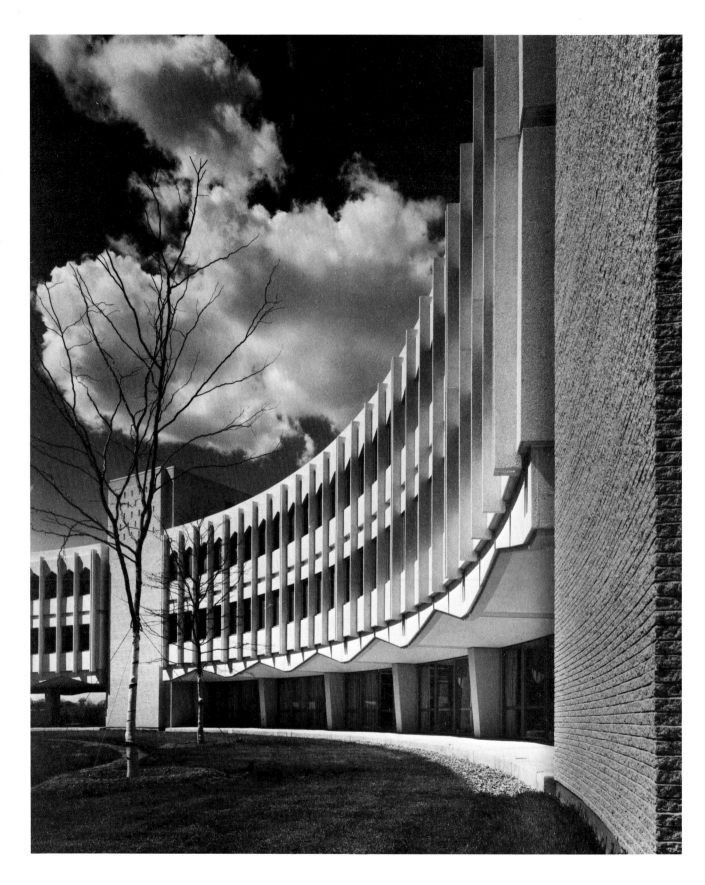

Where two plates are used to reproduce a photograph, the result is said to be a duotone, particularly where one plate prints black, and the second, another color. However, two black plates can be used to effectively extend the range of the black-and-white printing process. Here is a comparison with one plate used for the reproduction on this page, two plates for the facing page.

Photography by LARRY WILLIAMS

Duotones

Duotones are sort of a poor man's color process. The addition of a color plate to a black-and-white may increase the attention value of the illustration out of proportion to the extra cost, particularly where most of the competitive pages are only one color.

While duotones can be made from black-and-white reproduction copy, the optimum result will be achieved by starting with a color photograph which itself is duotone in character. A mixed ink can then be used as the color to obtain a very respectable representation of the original. Where the duotone is being run on a four-color form, one of the process colors can be used, usually with less approximation of the color photograph.

The original photograph reproduced in four colors.
Photography by HERMAN WALL

Reproduction using
the yellow ink of the
four-color process
and black.

Reproduction with
an ink mixed to more closely
approximate the original
when combined with black.

209

Upon Reflection–

Among the pages of history, there is no negation that truth bests the lie, that beauty defeats the ugly, and that good is better than bad. However, there are those to whom the mediocre is good enough, for whom the pursuit of excellence is uneconomic, those who believe that the intellectual and artistic level of the readers of mass media are such that the best is always wasted anyway.

There can be no waste in the best. It occupies no more space than the worst. It never offends the ignorant. And it frequently pleases the knowing. It is important to please the knowing, for there are more knowing than not.

Most important is a continuing effort to please oneself, to set standards too high for attainment, and reap the exciting satisfaction of trying. A single occasion of getting by with the barely adequate sets the stage for a future of mediocrity and attracts others for whom the best is too much trouble.

Portfolio
In the Studio

Illustrations, to be commercially stimulating, do not necessarily have to deal with commercial subjects. Many of the photographs which follow were created as experiments or simply because the photographer wanted to make them. They serve as idea sources for the future.

This graphic exercise in design is potentially full of
meaning depending upon the intensity and intellec-
tual bent of the viewer. The reproduction is from
an Ektacolor print which, in turn, was made from a
2¼-inch-square color negative. The diffuse
lighting was by electronic flash.
Photography by RUDY MULLER

On the next spread are two additional photographic
illustrations made in the spirit of artistic rather than
commercial achievement. Both are lighted by elec-
tronic flash and the reproductions are from 8 x 10
Ektachrome transparencies.
Photography by RUDY MULLER

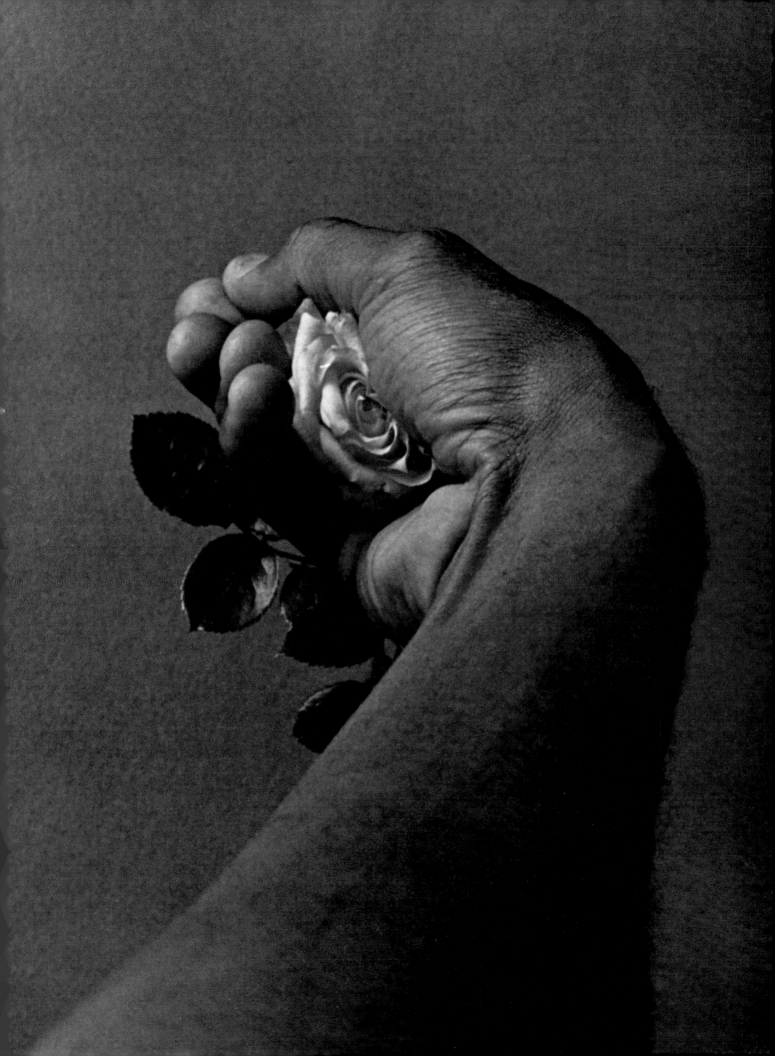

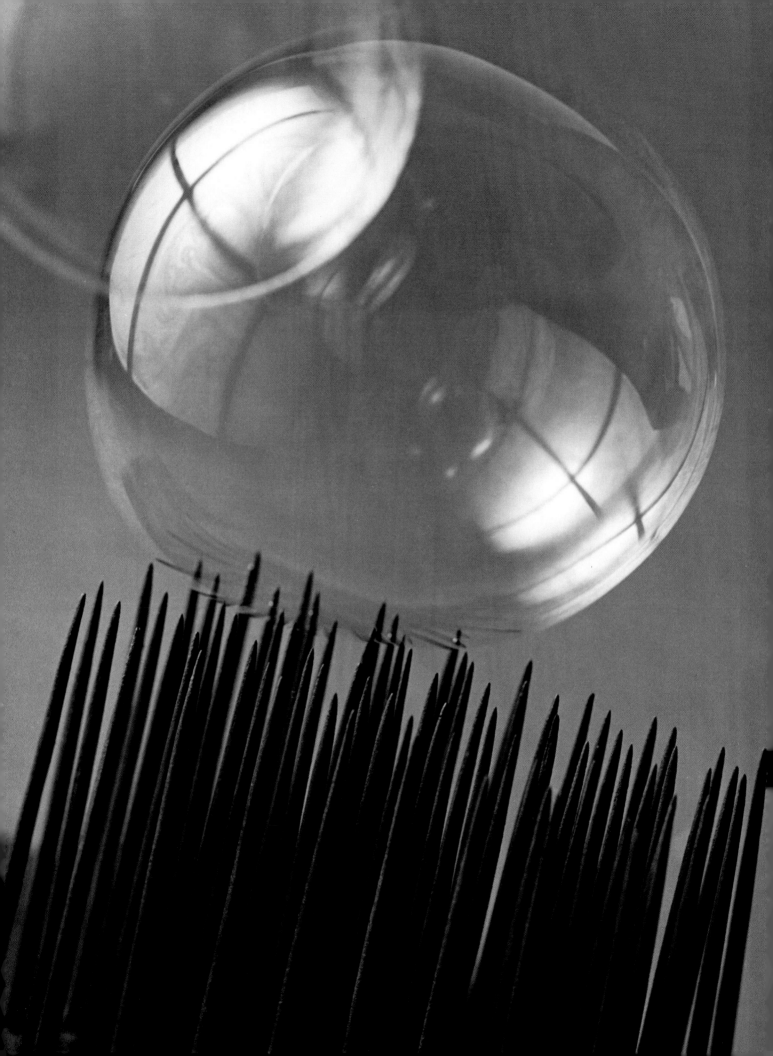

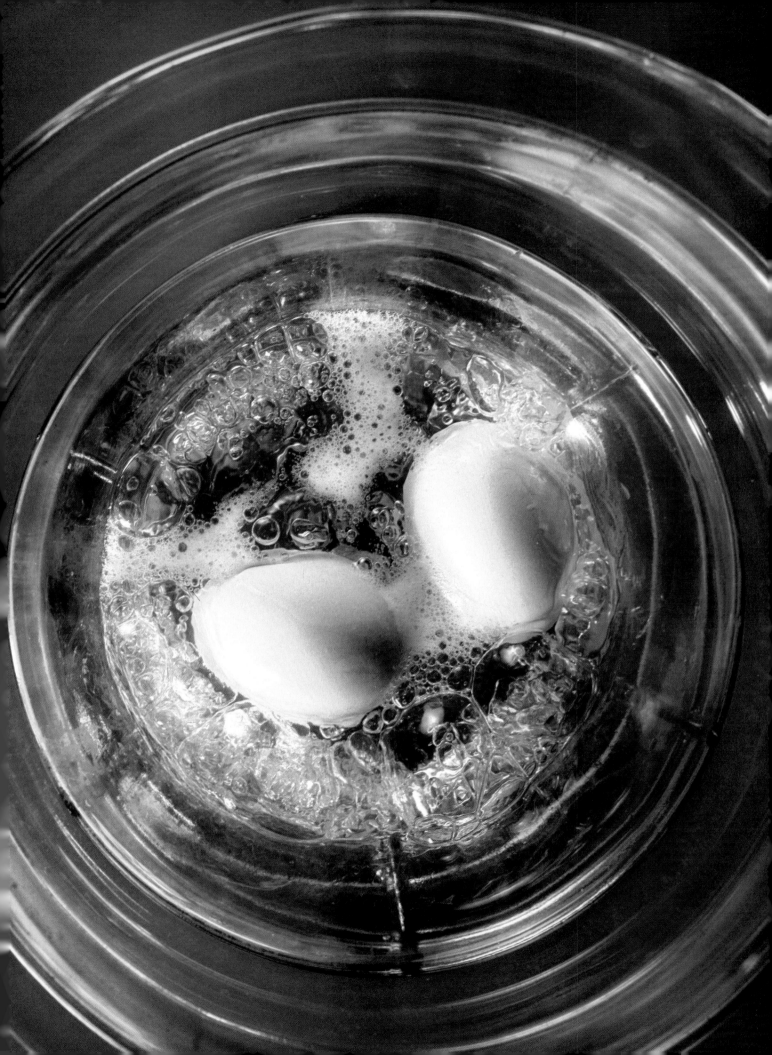

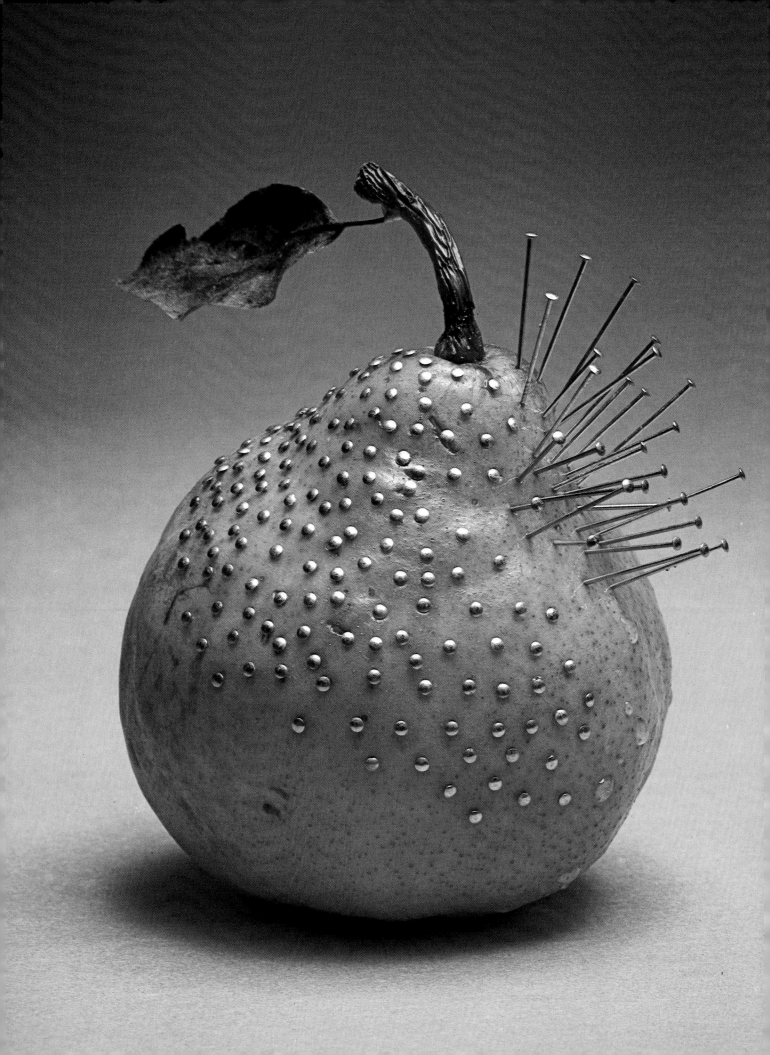

The beginnings of an experimental photograph may be in the drifting of an idle body and active mind. Wonderment with what happens to a pear when pierced with pins led to action and, in turn, this picture. It means neither less than nor more than the viewer wishes.

The two pictures overleaf are simple exercises in technique and design. From such photography comes the experience to handle the problems of the future and are in the nature of the artist's sketchbook. However, the photographer usually carries his experiment to a professional completion rather than being merely a suggestive reminder of an idea. All three of these illustrations were reproduced from 4 x 5 Ektachrome transparencies.

Photography by JERRY SARAPOCHIELLO

The exactly right use of light contributes to the
simple design in the creation of this fine illustration.
There are no unnecessary elements to distract the
eye, and not a shadow or highlight betraying the fact
that the subject was lighted for photographic
purposes. The reproduction was from an 8 x 10
Ektachrome transparency.
Photography by TONI FICALORA

221

Photographers have long been fascinated by the shapes and colors of vegetables as subject matter. From illustrative experiments such as this, to one advertising tomato soup is a comparatively short step. Reproduction from an 8 x 10 Ektachrome transparency.
Photography by TONI FICALORA

Variations on the theme of the color green.
These illustrations were created at the request
of the editor of *Applied Photography*
because he liked the color.
Reproductions from 8 x 10 Ektachrome
transparencies.
Photography by ALBERT GOMMI

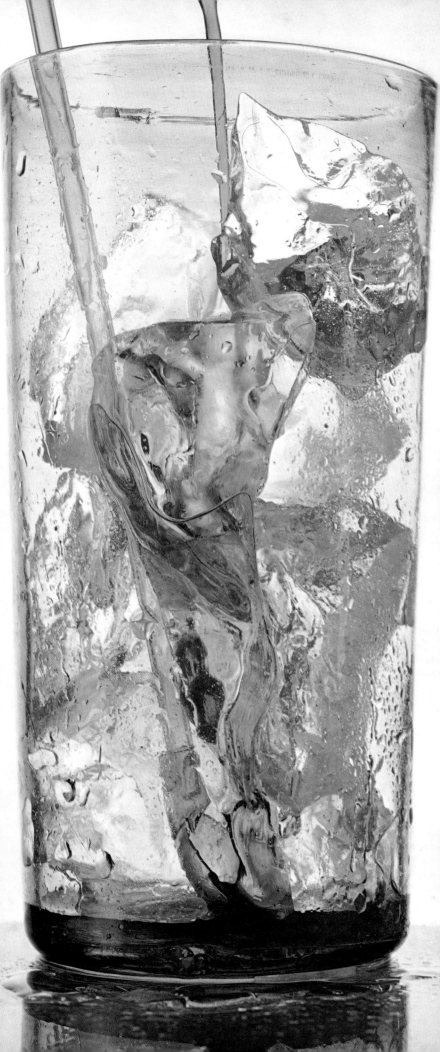

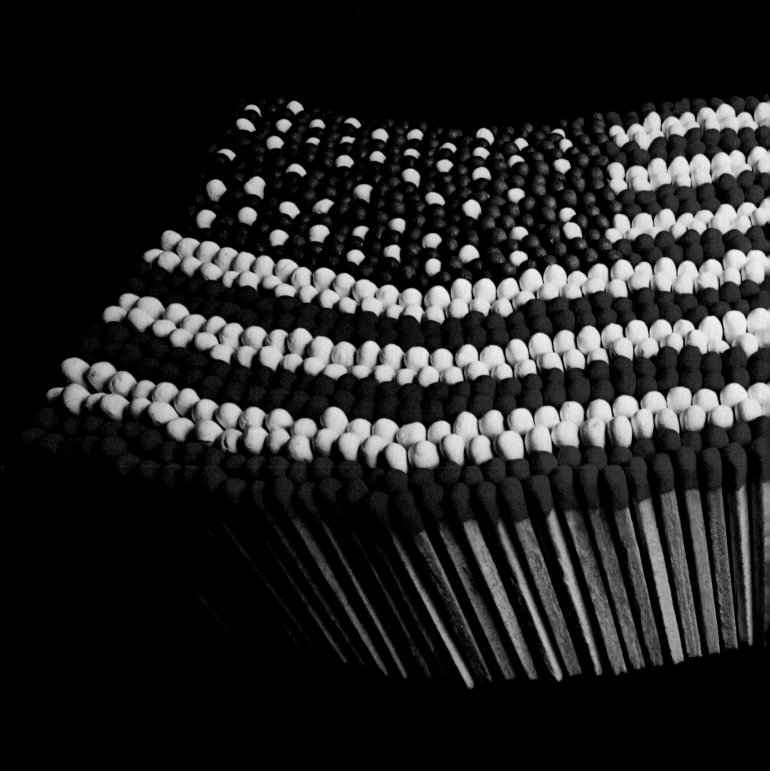

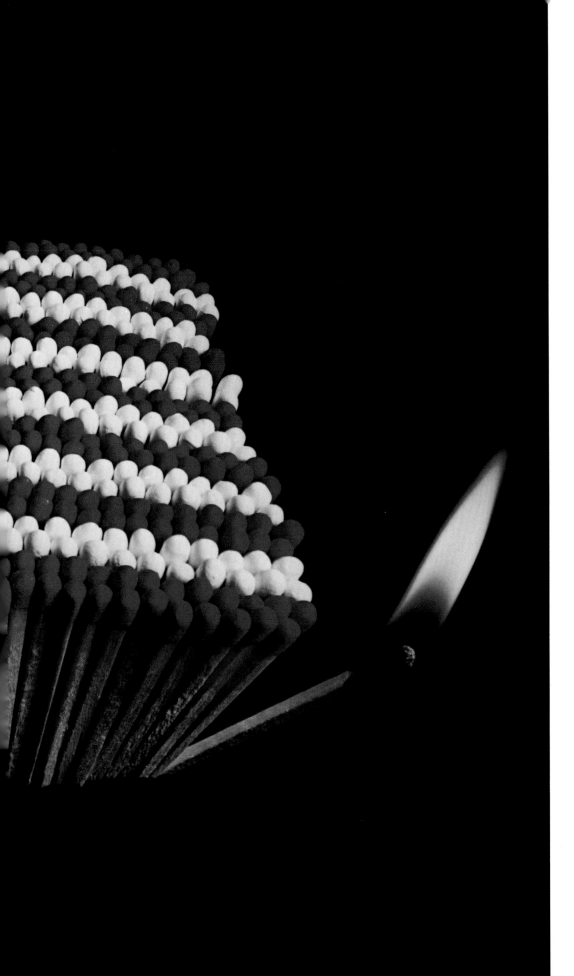

This photograph was made during a period when there was not an overwhelming unanimity of opinion in the country. It is a dramatic materialization of an idea and a fine example of symbols used as shorthand for a complex situation. Reproduction from a Dye Transfer print.

Photography by
WILLIAM STETTNER

The following two spreads are still-life studies created simply to form two pieces of graphic beauty. They demonstrate the mood which photographic tones can inspire. They exemplify, as well, what can take place when the photographer's sense of rightness is highly developed. Reproductions from 8 x 10 transparencies.

Photography by
FOTIADES-FALKENSTEEN

227

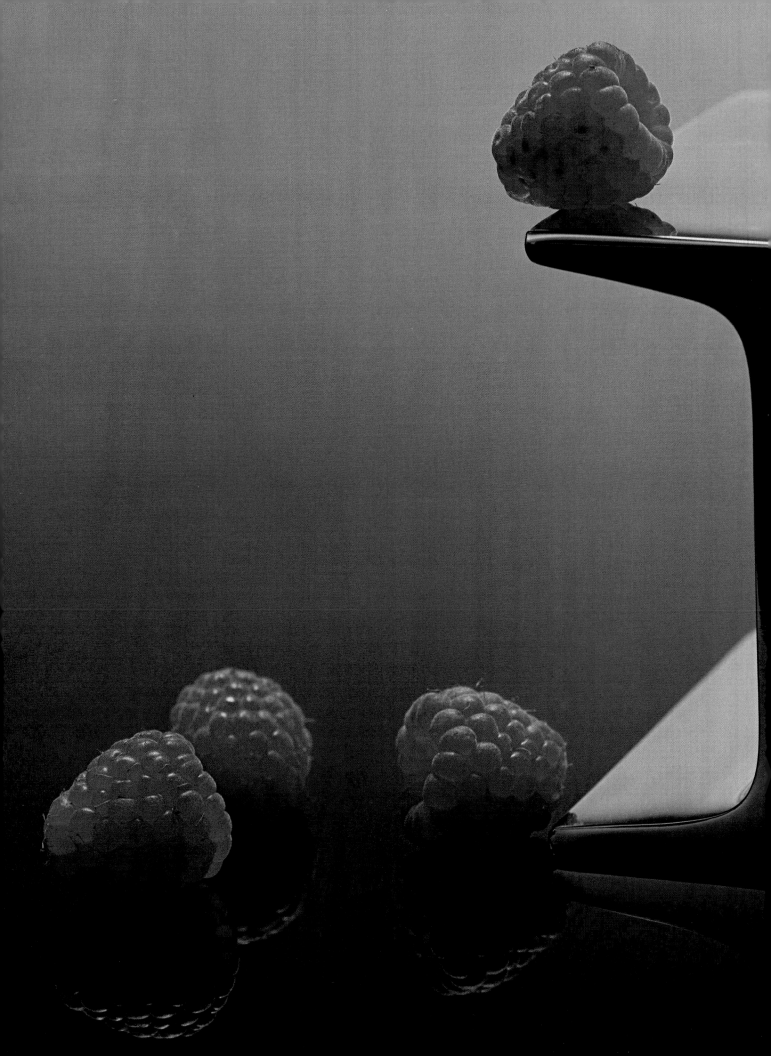

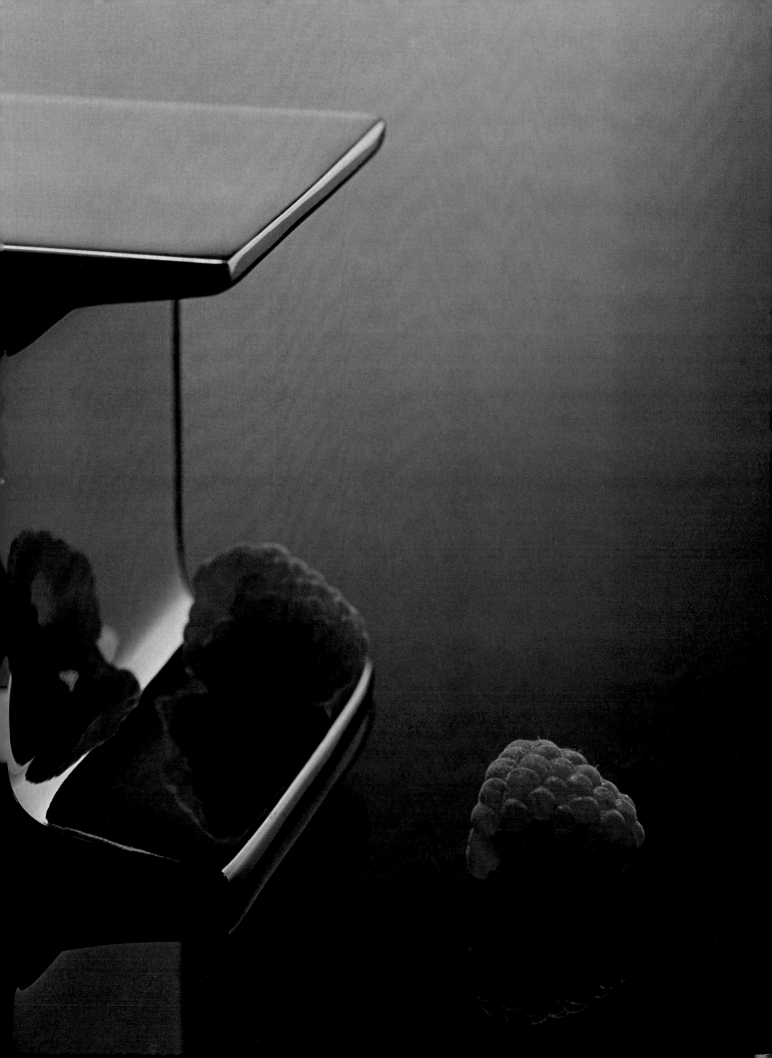

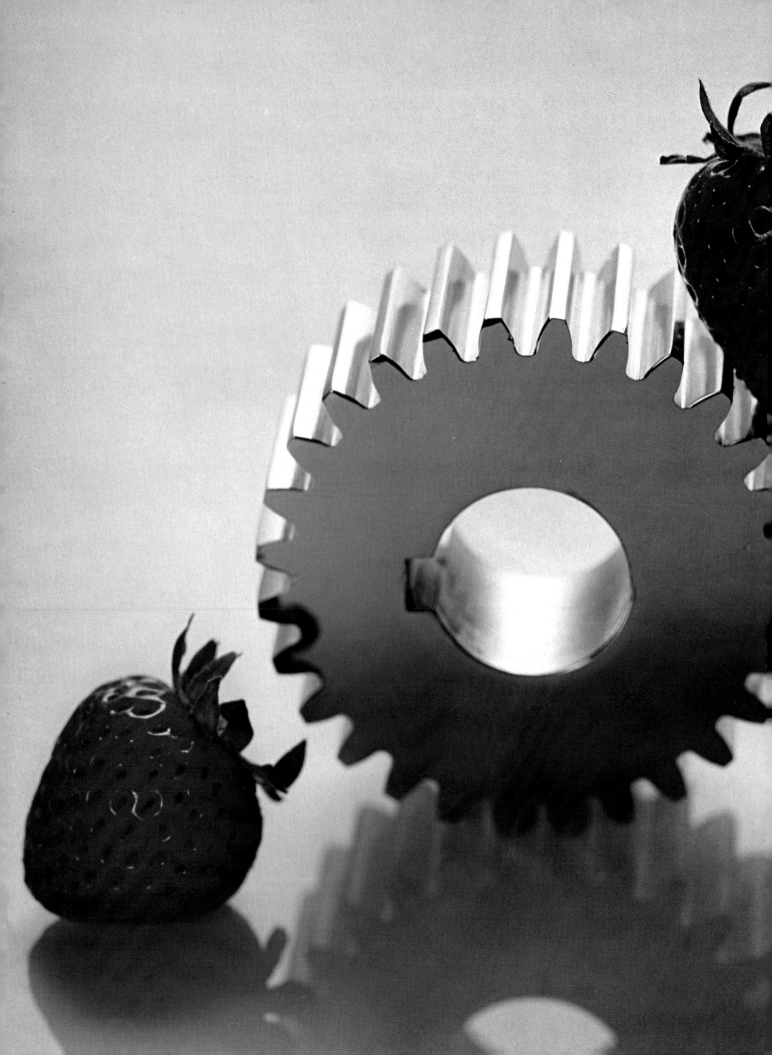

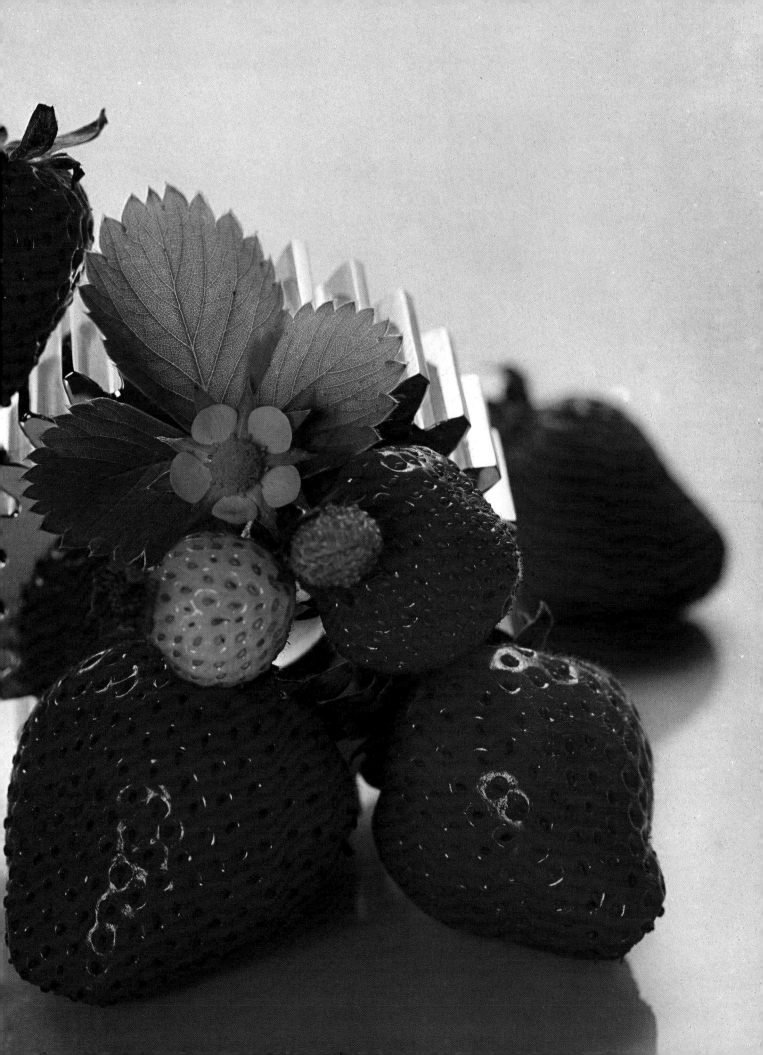

These are the patterns formed by dyes dropped into the water of an aquarium, and the result immobilized by electronic flash. The photograph is presented upside down so that the patterns rise rather than fall. Reproduction from an 8 x 10 Ektachrome transparency.
Photography by PHIL BRODATZ

The illustration on the following spread simply strives to present the tumbled appearance and texture of hair. It is presented as a carefully arranged still life. Reproduction from an 8 x 10 Ektachrome transparency.
Photography by RICHARD BEATTIE

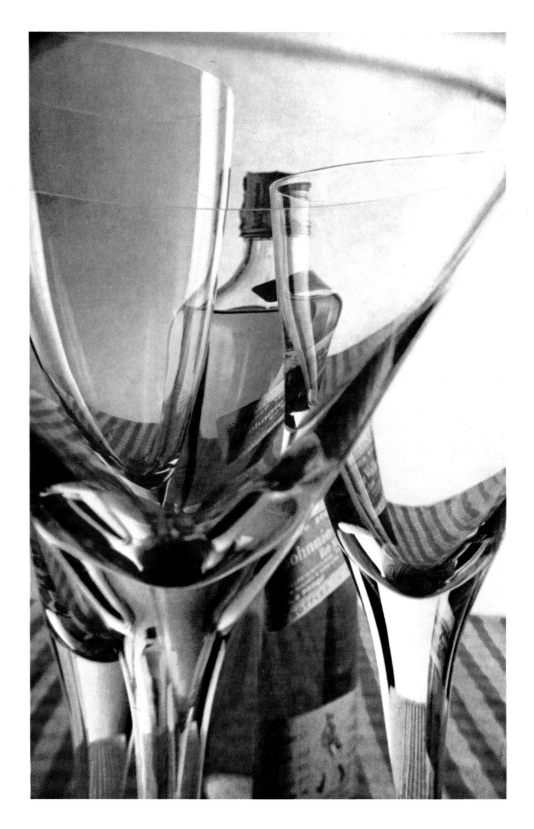

The 35mm camera can be used for still life to yield a different look to careful arrangements of common objects. Such studio use of equipment normally thought of as being in the province of location work requires meticulous control. It is important to totally fill the available film area, for there is not much of it. Reproduction from a 35mm Kodachrome transparency.

Photography by EDGAR deEVIA

The two illustrations which follow are interesting examples of what happens to the sense of size when a still life is arranged to eliminate it. The trees in both cases are exquisite examples of bonsai, the art of miniaturizing trees. The sets simulated natural conditions as did the lighting. In the first, artificial fog enhanced the illusion, while in the second, front projection of the background provided the sunset. Bonsai by John Naka. Reproductions from 8 x 10 Ektachrome transparencies.

Photography by GEORGE de GENNARO

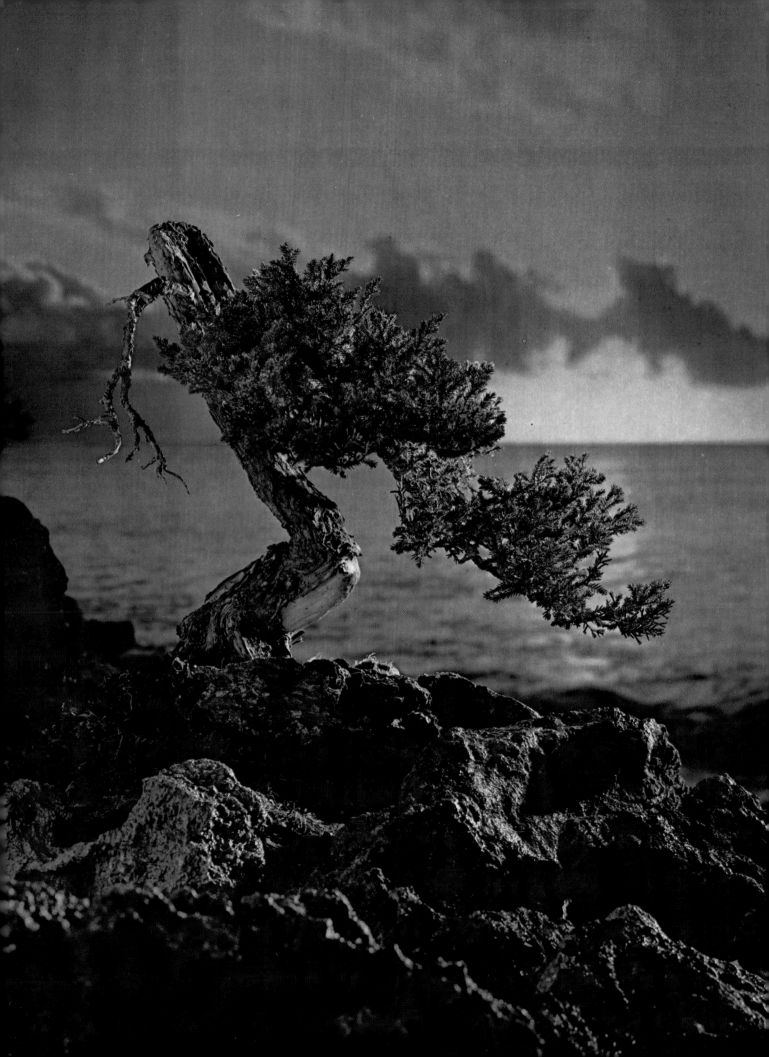

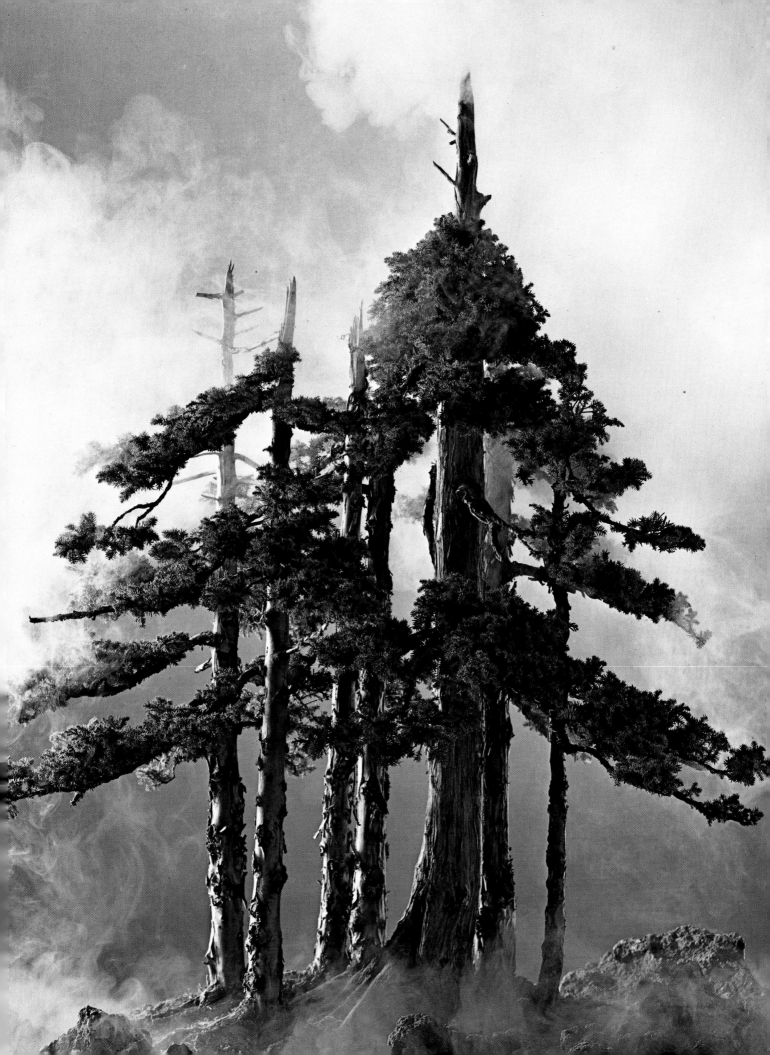

Much of what the layman believes to be photography is essentially a process of visual editing; of narrowing the vision; of clarification and emphasis by selecting a part from the confusion of the whole. Excellence in the photograph becomes a matter of what remains after elimination of the superfluous.

Photographic illustration, on the other hand, starts with nothing but the subject and the photograph is achieved by addition. The background may be as insignificant as a sheet of blank paper or a void of unlighted space. And the picture appears only after minimal elements are arranged and lighted in an emphatic, storytelling way.

Creativity expressed in photographic terms most certainly involves selectivity of a part from the whole, particularly if what is left has been shaped by an individualistic vision of a final image. Even more an evidence of the creative phenomenon is a shining testimony to the virtue of an object when there is nothing more at the start than the object itself.

Portfolio
On Location

Take the camera outside the studio to the wide world beyond. There are unthought-of ideas out there just waiting to happen, inspired by new environments and new experiences. The creative process needs stimulation if it is to climax in originality, and this well never runs dry when fed by infinity.

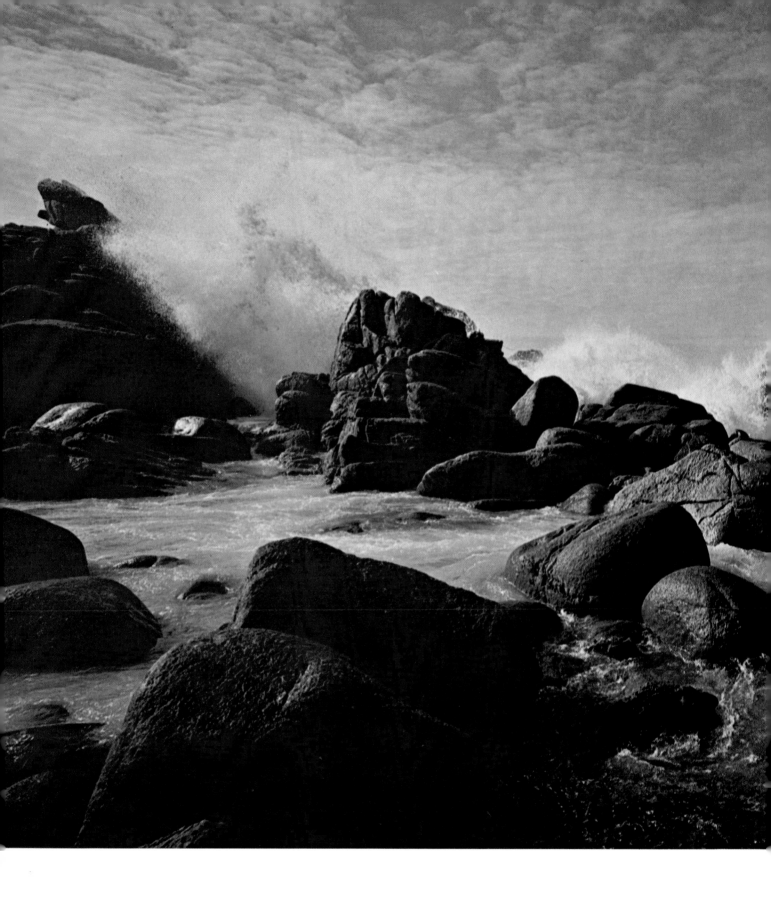

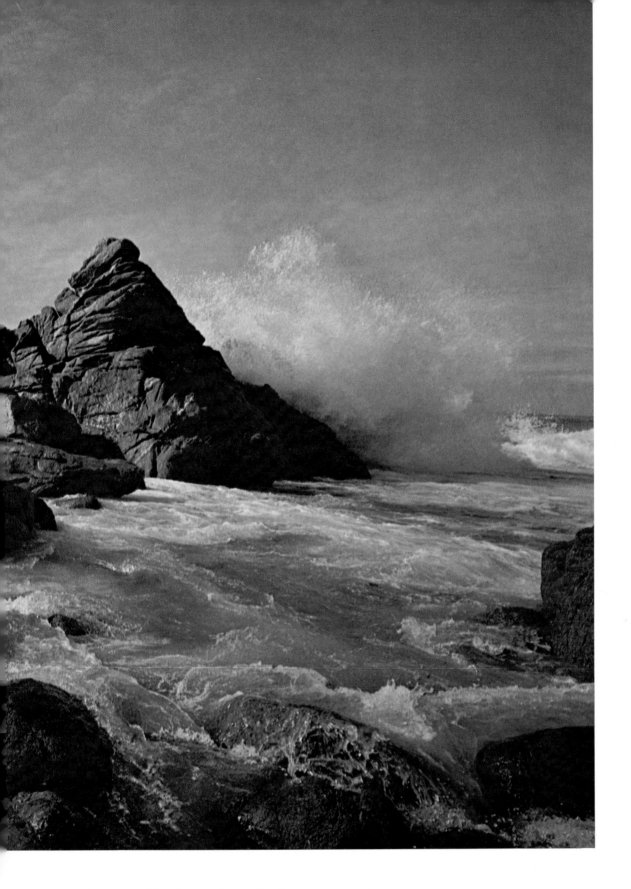

A free reprint of this photograph was offered in an uncouponed
advertisement to a total readership of approximately 80,000. More
than 8,000 requests were received! The readership was made up
of those in the advertising business: advertising managers,
art directors, agency personnel—a tough house to play. Beautiful
photography attracts attention and motivates action.
Photography by RICHARD BEATTIE

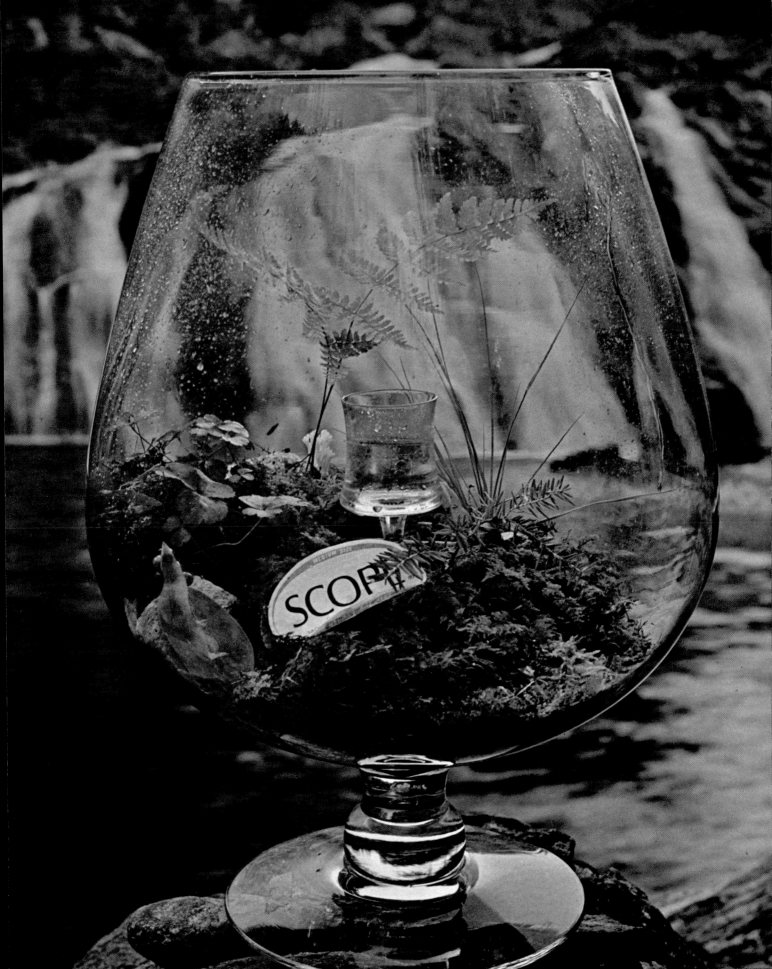

This illustration was an experiment in using a variety of symbols to suggest that use of the product resulted in a feeling of fresh coolness. It was photographed after sundown when the light was blue, thus utilizing the cool connotation of that color. While the brandy snifter-like glass container was quite large to begin with, it was made to dominate the scene completely by positioning it quite close to the camera. Drawing in the background was retained by using a small f/stop to gain depth of field. Reproduction from a 2¼-inch-square Ektachrome transparency.

Photography by OZZIE SWEET

Pancakes and maple syrup remind many of breakfast down on the farm, and they were handled in that spirit for the illustration on the following spread. Many unexpected sets and properties fall to the lot of those on location. These help create unusual photographs which would simply not have been imagined otherwise. Reproduction from a 4 x 5 Ektachrome transparency.

Photography by
OZZIE SWEET

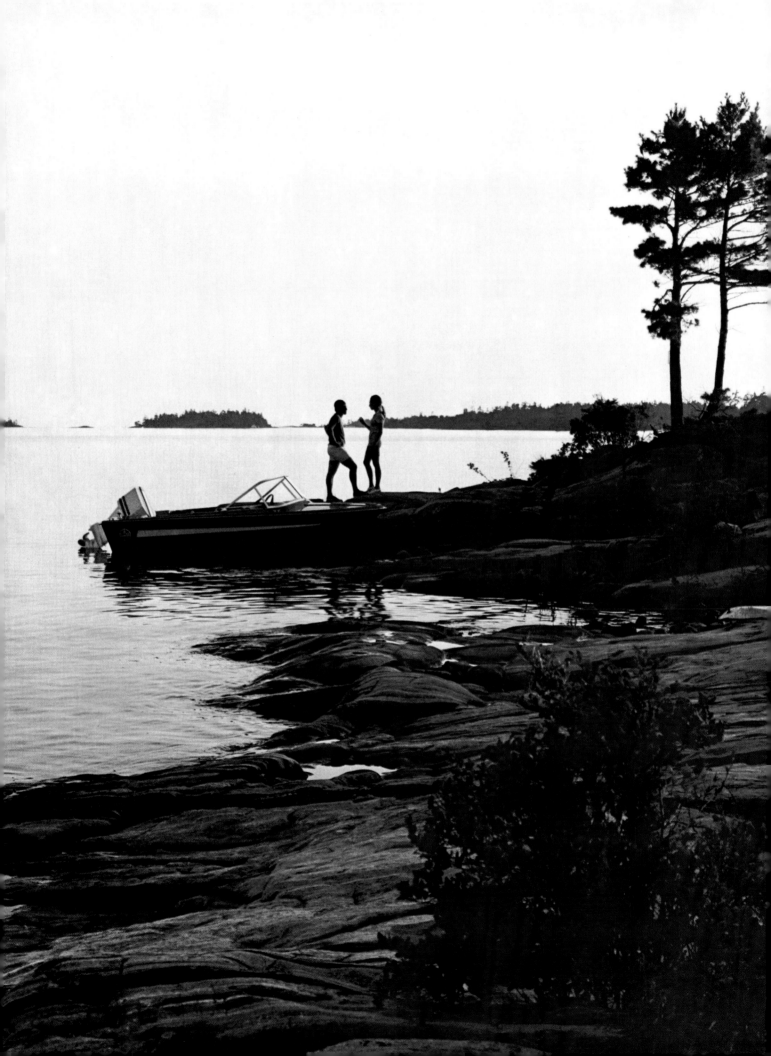

This photograph and the one on the following spread were part of a series which set out simply to illustrate the beautiful places one could visit in a boat, and the pleasure one could anticipate in doing so. The efficiency of such a project can be greatly increased if the location is chosen carefully for its many possibilities, the people and properties assembled in advance, and a rough working schedule planned. A whole campaign can be completed with one big effort.

It is somewhat self-defeating to plan the photographs in every detail ahead of time, for the whole idea of going on location is to take advantage of the ideas inspired by what is there. However, there should be a plan for what is to be said in the illustrations, the space they are to occupy, and possible multiple uses for them. It is comparatively easy to do several variations on an idea, particularly when small cameras are used. A change in camera angle can change the look of a set and hence the illustration, without altering the original premise.

Several days in a good location can result in an amazingly large selection of photographs, making the venture far more economical than if each picture were made one by one. Reproduction in the case of the picture opposite, from a 2¼-inch-square Ektachrome transparency; on the following spread, from a 16-inch-square Ektacolor print.

Photography by BROR HANSON

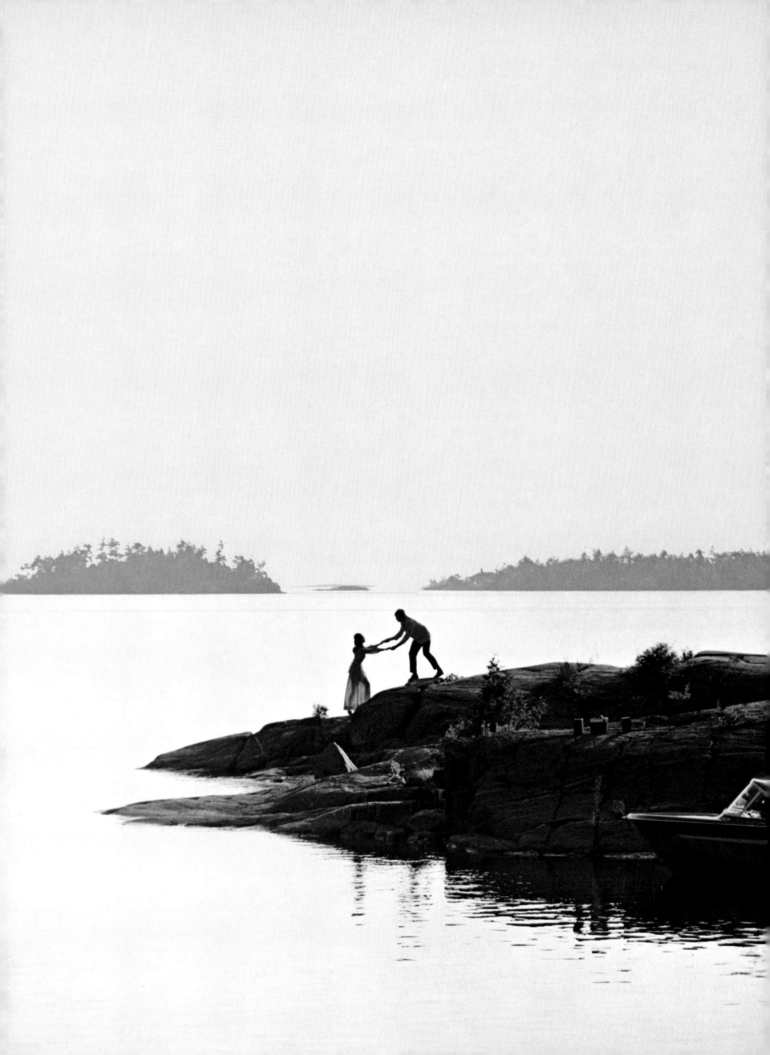

Two illustrations of yacht hardware originally made experimentally because of the photographer's interest in things nautical. They were ultimately used as posters in trade and boat shows by the product's manufacturer.
Photography by JASON HAILEY

The Extra Large, the Extra Long, The Big Picture on the Wall

Panoramic cameras are not a particularly new idea. Many years ago their use was widespread for banquets, graduating classes—and military regiments! Their use was restricted to immobile subject matter; to black-and-white only; and of late years, even further restricted because their manufacture had long since ceased.

Two new photographic means to 360-degree panoramas have recently surfaced. They promise interesting uses in the way of wall décor. Since both use roll films of satisfactory size for any reasonable degree of enlargement, it can be seen that photographs can stretch in one unbroken piece across large areas.

The photographs on this three-page spread were made by MICHAEL LAWTON with his Cerama 360 camera which is his own invention.

The Extra Large, the Extra Long, The Big Picture on the Wall

These photographs were made with a Cyclopan 70 camera available through the Third Media Company. The 70mm (approximately 2½ inches wide) negative for the scene in Canyonlands National Park was made with an 80mm lens and was 18 inches long. The negative on the same film stock of the farm scene was made

with a 150mm lens and was 36 inches long. Both covered a full 360 degrees without distortion, and both Ektacolor prints made from them have been cropped somewhat to better fit this space. It should be noted that each of this camera's interchangeable lenses results in a different negative length, thus the picture proportion can be tailored to the available space.

This camera is a very new arrival. The pictures here are fairly simple examples of its use. As more photographers apply their ingenuity and creativity to illustrative problems using this tool, a new way of looking at things probably will be revealed.

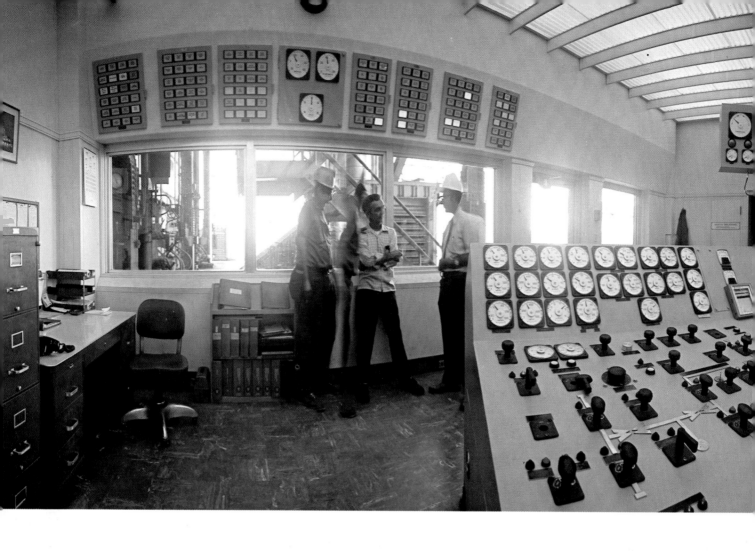

San Diego Gas and Electric Company

These pictures by MICHAEL LAWTON, made with his Cerama 360 camera, demonstrate a few more illustrative uses to which this 360-degree instrument can be adapted. This camera is equipped with a noninterchangeable 50mm lens, and the negative resulting is approximately 10 inches long by 2¼ inches wide (120 film). The wide-angle attributes of this lens tend to compress the scene. The resulting image quality lends interest to otherwise common-place subject matter.

Below: Exterior appearance of interior shown at right. The illustration was made with the camera on a vertical axis rather than a more usual horizontal aspect.

The thought processes on this illustration involved the long-life, nonrusting properties of copper pipes coupled with the remembered delivery system on an old-time water wheel. The camera was hand-held comparatively close to the subject matter and was fitted with a wide-angle (40mm) lens. Reproduction from a 2¼-inch-square transparency.
Photography by RICHARD ATAMIAN

The spice still life was inspired by the herb gardens of long ago where small groups of plants formed a living, intricate pattern. The bamboo was included to help with a tropical atmosphere, and the packages to provide an identification of the products in a more familiar form. Reproduction from a 2¼-inch-square Ektachrome transparency.
Photography by CHARLES SMITH

Nighttime scenes such as this are made by what is known as a split exposure. The camera is set up firmly on a tripod, and a partial exposure made at dusk which records detail in the sky and other areas of the scene which would otherwise not be lighted. The camera is then kept in exactly the same position until after dark. When the artificial illumination is turned on, a second exposure is made on top of the first one, thus recording the scene as the eye sees it.

Photography by
ARTHUR d'ARAZIEN
for General Electric
Company

The use of light and an unusual camera angle create a sense of dramatic action in what would otherwise be a prosaic record of farm machinery. There is little excuse for dullness in the illustration of almost any object, for there are almost countless photographic ways of changing the commonplace to the exciting. A prerequisite for such a desirable end is a willingness to forego self-inflicted ground rules of the sort rooted in what has been done before. Reproduction from an Ektacolor print.
Photography by DENNY HARRIS STUDIO

Overleaf: A very close look at an industrial process frequently will be more effective than one cluttered by machinery which contributes little to the story. An important function of a photographer is to see pictures which are overlooked by others. Such an ability is a cultivated one, and is the result of relating what is seen by close observation to mental images of possible pictures. Those who take the time to really see things instead of hastily glancing at them will find that constant practice will develop a similar capacity. Reproduction from an 8 x 10 Ektachrome transparency.
Photography by ARTHUR d'ARAZIEN

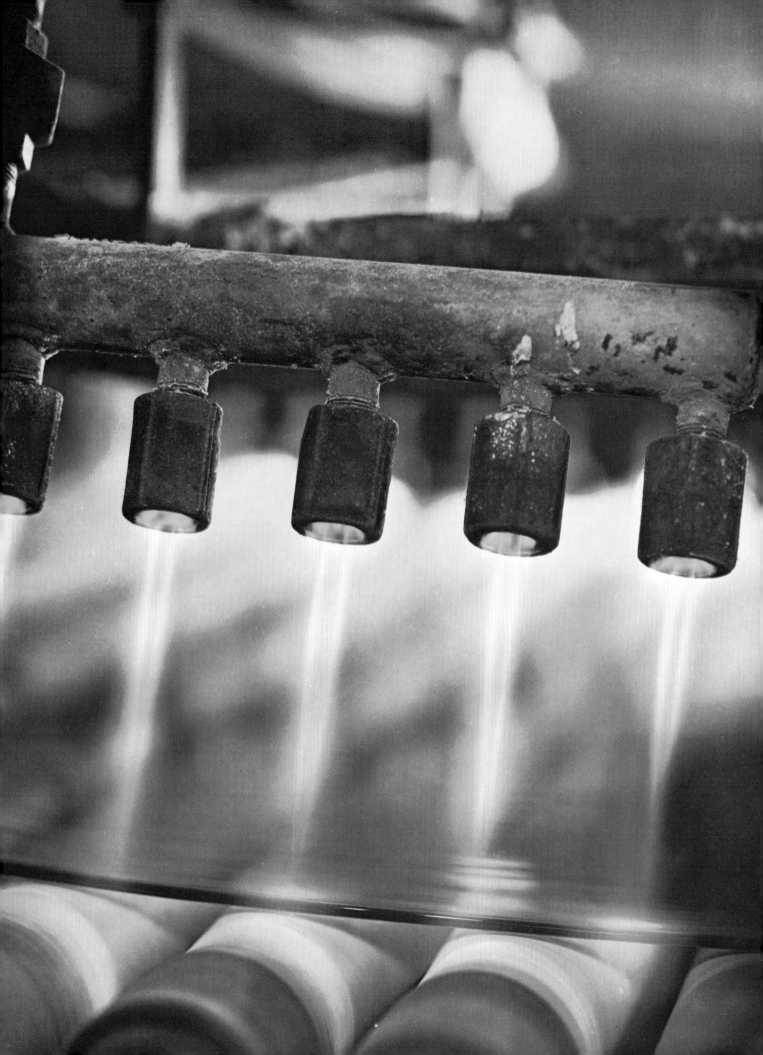

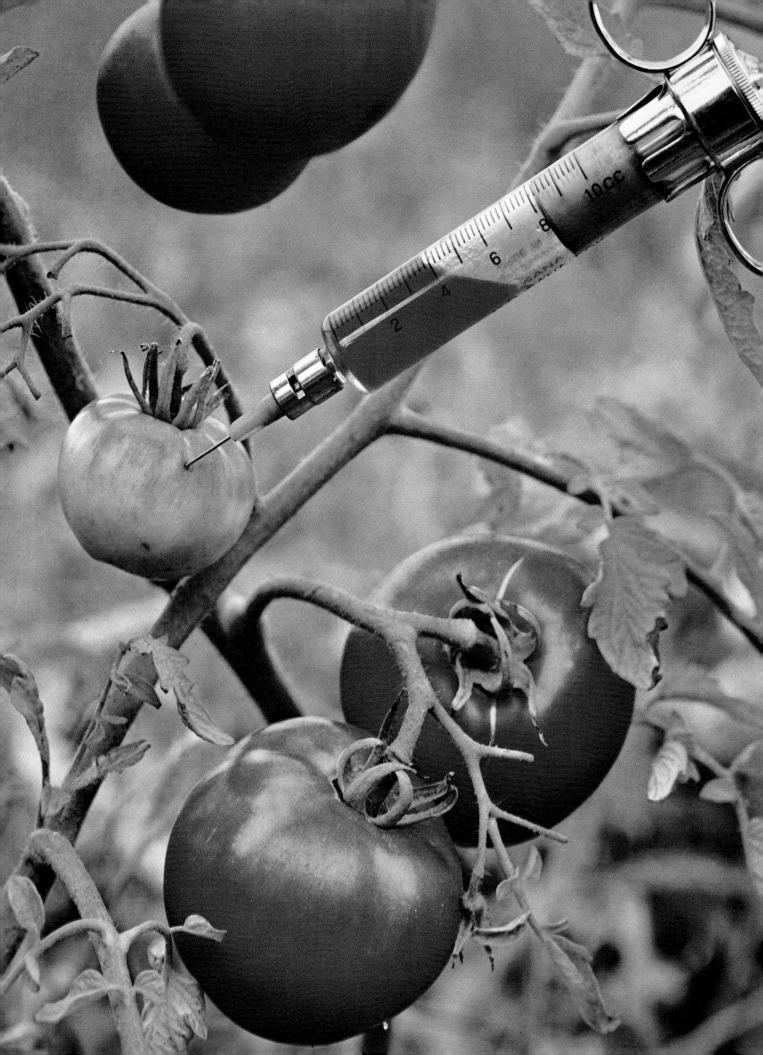

An active sense of humor can be a fine source of illustrative inspiration, particularly a sense which is reasonably well developed intellectually. Humor without intellect tends to become corn without the cob. While it may be true that there is even a market for the latter, it scarcely seems necessary to encourage it. Perhaps advertising illustration could profit from a few more smiles with an appeal to the happy people. This illustration was originally made for an advertisement about photography for Eastman Kodak Company. Reproduction from an 8 x 10 Ektachrome transparency.

Photography by RUDY MULLER

Much good illustration is quite simple in concept and uncluttered and direct in execution. Every element in the scene is there for the purpose of contributing to the story, or being physically necessary to contain the subject. In fact, there has been a quite traceable trend in illustration over the past 25 years toward simplification and elimination of the superfluous.

This illustration was created for a cookbook. It was thought desirable to position the subject matter as close as possible to its source. And so it was done with a minimum of pomp and a maximum of effect. Reproduction from an 8 x 10 Ektachrome transparency.

Photography by
ALBERT GOMMI
for General Foods Corporation

The manufacturer of these lamps has been illustrating its line by photographing the product in attractive desert, mountain, and seacoast locations. The corporate image these photographs have created has been so strong that the company is recognized in the trade as "The California Lamp People." Before this innovation, lamps were traditionally shown in room settings which made the illustrations descriptive but not unique.

Like many manufacturers in the furniture and home furnishings fields, the company depends upon photography to serve as salesmen's samples. Pictures such as these have been greeted enthusiastically and have had further uses as exhibits in trade shows, in space advertising, and in sales literature. Reproductions from Ektacolor prints.

Photography on this and next spread
by JACK NELSON for The Feldman Company

Since there was no source of electricity available on these locations, flashbulbs were used to simulate the lighted lamps. It was not possible to measure the brightness of the lighted lamp shade, but the negative-positive way to color made it possible to adjust tonal balance between lamp and surroundings in the darkroom.

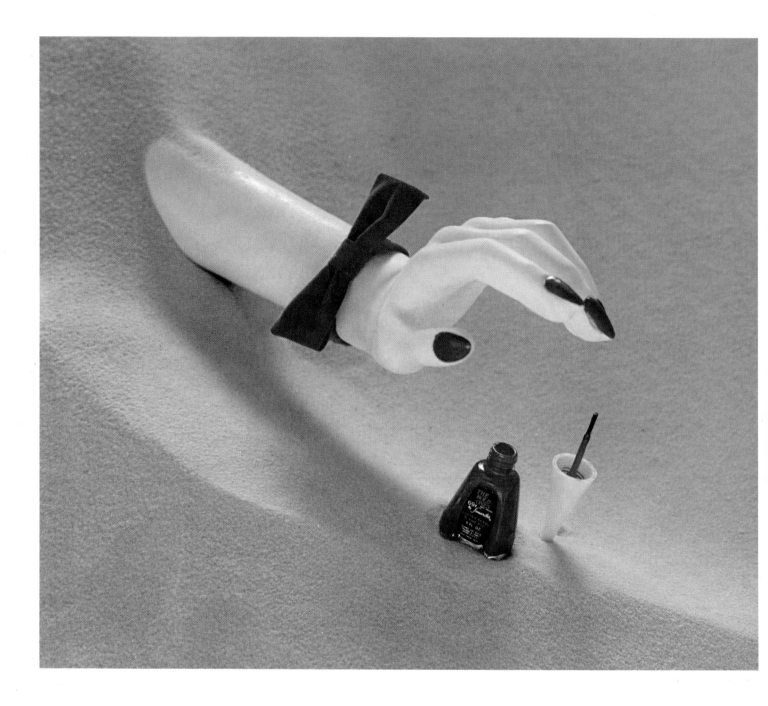

These flights of whimsy were motivated by the remembered sequence of a table-top gadget during which the box lid opens, a hand appears, disappears, and the lid closes. The idea of the disembodied hand remained as a way of displaying nail polish.

Nothing remarkable was necessary in executing the idea. The black arm was positioned in shaded black volcanic ash, the lighting contrast supplied by a reflector. The white arm was treated similarly in white sand, the whole area being screened with fiberglass to cut down the contrast which would have resulted from a sunlit scene.

The two pictures serve as reminders that anything seen and remembered can serve as an idea source for something someday. One need only isolate the problem and search the mental file for a solution. Reproductions from 2¼-inch-square Ektachrome transparencies.

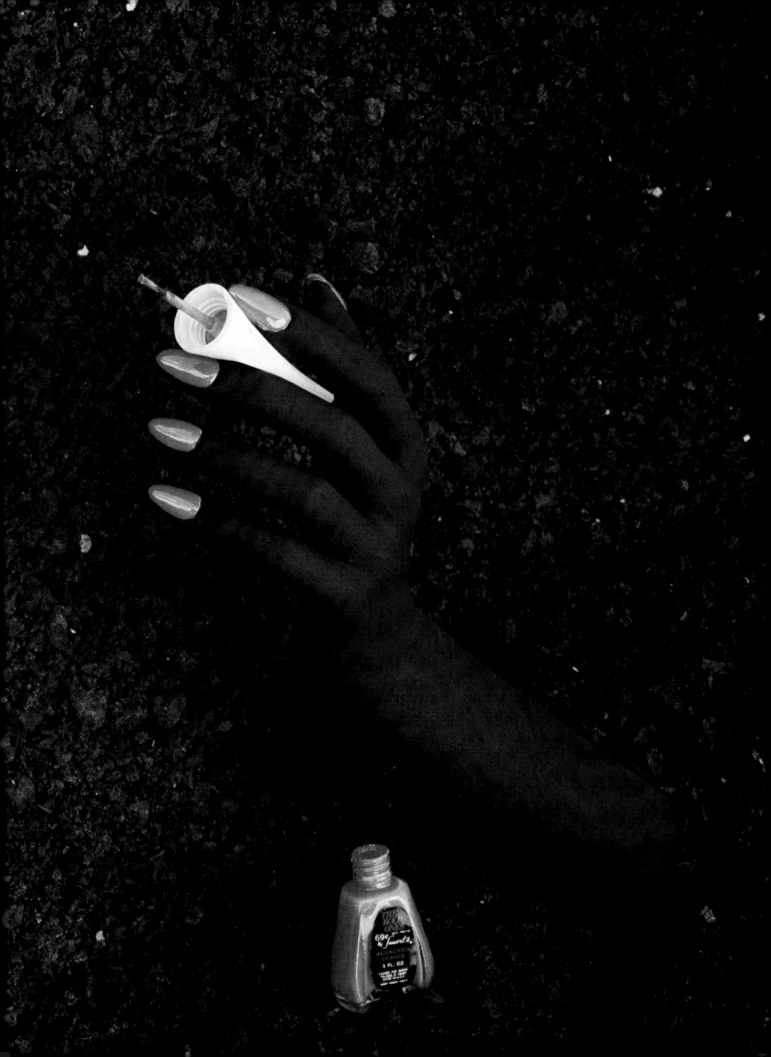

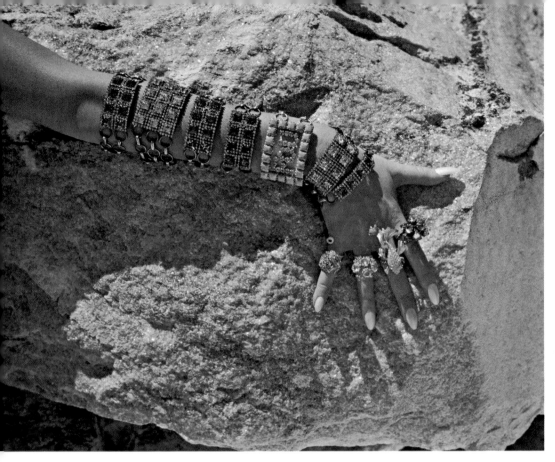

Natural locations provide many unexpected settings which enhance the product in unusual ways. Locations which show the hand of man are other sources with a whole new set of variations. These illustrations were made on the property of a marble quarry, and even chunks of discarded trimmings provided ideas which would never have been born in the studio. Reproductions from 4 x 5 Ektachrome transparencies.

Photography by
GEECH KRAVALLE

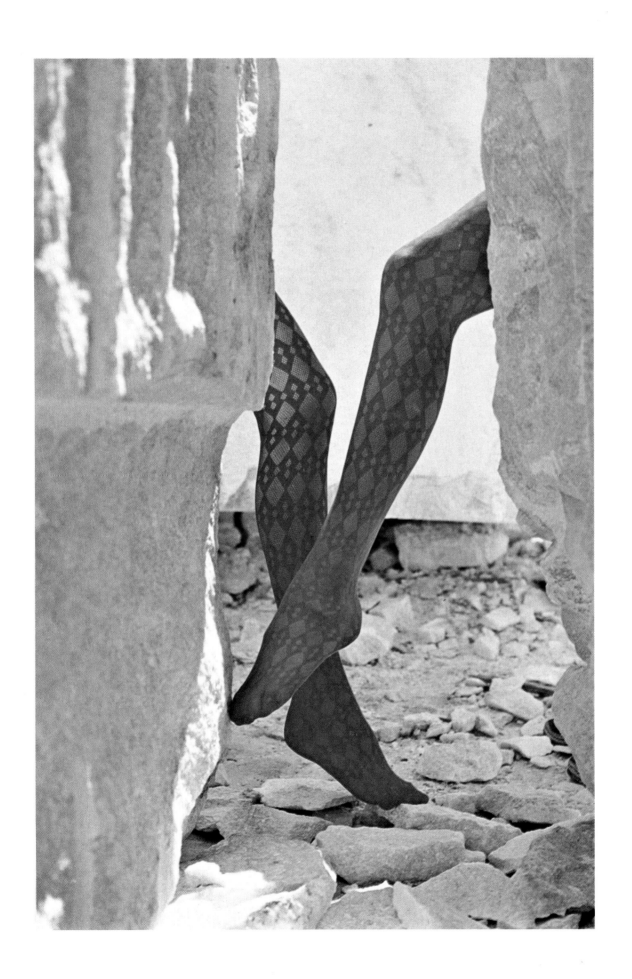

The problem solved by the series of photographs of which these are a part was to illustrate rug samples with tuberous-rooted begonia blossoms as a recurring accessory. Wedding anniversaries were considered suitable vehicles to serve as a continuous theme for the series. Three of them are shown here: silver, paper, and gold. Reproductions from 2¼-inch-square Ektachrome transparencies.

Photography by
HERMAN V. WALL

A highly dramatic way of distilling the essence of railroading into a single illustration. The use of light and perspective are particularly noteworthy. It is the sort of subject matter almost definitively suited to the 35mm camera. There can be considerable doubt that the picture would have been made if the photographer were not thinking along the lines which the 35mm format seems to encourage. Reproduction from a 35mm Kodachrome transparency.
Photography by ROBERT HUNTZINGER

Overleaf: There are many ways of achieving special effects and of creating images long removed from the clear-cut sharp record which is everyone's first impression of what photographic means. But it is only when the special technique is used for an effect which heightens the story and strengthens the mood that it has complete validity. Such an example is on the next spread. The heart of the matter is action, and the photographer's technique made the point unmistakable. This, again, is a subject matter impossible to accomplish except with a small hand-held camera and, most conveniently, with the 35mm format. Reproduction from a 35mm Kodachrome transparency.
Photography by MARVIN KONER

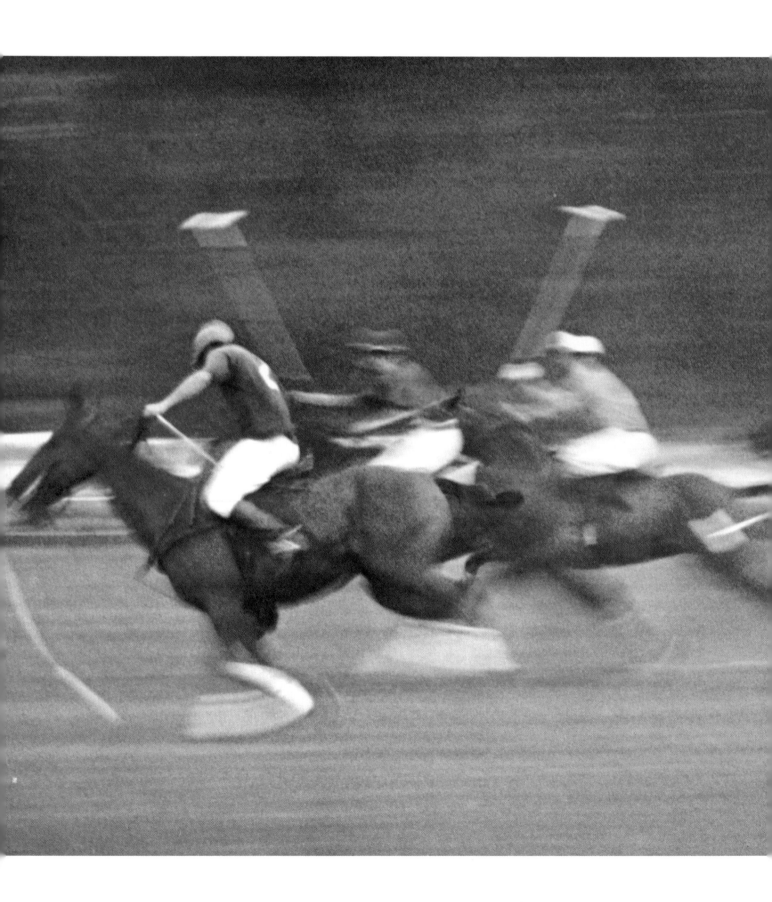

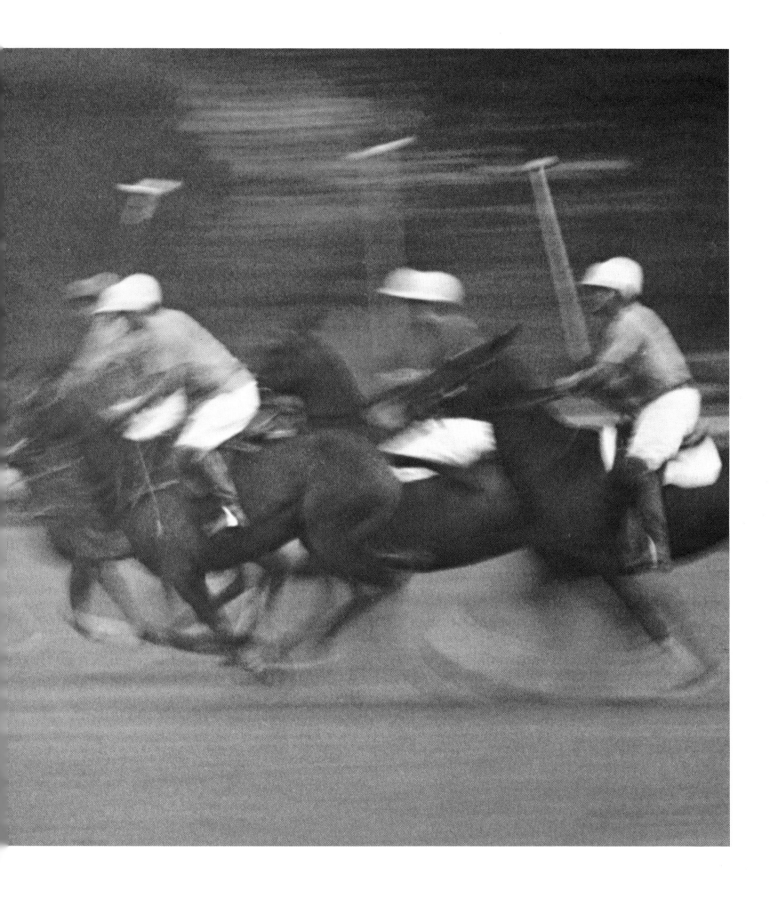

These photographs were part of a series made on the shores of Lake Powell in Arizona. They were realistic and uncomplicated demonstrations of the product in use, yet they took advantage of the rather dramatic settings which abound in the area. Reproductions from Ektacolor prints made from 2¼-inch-square color negatives.
Photography by
JOE MUNROE

These are two photographs from an editorial coverage on Indian arts and crafts. At the left, the basket weaver and her children are integrated into the environment of Monument Valley which is her home; and, below, the thought is carried out that every self-respecting ogre ought to have his own cave. He is a black ogre, a Hopi Kachina doll.

FLAMING FESTIVITIES

FOR FAMISHED SUNDOWNERS

An exercise is poster-making utilizing the effect of a camera equipped with a wide-angle lens positioned close to the principal subject matter. Reproduction from a 4 x 5 Ektachrome transparency.
Photography by MICHAEL SHELDON

A dramatic demonstration of what can be done with a length of fish line. Good design can exist no matter how simple the subject matter. Reproduction from an Ektacolor print made from a 2¼-inch-square color negative.
Photography by RICHARD ATAMIAN

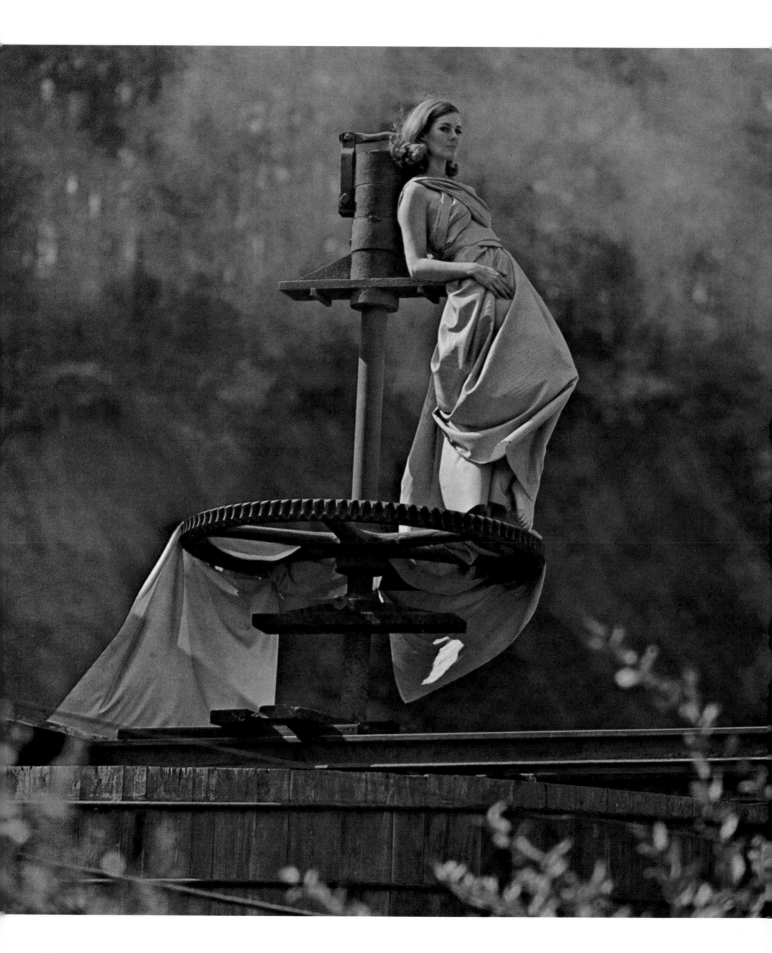

The photographs on the opposite page and following spread were part of a series of editorial illustrations in *Applied Photography* magazine demonstrating ways in which fabrics could be handled by costuming models without passing through the dressmaking stage. The three pictures serve as interesting examples of lens use, since a different focal length was used for each.

For the photograph opposite, the model was posed on top of a settling tank at a clay mine. To minimize the angle of view and to minimize the effect of peering upward, the camera was positioned at a considerable distance from the subject. A very long lens (350mm) was then used so that the full film size could be utilized.

Because the distance between model and camera was more modest in the case of the lady and the truck on the next page, a more normal lens of 120mm in length was needed. A shorter lens would have destroyed the desired relationship of object sizes in the scene, while a longer one would serve no purpose but to increase communication distance. Since the camera was one with a 2¼-inch-square format, the normal length is considered to be 80mm.

The effect desired for the third illustration dictated the use of a wide-angle, or very short focal length lens. This enabled the photographer to move in quite close to the model so that the near portions of the fabric appeared to be relatively larger than the far portions. The shortness of the lens' focal length made it possible to keep all of the scene in sharp focus, and the result was an illustration with a dramatic distortion. Reproductions from Ektacolor prints from 2¼-inch-square color negatives.
Photography by RICHARD BOYER

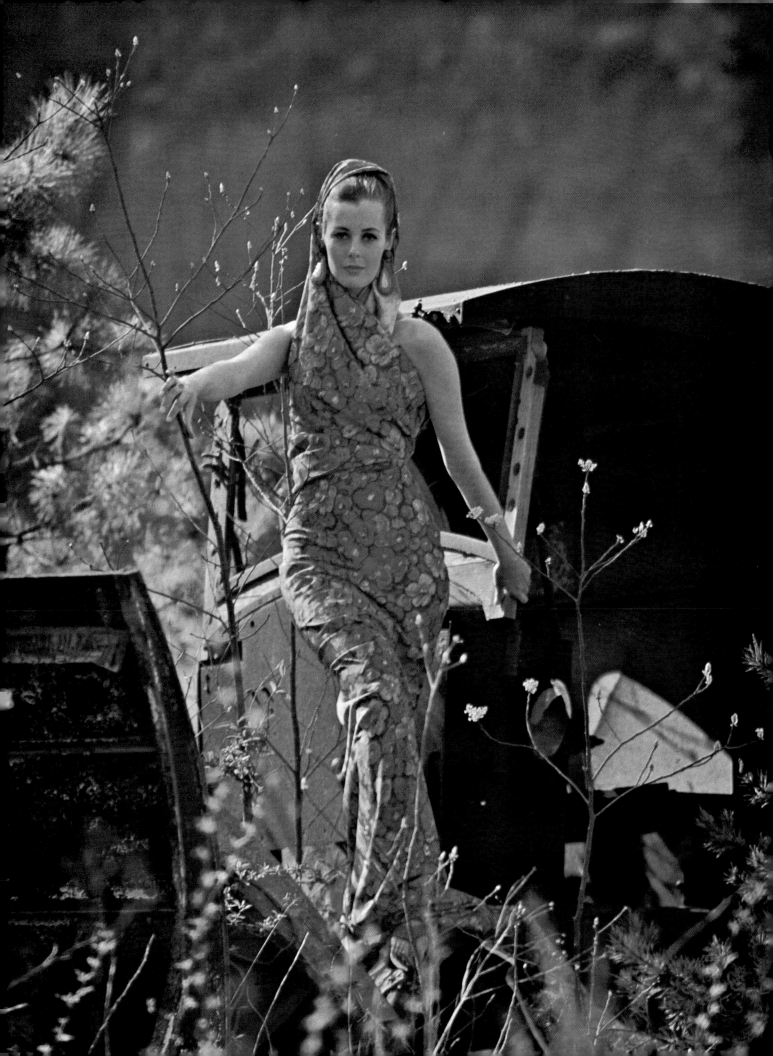

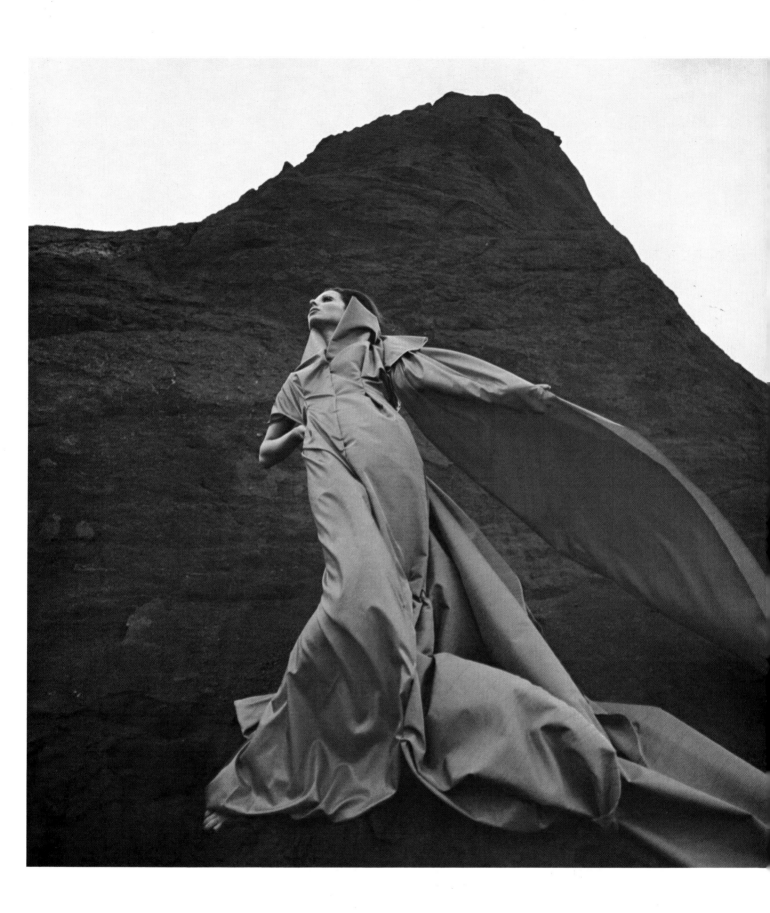

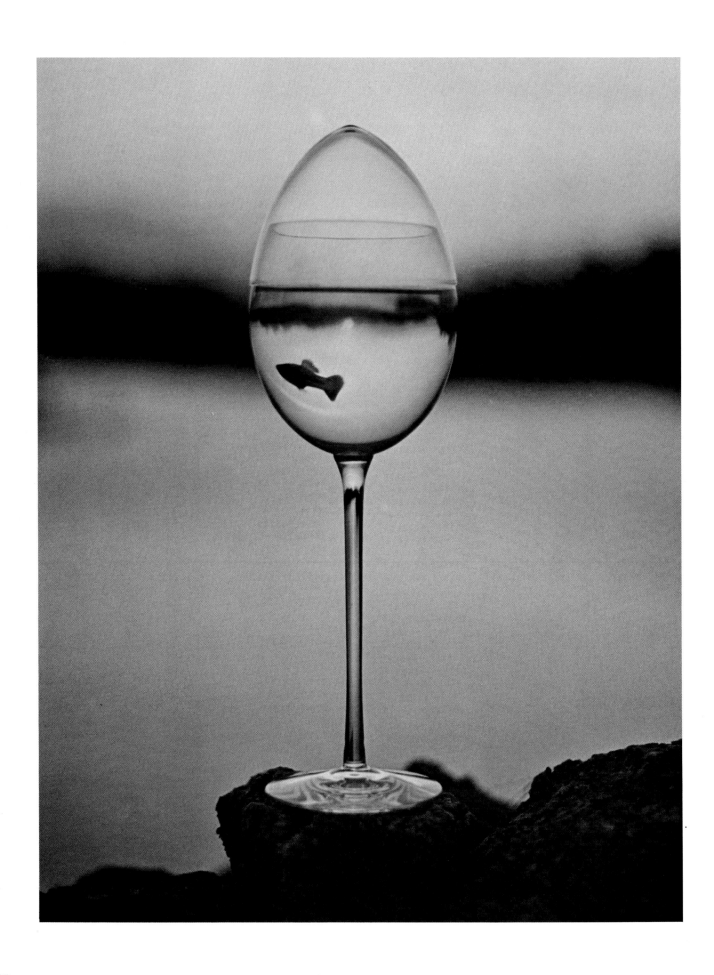

The illustration on the opposite page has no
meaning other than as a pleasing piece of design
developed from a rather whimsical idea. The glass
is meant to house a rosebud, but to the participants
in this exercise, it seemed like a quaint shape for an
aquarium. The addition of the fish followed, and the
setting and time of day provided the balance of the
simple composition.

The name of this perfume
inspired the use of a natural
setting and the choice of the
actual set was influenced by
the art director's fondness for
miniature trees. The combina-
tion seemed fitting, and the
back light added a glow to
the product. Reproductions
from 2¼-inch-square
Ektachrome transparencies.

Photography by
LOU BUZONE

When a color image is overenlarged, it becomes grainy, the sharpness fades into softness, and what is usually thought of as the technical quality begins to disappear. In the process, it may well change, and even improve, the emotional appeal of the picture, which serves to prove that all dogmatic statements concerning photography have their exceptions, perhaps, including this one.

These soft images tend to make the photographs nonliteral, and the subject matter more generic in character. The photographs here are not reports on specific individuals. Rather, they tend to describe clowns and lion tamers in general. Reproductions from Ektacolor prints.

Photography by THOMAS LOWES

The right place at the right time made this clever concept a success. The emphasis is on the tinted glass which is the product of importance, yet all elements work together to form the illustration. Reproduction from a 2¼-inch-square Ektachrome transparency.
Photography by VINCENT LISANTI

The idea for this illustration was inspired by the name of the product and the availability of a nineteenth-century room. The hatbox and hat act as further symbols for a flattering association. Reproduction from an Ektacolor print.
Photography by LIN CAUFIELD

"Color so real, you think you're there" was the
approximate headline for which this photograph
was the illustration. All of the elements were present
in the scene, and all were included in a single
exposure. Some masking of light intensities was done
on the camera to achieve this effect. Reproduction
from an 8 x 10 Ektachrome transparency.
Photography by MICKEY McGUIRE
Boulevard Photographic, for RCA

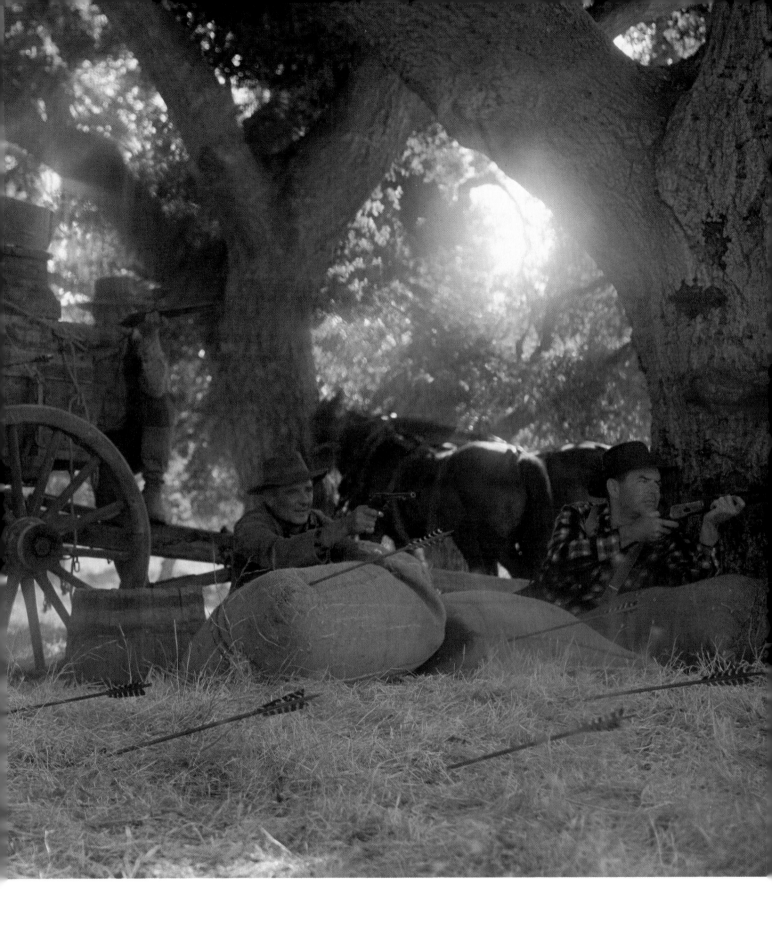

The original intent of these illustrations was to use
the exotic connotation of orchids as an enhance-
ment for the image of Linde synthetic jewels. By
choosing relatively small blooms, the jewels seem to
be larger than they really are. The pictures were
made with close-up equipment at a magnification
of 1:1. Lighting was by electronic flash. Reproduc-
tions from 2¼-inch-square Ektachrome transparencies.

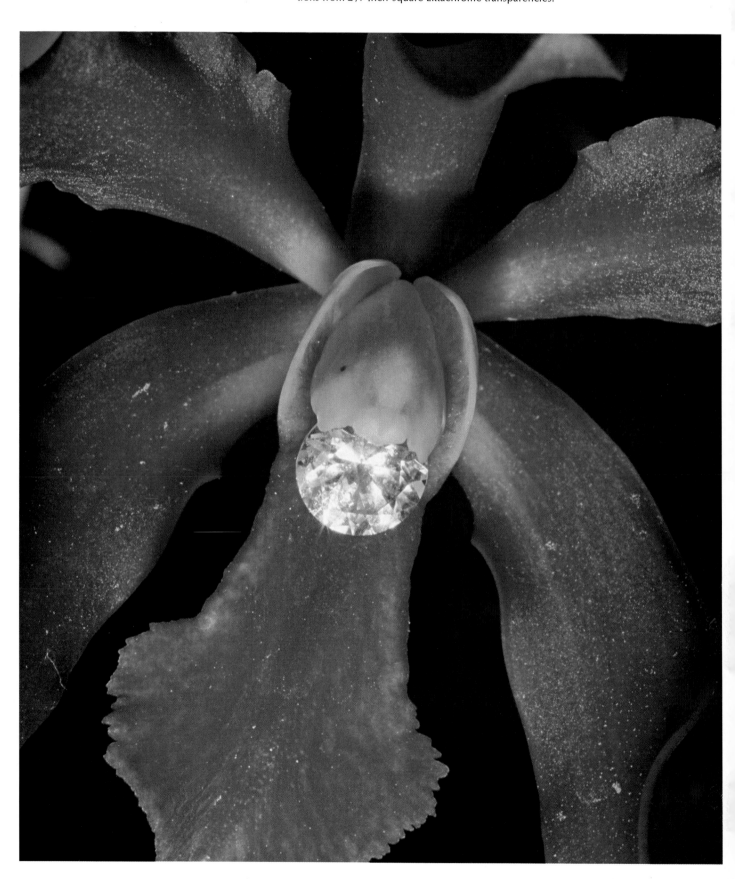

These are simply two experiments to see what happens when neckties visit a location. The illustration with coconuts was made for the imaginary headline "It's what's inside that counts!". Both used only natural light. The bow ties, being in the shade, required additional reflectors, while the other utilized a diffused spot of sunshine to achieve the effect. Reproductions from 2¼-inch-square Ektachrome transparencies.

Portfolio
Portraits for Publication

Where the destiny of a portrait is publication rather than the more private wall of a home, the responsibility of the photographer is extended beyond the subject to the public and, perhaps, posterity as well. If the portrait is to delve more deeply than a surface facade, it must be approached in a manner similar to the search for a concept in illustration.

The photographs on the pages to follow are examples of portraiture which achieve illustrative status.

All are the work of ARNOLD NEWMAN
and are copyrighted © by Arnold Newman

Harry S Truman

Vannervar Bush

Frank Lloyd Wright

Edward Hopper

Alfried Krupp

Brooks Atkinson

Rothschild Banking Partners

David Ben-Gurion

Frank Stella